How to Sketch Animals

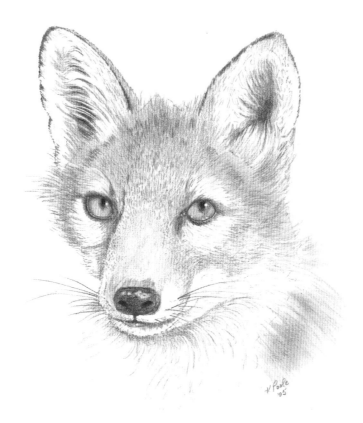

V. Poole
'05

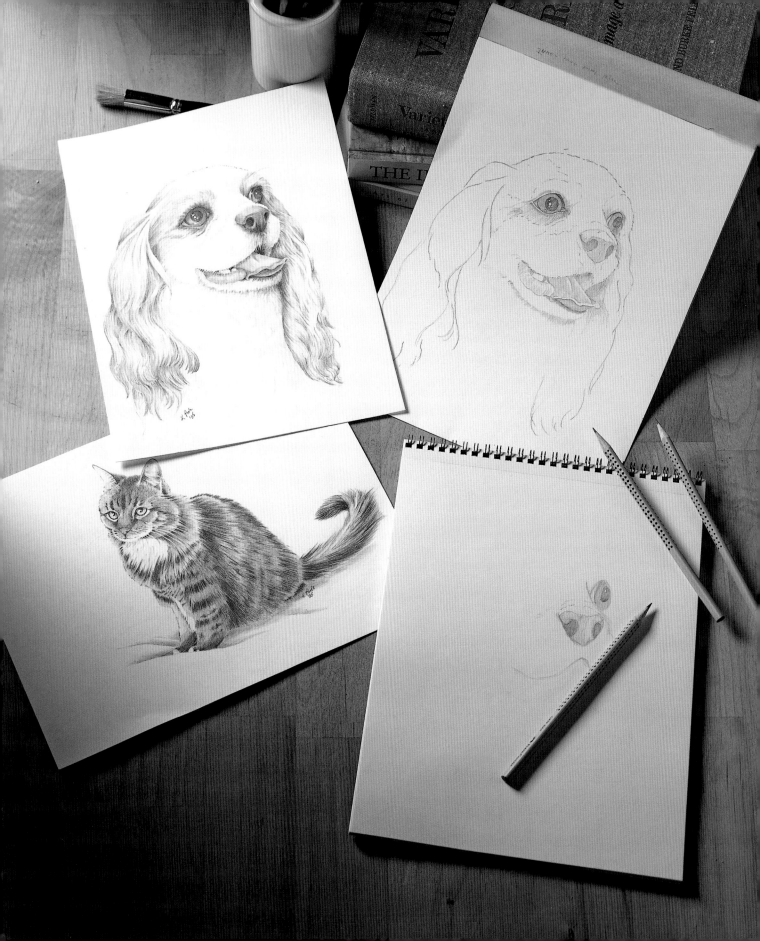

How to Sketch Animals

Kaaren Poole

Sterling Publishing Co., Inc.
New York

Prolific Impressions Production Staff:

Editor in Chief: Mickey Baskett
Copy Editor: Phyllis Mueller
Graphics: Dianne Miller, Karen Turpin
Styling: Lenos Key
Photography: Jerry Mucklow
Administration: Jim Baskett

Library of Congress Cataloging-in-Publication Data

Poole, Kaaren.
 How to sketch animals / Kaaren Poole.
 p. cm.
 Includes index.
 ISBN-13: 978-1-4027-3515-8
 ISBN-10: 1-4027-3515-4
 1. Animals in art. 2. Drawing--Technique. I. Title.
NC780.P65 2007
743.6--dc22

 2006023426

2 4 6 8 10 9 7 5 3 1

Published by Sterling Publishing Co., Inc.
387 Park Avenue South, New York, NY 10016
© 2007 by Prolific Impressions, Inc.
Distributed in Canada by Sterling Publishing
c/o Canadian Manda Group, 165 Dufferin Street,
Toronto, Ontario, Canada M6K 3H6
Distributed in the United Kingdom by GMC Distribution Services,
Castle Place, 166 High Street, Lewes, East Sussex, England BN7 1XU
Distributed in Australia by Capricorn Link (Australia) Pty. Ltd.
P.O. Box 704, Windsor, NSW 2756, Australia

Printed in China
All rights reserved

ISBN-13: 978-1-4027-3515-8
ISBN-10: 1-4027-3515-4

For information about custom editions, special sales, premium and corporate purchases, please contact Sterling Special Sales Department at 800-805-5489 or specialsales@sterlingpub.com.

About the Artist
Kaaren Poole

Kaaren Poole is a self-taught artist. Among her early works are her third grade arithmetic papers enhanced with horse portraits. While pursuing a career in the computer industry, she took up china painting as a hobby, and from there, progressed to artists' acrylics and watercolor. Finding little sympathy for her favorite subject – animals – in the fine art world, she turned to decorative painting.

"Retirement" now allows her to work full-time on her art. Her first book, *Nature's Vignettes,* a collection of ten animal designs, was published by Plaid Enterprises, Inc. in 2005.

Kaaren lives in rural Northern California with her three dogs, twelve cats, and four ducks. She has been a member of Sierra Wildlife Rescue's squirrel team for the last three years and has successfully raised and released orphaned fox squirrels and western gray squirrels on her property.

Kaaren may be contacted through her website: http://www.kaarenpoole.com.

For Doug and Bruno, A Boy and His Dog

Special thanks:

Thanks to my daughter, Audrey, for believing in me and cheering me on as I start my new career as an author.

Thanks also to my sisters, Shelley and Andy, and to my father for all of your encouragement.

Of course, I acknowledge my mother – a talented, devoted, and enthusiastic artist. I am grateful for her inspiration.

And thanks to the talent and generosity of the amateur photographers who granted me permission to use their wonderful photographs, which are the foundation of this book. Their eyes and cameras have made my drawings possible. Each of you has a special talent and a generous heart. (To learn more about the photographers, see the Photo Credits page at the end of the book.)

Lastly, my sincerest thanks to Mickey Baskett for making this project possible and for doing a lovely job editing my manuscript and preparing this book for publication.

As a footnote, I thank all the wildlife rehabilitators who give their time and money to nurturing orphaned and injured wild creatures. Many of the wildlife photographs in this book come from these warm-hearted individuals who have a unique perspective on the value of all life.

Table of Contents

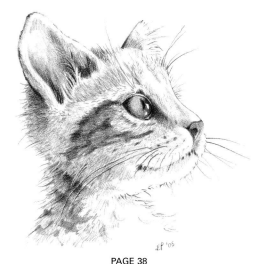

PAGE 38

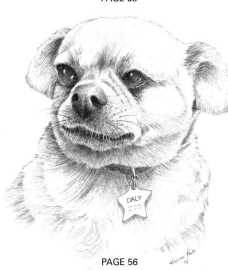

PAGE 56

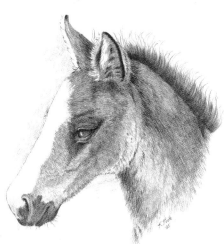

PAGE 76

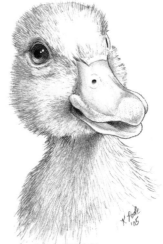

PAGE 92

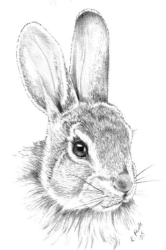

PAGE 110

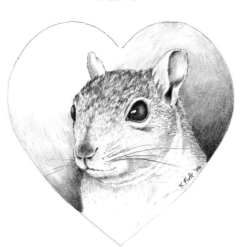

PAGE 122

Introduction

The brightest eyes. The sweetest face. A tiny body that fits in my hand, covered with fur so soft it begs to be stroked. Then there's her inner beauty. Courage, resilience, a determination to live and thrive, an open heart, and a spirit eager for life's adventures. I believe animals are our brothers and sisters in God's creation. As an artist, animals are my favorite subject.

My Message

I have always been interested in doing art, but turned away from it early on because the conventional wisdom was that to be an artist one must have a message. I didn't think I had one. But, years later, I realize that I do! My message is so simple that it eluded me. It is "Look at this! Isn't it beautiful?" The desire to draw or paint is, in itself, a message of appreciation of the world around us.

My Medium

Drawing with graphite pencils – working in black, white, and shades of gray – is my favorite medium. The tools are simple and portable. Slight changes in pressure yield a full spectrum of value from the lightest lights to the darkest darks. The medium invites the subtle yet allows the dramatic, all in the simple language of light and dark.

Creating a likeness of a vibrantly colored three-dimensional creature in two dimensions and shades of gray is a challenge. But the results can be as compelling as any painting. And the process is a great teacher in the critical skill of seeing.

My Advice

My best advice is to draw every chance you get. The only way to learn to draw is to draw. And appreciate your work. We are all our own worst critics. Yes, we learn from our mistakes, but we also learn from our successes. For every problem that discourages you, focus on something you did right, and celebrate it!

Developing your drawing skills is a life-long process. It's good news that there's always something to learn. While your progress will be generally upward, it's not linear. There will be rough spots, but they will pass. And there is always the possibility that, at any point in your artistic career, you will create something you will be very proud of for the rest of your life. I have a drawing of my younger sister that I did when I was 13 and I don't think I could top it now, not because it's a technically perfect drawing, but because it conveys a special feeling. We never know when we'll surprise ourselves.

My Hope

Combining my favorite subject with my favorite medium has made creating this book a true labor of love. My sincere hope is that it inspires you and assists you along your artistic path.

Kaaren Poole

How to Use This Book

In this book I present my method for drawing animals. My method divides a complex subject into a series of manageable steps, making the drawing process more accessible. In Chapter 3, "My Drawing Process," I present my method in detail, using a chipmunk as the subject. I cover three different ways of developing the animal's likeness in a line drawing, then offer detailed information about developing the line drawing into a finished piece of art.

In the chapters of this book, I present thirty-one animal drawings from nine different species. For each species, I provide detailed drawings of the animal's most prominent features.

In each demonstration, I work from a photograph. I prefer photographs to live (I should say "lively") models who, in my experience, just can't sit still long enough. But I constantly observe animals to increase my understanding of their personalities, postures, and movements. And as I draw, this understanding guides me.

There are two ways to use this book. One is to draw along with the demonstrations, beginning with my source photo and working all the way through the process. An option is to trace my line drawings (you may then have to enlarge them), then practice the techniques to finish them.

The second way is to study my method and apply it to creating drawings from your own photographs.

Drawing from Photographs

Photographs are a wonderful resource for artists because they give us visual information we might otherwise not be able to have. (For example, it's highly unlikely that I could adequately study the details and proportions of a red fox solely from observations from life!) But photographs, for artists other than photographers, are a means to an end, not the end itself.

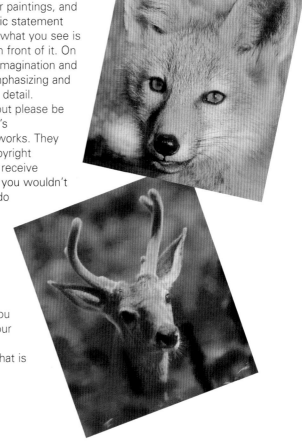

There are several differences between photographs and drawings or paintings, and the artist should take advantage of these differences to make an artistic statement rather than trying to create an exact copy of a photo. In a photograph, what you see is what you get. The camera records with absolute accuracy the image in front of it. On the other hand, when drawing or painting, the artist is limited only by imagination and may freely combine images in compositions, create focal points by emphasizing and de-emphasizing elements, and manipulate value, contrast, and level of detail.

Photographs are great sources of both information and inspiration, but please be aware that there are serious legal issues in working from other people's photographs. Photographs, just like paintings or drawings, are artistic works. They are the intellectual property of the photographer and are subject to copyright protection. You may work from other people's photographs only if you receive permission. The Golden Rule ("Do unto others...) is a rule of thumb. If you wouldn't like people using or doing something with **your** artwork, don't use or do something with **theirs**. (These are guidelines – I am not a lawyer. Laws vary by area of the country and laws change. When in doubt, contact a lawyer specializing in copyright law.)

The safest course is to work from your own photos. You could also use one of several artists' photographic reference books, which are available on a variety of subjects and are intended to provide artists with photograph source material.

It's important to remember that when you are creating a drawing, you are not recreating your source material. When you are finished with your drawing it will stand on its own, without reference to what inspired it. Don't try to reproduce every little detail. Focus on creating a drawing that is pleasing on its own.

1 Tools & Materials

Pencils

When it comes to pencils, my advice is to keep it simple. For black and white work, I use two mechanical pencils, one with 5mm HB lead and another with 2B lead. Lead is labeled by its diameter (5mm is the smallest readily-available lead) and relative hardness or softness.

I prefer 5mm because this size allows fine lines and small details, but it gives a thicker line if I dull the lead by rubbing it back and forth on a piece of scrap paper. Thicker (7mm and 9mm) leads and pencils are readily available, and fine (3mm) leads and pencils are available from art supply stores.

"HB" and "2B" refer to the hardness of the lead. Drawing pencils from art supply stores vary in hardness/softness, from 6H, which is the hardest, through 4H, 2H, HB (which is in the middle of the hardness/softness range), 2B (which is softer than HB), through 4B, then 6B, which is the softest. Artists use the different leads to achieve different values – the level of lightness or darkness. With the same pressure, 6H gives the lightest line, while 6B gives the darkest.

I prefer to use the two middle-value leads (HB and 2B) and use pressure to vary the value of the line. I find that creating value by varying pressure is less complicated than juggling pencils but still gives me a good value range. A light pressure gives a very light line, while a heavy pressure gives a darker one. I use the HB pencil for most of my drawing process and use the 2B pencil at the end to get the darkest darks. When working on colored paper, I also use a white chalk pencil available from art supply stores.

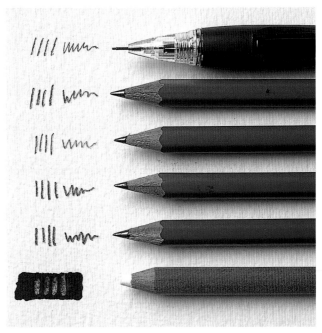

From top to bottom: HB mechanical, 5mm, 2B drawing pencil, 2H drawing pencil, HB drawing pencil, 3B drawing pencil, chalk pencil.

Erasers

I use two types of white polymer erasers, both available at office supply stores. The familiar rectangular eraser is good for large areas. I use a click eraser for smaller areas. This is a long round eraser stick in a plastic holder. It looks like a pencil. A clicking action advances the eraser.

Blending Tools

Paper Blending stumps and **chamois** are used to soften color by smudging it. Both are available in art supply stores. A paper blending stump is absorbent paper that's been compressed and rolled into a pencil shape.

Transferring Supplies

Transferring a drawing makes it possible to develop a sketch on a piece of draft-quality paper and finish it on a better quality or colored paper.

Tracing Paper: Use this to trace a design from this book, or to trace your photograph.

Black Transfer Paper: To transfer drawings to a fresh sheet of paper, I use black transfer paper.

Stylus: Use to trace over the design lines. Use the smallest stylus tip you can find. Accuracy in transferring pays off later.

Here's how to transfer a drawing:

1. Tape a piece of tracing paper over the drawing and trace it.
2. Remove the tracing paper and tape it in place over a fresh piece of paper.
3. Slip a piece of transfer paper, graphite side down, between the tracing paper and the drawing paper.
4. Go over the lines on the tracing paper with a stylus. This transfers the line to the drawing paper.

Transfer Tips:

- Transfer lines are hard to erase so press lightly with the stylus.
- Keep a paper towel under your hand while you work. Pressure from your hand can transfer smudges to your paper.

Papers

There are many types and qualities of drawing papers; over time you will develop your own preferences. A quality that will most affect your drawing is the "tooth" of the paper – the paper's relative roughness or smoothness. I prefer smooth paper.

The best papers are acid-free 100% cotton papers. I use these for my final drawing. They are long-lasting and don't react with pencil lead or paint over time. My favorite is a 100% cotton, vellum finish, neutral pH/acid-free paper. (250 GSM is a nice heavy weight.) It is near-white but not distractingly bright. It stands up to lots of erasing without compromising the vellum finish so it's a fine paper both for developing your drawing and for the finished product. It is available in tablets of various sizes. It is somewhat pricey, but worth it for a drawing you intend to keep and frame.

For creating my sketch, I use an acid-free drawing paper that is quite smooth, but not as smooth as a vellum finish. It is light ivory in color and holds up well to repeated erasing and rework. It is economically priced (less expensive than vellum-finish paper), and available in tablets in a range of sizes. I have framed drawings on this paper that are ten years old (or more) with no problems.

I do not use sketching paper. I find that it doesn't hold up well to repeated erasing and rework, and if I do a drawing that I really like, I'm stuck with a nice drawing on a poor surface.

Continued on next page

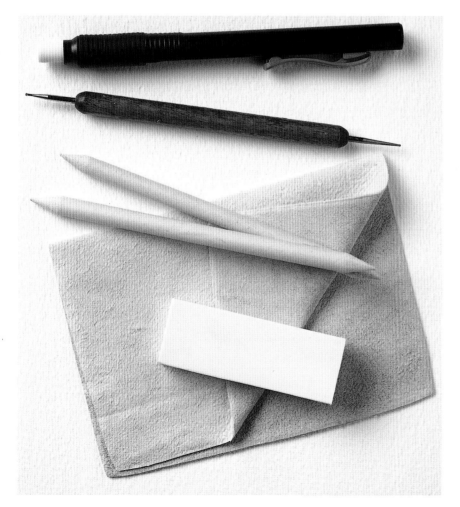

Pictured top to bottom: eraser, stylus for transparencies, blending stumps, chamois, and polymer eraser.

continued from page 11

Measuring Tools

Rulers: I use two rulers – a 6" ruler for small spaces and a standard 12" ruler. Clear rulers are preferable because it's helpful to see your work through the ruler.

Compass: A compass or calipers is a most useful tool. I use it for determining proportions. It should be large enough to easily open to 8".

Workable Fixative

Because graphite smudges so easily, it is important to "set" your finished drawing by spraying it with a coat of spray fixative. You may also want to set your drawing between layers to control smudging. Be aware that fixative is different from sealer. Fixative allows you to continue working over it.

Always set your drawing before switching media (for example, before applying colored pencil or washes). Be aware that water will run – and ruin – graphite, so be sure to set your drawing before using any water, such as dampening watercolor pencil or using acrylic washes.

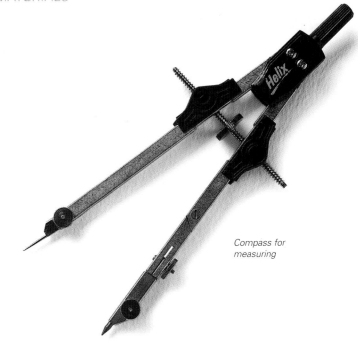

Compass for measuring

Fixative and white gouache

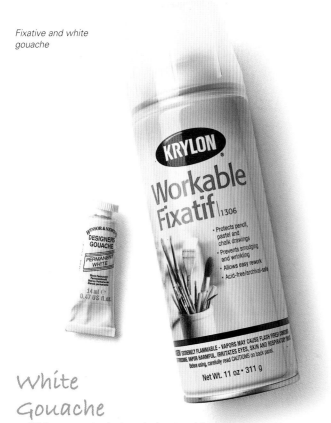

White Gouache

White gouache is handy for touching up tiny white areas, such as highlights in eyes. Apply it with a small brush.

Materials for Adding Color

Color is an optional, but often very effective addition to pencil drawings. There are several ways to add color. Ones I use include colored base papers, colored pencils, watercolor pencils, and washes of acrylic paint.

Colored Papers: Sometimes using a colored paper is a nice choice for adding a little color to a drawing. A mid-tone colored paper works especially well when the subject is a combination of very light and dark values. Be sure to use a paper that is heavy enough to stand up to a sharp pencil point.

Colored Pencils: Colored pencil drawing is an art form in itself and is beyond the scope of this book. But colored pencils can be used to lightly wash color over a black and white drawing. The result is reminiscent of old-fashioned hand-tinted photographs and can be quite beautiful. You can buy colored pencils in sets or individually at art supply stores.

Watercolor Pencils: Watercolor pencils can be useful for coloring large areas of background. They are applied by drawing with them and then are dampened with water, which dissolves the color. Their drawback is that the colors can get quite a bit darker when dampened so they must be used very carefully. Though typically sold in sets, art supply stores sometimes have several colors of watercolor pencils available for individual sale.

Acrylic Paints: Acrylic paints thinned with water can be used as an alternative to colored pencils to apply thin washes of color over a black and white drawing. They are available at crafts stores in individual colors and are a good choice for people who are already comfortable with painting.

2 Building Skills

Pencil Basics

Build layers. Graphite pencil is a transparent medium. The benefit of transparency is being able to build a drawing in layers. Each new layer has a cumulative effect with previous layers, deepening texture and darkening value. Some very subtle and beautiful effects are possible with pencil.

Drawing is a "light to dark" process where darks are progressively deepened, leaving lighter areas untouched once they have reached their desired value. White is portrayed by the white of the paper. Because precision erasing is nearly impossible, white areas must be drawn around, which can be tricky.

Keep your lead sharp. I like working with mechanical pencils because the leads are always sharp. However, even with a mechanical pencil, depending on how you work, the lead is more or less sharp, giving thinner or thicker lines. For a thick line, rub the pencil back and forth on a piece of scrap paper without turning it until there is a flat, worn spot on the lead. Drawing on this worn spot gives a thick line. For a thin line, rub the pencil back and forth as for the thick line, but draw with the resulting very sharp point. For a medium line, turn the pencil frequently as you draw. This wears the lead evenly and keeps it sharp.

Vary the pressure. Varying the pressure applied to the pencil varies the value of the resulting line. A light pressure yields a light line, and a heavy pressure yields a dark one.

Strokes create texture. The texture of the area depends on the strokes used to fill it. A pencil draws either a dot or a line. To draw a solid area, cover the area with lines set next to each other.

Whenever I say to "block in" it means to roughly sketch in a "blocky" way. This usually occurs before you begin refining the drawing.

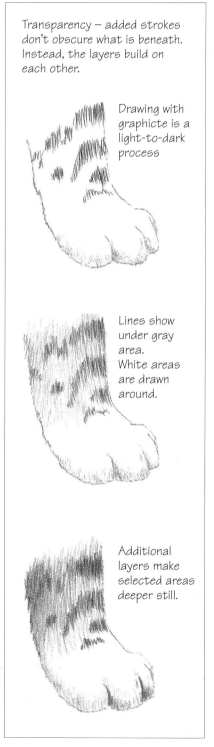

Transparency — added strokes don't obscure what is beneath. Instead, the layers build on each other.

Drawing with graphicte is a light-to-dark process

Lines show under gray area. White areas are drawn around.

Additional layers make selected areas deeper still.

USING CHAMOIS & BLENDING STUMPS

A chamois is a wonderful tool for softening graphite so individual strokes don't show. (Of course, the more even tone you begin with, the easier it is to achieve a smooth look with chamois.) To use, wrap a small piece around the tip of your finger, and touch the chamois to the drawing — a series of small dabbing motions will nicely smooth the area. **Do not** rub the chamois over the drawing. As you work, the chamois picks up

Continued on next page

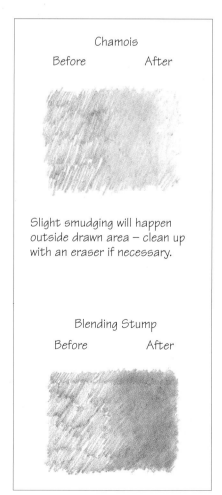

Chamois

Before After

Slight smudging will happen outside drawn area — clean up with an eraser if necessary.

Blending Stump

Before After

Pencil Basics, continued from page 13

graphite. If you are working in an area that contains both dark and light portions, begin with the light area so you won't darken it with graphite rubbing off from the chamois.

A paper blending stump can also be used to soften graphite. Because of its compact shape, a blending stump is easy to use in tight spaces.

PENCIL STROKES

Texture is especially important in drawing animals. For example, is the animal's coat soft or coarse, thick or sparse, long or short? How does the texture change from place to place on the body? Pencil is an ideal medium for this task – the various pencil strokes create texture in your drawings, and the transparency of graphite allows you to build rich texture in layers.

Smooth texture. A smooth texture is created with a dull pencil lead and strokes laid side by side so that the individual strokes don't show. Varying the pressure creates lighter or darker areas. Switching from an HB pencil to 2B gives the darkest values. I use smooth texture for eyes, for drawing very short velvety fur, and for darkening or shading over other textures.

Smooth fur. I draw smooth fur with a series of close-set straight lines. It is best to use strokes with fine tails on both ends. (Draw this type of stroke by stroking onto then off of the paper – like landing a plane then taking off again.) I use short strokes for short fur, medium strokes for medium fur, and long strokes for long fur. I space the strokes so that a little of the paper shows between the strokes. Additional layers enrich the texture and darken the value.

Rougher fur. For rougher fur, I follow the same procedure as for smooth fur, but use criss-cross strokes. To make this stroke, I draw a stroke at a slight angle to the direction the fur is growing, then draw a second stroke back in the opposite direction, crossing the original stroke.

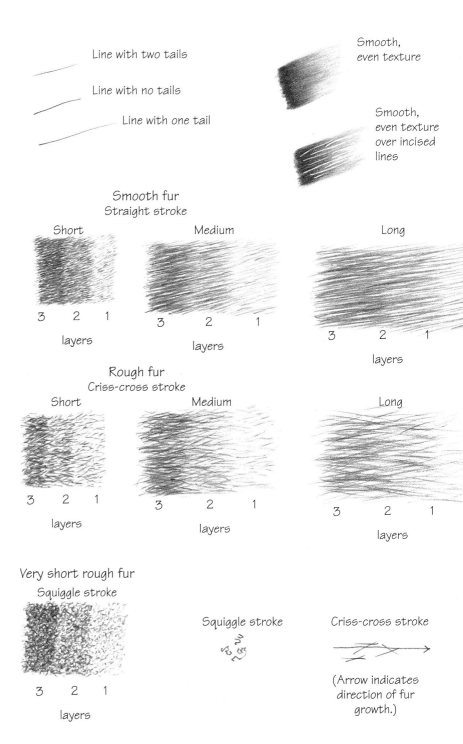

Creating Texture

Line with two tails

Line with no tails

Line with one tail

Smooth, even texture

Smooth, even texture over incised lines

Smooth fur
Straight stroke

Short Medium Long

3 2 1 3 2 1 3 2 1
layers layers layers

Rough fur
Criss-cross stroke

Short Medium Long

3 2 1 3 2 1 3 2 1
layers layers layers

Very short rough fur
Squiggle stroke

3 2 1
layers

Squiggle stroke

Criss-cross stroke

(Arrow indicates direction of fur growth.)

Very short rough fur. For very short rough fur, or for areas where the fur is growing straight towards the viewer and we see only the tips, I use a tiny squiggle stroke. As with the other strokes, applying additional layers enriches the texture and deepens the value.

Incising. Incising creates white lines in darker areas. Generally, I create white areas by leaving the white of the paper showing, but sometimes this isn't practical, e.g., drawing tiny white hairs against a dark background. I use a stylus to press, or incise, a line into the paper. When I go over the area, the incised line shows as white.

Animal Anatomy

Having a basic understanding of an animal's anatomical structure helps you draw the animal more realistically. I have found that the best and easiest way to understand an animal's structure is to relate it to my own. (I also find it helpful to correlate and refer to animal's body parts by the same words I use to describe my own.) With very minor exceptions, humans and all the mammals in this book share the same skeletal structure. The differences are in the relative lengths of the bones in the limbs, and in the shapes of the shoulder blades and pelvis and their orientation to the spine.

Sometimes, when I'm having difficulty interpreting what I'm seeing in a photograph, mentally tracing the lines of the spine and limbs solves my problem. Other times a part of the animal may be obscured and I need to call on my basic knowledge of the animal's structure to fill in the blanks. Before I begin to draw an animal I find it helpful to study the pose and clarify for myself where the major joints are and how the spine, head, and limbs are oriented.

Skulls:

Of course, the shapes of skulls vary from species to species. The one constant is that the lower jaw hinges down from the skull. This means that when animals open their mouths it is only the lower lip and chin that moves. The rest of the features – eyes, nose, and upper lip – do not move.

Spine:

In quadrupeds (animals that walk on four legs), the spine runs along the top of the back with the hip and shoulder joints high on the body. The upper arms and upper legs (our thighs) lie within the body. The elbows and knees are at the level of the lower edge of the body. Very loose and ample skin allows a full range of motion in these upper limbs. To understand this, imagine wearing a cape that has holes at the level of your elbow so that your forearms are outside the cape. You still have full range of motion between the shoulders and elbows because there is ample fabric to allow it.

Continued on page 16

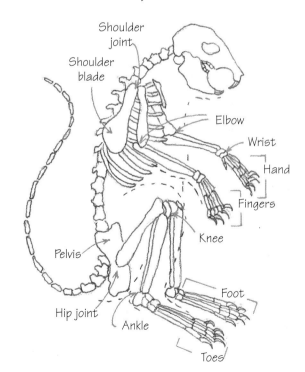

Squirrel

Animal Anatomy, continued from page 15

Dog

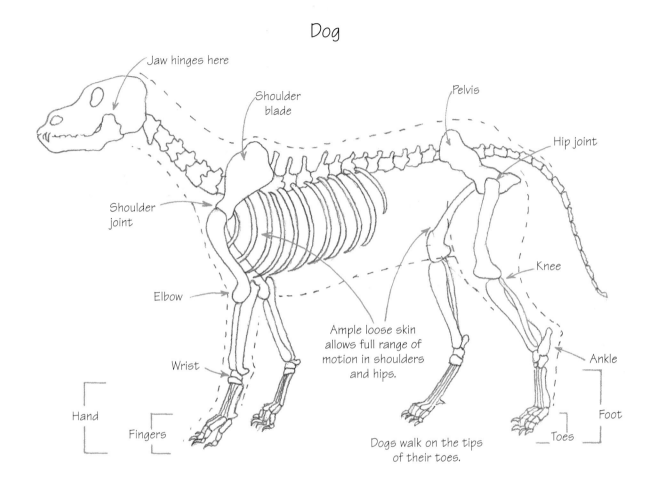

Jaw hinges here

Shoulder blade

Pelvis

Hip joint

Shoulder joint

Knee

Elbow

Ample loose skin allows full range of motion in shoulders and hips.

Wrist

Ankle

Hand

Foot

Fingers

Dogs walk on the tips of their toes.

Toes

Tail:

The spine typically runs the length of the tail. This is important because it is muscles attached to bone that create motion. So the elongated spine allows very fine movements in a long tail. A long, flexible tail has several uses. It helps with balance. And also it is a very visible means of communication. An animal may use its tail to interact with others of its own kind. A familiar example is a dog signaling submission by wrapping its tail between its legs. The tail may also act as a warning to enemies. Get out of the way if you see a skunk with its tail up!

Limbs:

The lengths of the different portions of the limbs vary from species to species. In deer and horses, the "hands" and "feet" are very long and contribute to the animal's speed. The fingers and toes are fused into hooves. In horses, they are fused into a single hoof; in deer, they are fused in two sections, in a split hoof. Some animals, such as squirrels and raccoons, walk on their entire "hands" and "feet." Others, such as dogs, walk on their tiptoes.

Representing Three-Dimensional Shapes

A major challenge of drawing is to convincingly represent three-dimensional objects in a two-dimensional medium. Two concepts can help. The first is understanding how lines curve around three-dimensional shapes and how these lines appear to change as the underlying shape turns and tilts. I call this centerlines and orientation. The second is understanding how light falling on a three-dimensional object results in highlights and shadows, often referred to as shading.

CENTERLINES AND ORIENTATION

Animals' heads are basically spheres or egg shapes. Properly placing the features on these three-dimensional shapes can be tricky, especially when the head is turned and/or slanted. Establishing vertical and horizontal centerlines that are consistent with the turn (looking left or right), tilt (looking up or down), and slant of the head helps place the features.

The centers of the forehead, nose, mouth, and chin line up on the vertical centerline of the head. The eyes generally line up along the horizontal centerline of the head, although there are variations between individuals and species. Even if the eyeline falls above or below the horizontal centerline, it will be parallel to it.

Figures 1 and 2 show a series of sphere and egg shapes with centerlines representing a variety of orientations. Notice that even when the centerlines are curved around the sphere or oval, the vertical centerline – if the head is not slanted from side to side – starts at 12 o'clock and ends as 6 o'clock; the horizontal centerline starts at 9 o'clock and ends at 3 o'clock.

When the head is looking straight ahead (left column), whether it's looking up, down, or forward, the eyes are the same distance from the vertical centerline. However, whenever

Continued on next page

Figure 1 – Sphere Shapes

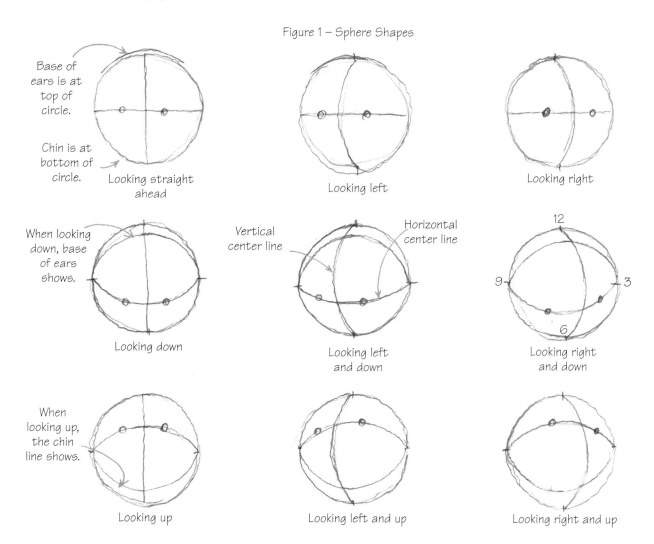

Base of ears is at top of circle.

Chin is at bottom of circle.

Looking straight ahead

Looking left

Looking right

When looking down, base of ears shows.

Looking down

Vertical center line

Horizontal center line

Looking left and down

12
9 3
6

Looking right and down

When looking up, the chin line shows.

Looking up

Looking left and up

Looking right and up

Figure 2 – Egg Shapes

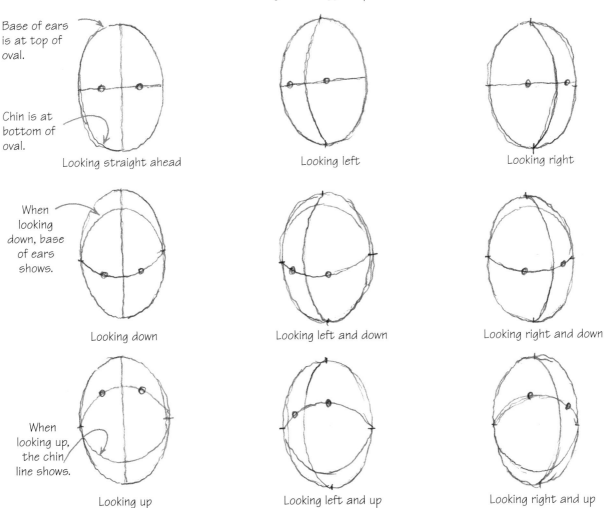

Base of ears is at top of oval.

Chin is at bottom of oval.

Looking straight ahead

Looking left

Looking right

When looking down, base of ears shows.

Looking down

Looking left and down

Looking right and down

When looking up, the chin line shows.

Looking up

Looking left and up

Looking right and up

Representing Three-Dimensional Shapes, continued from page 17

the head is looking left (center column), the left eye is closer to the vertical centerline than the right one. The more the head is looking left, the greater the difference. Likewise, whenever the head is looking right (right column), the right eye is closer to the vertical centerline than the left one. ("Left" means my left; "right" means my right.)

Figure 3 shows head shapes that are slanted as well as turned and tilted. The first one is an egg shape that is slanted to the right, turned to the left, and tilted down. The effect of the slant is to change the positions of 12 o'clock, 3 o'clock, 6 o'clock, and 9 o'clock – 12 o'clock and 6 o'clock are at the ends of the slant line and 3 o'clock and 6 o'clock are at the ends of a line that is perpendicular to the slant line.

The second one is a pointed egg shape that is slanted to the right, turned to the right, and looking up. The same principles apply despite the point on the egg.

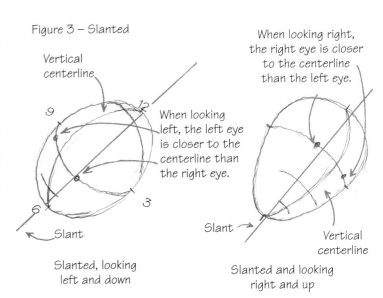

Figure 3 – Slanted

Vertical centerline

When looking right, the right eye is closer to the centerline than the left eye.

When looking left, the left eye is closer to the centerline than the right eye.

Slant

Slanted, looking left and down

Slant

Vertical centerline

Slanted and looking right and up

Shading & Highlighting

Shadows are portrayed by laying down dark values; highlights are portrayed by letting the white paper show. Shading and highlighting, as well as the gradations between them, define the form and create a convincing three-dimensional look. When light falls on a three-dimensional object, the result is highlights and shadows.

The positions of the highlights and shadows are determined by the light source – the direction from which the light is coming. The shapes and locations of highlights and shadows are visual clues to the shape of the object. The illustration opposite shows two shapes that frequently occur in animals – an egg shape and a cylinder – and the location of the highlights and shadows with two different light sources. In an animal drawing, there will be highlights and shadows on the natural main shapes, such as the egg shape of the head, the cylinders of the legs, or the cylinder of the body.

When the object is smooth, as in the illustration, the gradation between light and dark areas is smooth. If the object were rough, the gradation would be more broken. Notice the reflected light. This is a relatively lighter area along the dark side of the deepest shadow. The idea is that light reflected from the surroundings actually lightens the appearance of the lower part of the shadow.

When objects are combined, each has its own highlights and shadows dependent on the light source. But there are also cast shadows – shadows that one object casts on another. The position and shape of the shadow depends on the shape of the object casting the shadow, the shape of the object the shadow is cast on, and the location of the light source.

In an animal drawing, there will be shadows cast by one part of the body on another, such as the shadow of the chin on the neck. In the illustration, the egg and cylinder shapes are combined into what might be a head and neck.

Placement of Highlights & Shadows

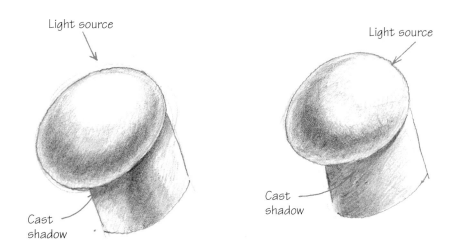

Drawing Fur

Animal fur varies widely from species to species. In each animal chapter, you'll see the techniques I use to draw that particular animal's coat, but some basic principles always apply. These illustrations show the direction of fur growth on a cat. It is similar for other mammals, and the same principles apply.

Stroke in the direction of growth. First and foremost, stroke in the direction the fur grows. On the face, the fur generally radiates from a point on the nose between the eyes. So it grows back over the forehead, sideways around the cheeks, and downward on the chin. The fur radiates out from the eyes, but at differing angles at different points. The fur direction on the nose is very complex, but the fur is generally very short in this area, and I often draw it as an even tone.

Fur grows along the length of the body. The fur grows down the chest but begins to radiate sideways around the shoulders, then grows lengthwise along the body. There is an interesting growth pattern on the front legs where the fur grows downwards on the front of the leg but sideways on the back. This results in a little fan shape at the top front.

Mimic the fur. Fundamentally, my pencil strokes always mimic the fur I'm drawing. Both fur length and texture vary on different parts of the body. Draw long fur with long strokes and short fur with short strokes. Use a dull lead for a soft stroke where the fur is very soft and the individual hairs are less distinguishable. On the other hand, where you see individual hairs, use a sharp lead. My individual strokes are wavy or straight, thick or thin, closer together or further apart, following the lead of the fur I'm drawing.

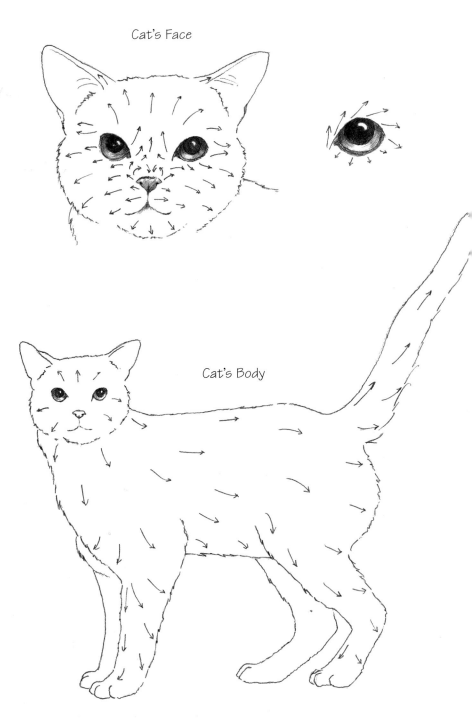

Cat's Face

Cat's Body

Drawing Eyes

The eyes are truly the windows to the soul. I always draw the eyes first because once I have drawn the eyes, the animal seems to come to life and talk to me, guiding me through the rest of the process.

For each of the animals in this book, I discuss the process used to draw the eyes, but these basics always apply:

- **Whites of the eyes.** The whites of animals' eyes seldom show. This is because the iris and pupil are relatively large in animal eyes.

- **The iris.** If we could see the eyeball from the side, we would see that the iris is in a flat plane across the eye. The iris is the colored portion. It often has a beautiful range of colors and may be flecked. It usually has a darker edge. The pupil is actually an opening in the iris. It always looks so dark because we are looking through this opening into the dark interior of the eyeball. The area in front of the iris is a clear cornea and lens.

- **Shape.** The shape of the eye, as we see it, is determined by the shape of the eyelids and how they close over the eye.

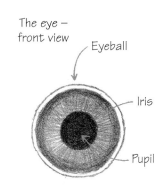

The eye – front view

Eyeball

Iris

Pupil

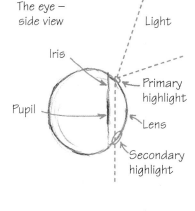

The eye – side view

Light

Iris

Primary highlight

Pupil

Lens

Secondary highlight

The eyelid covers part of the eyeball.

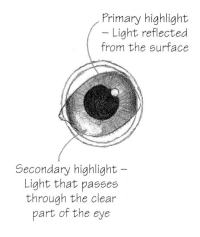

Primary highlight – Light reflected from the surface

Secondary highlight – Light that passes through the clear part of the eye

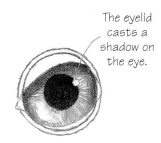

The eyelid casts a shadow on the eye.

- **Highlights.** The portion of the eye that we see is actually more like a transparent sphere than an opaque one. When light falls on a transparent sphere it creates different highlights than on an opaque sphere. When a beam of light falls on a transparent sphere, some of the light is reflected from the surface and some of the light travels through the sphere and comes out the other side.

The light that is reflected creates a *primary highlight*. The primary highlight is very bright and its edges are sharp. The primary highlight can be over the pupil, over the iris, or over the boundary between the two. Its position is determined by the light source.

The light which goes through the sphere creates a *secondary highlight*. The secondary highlight is less bright and its edges are soft. The secondary highlight is larger than the primary one and is located opposite the primary highlight.

The shapes of highlights should be consistent with the sphere. They will either be circles or kidney shapes that appear to curve around the sphere's surface.

- **Shadows.** Assuming the light is coming from above, the upper eyelid will cast a shadow on the eyeball. The thicker the eyelid is, the wider the shadow will be.

The Skill of Seeing

Drawing is a visual art, and the most important skill for drawing is seeing.

As a person's brain grows and matures, it develops shortcuts. So when it sees bushy tail, bright eyes, and small pointy ears, information stored from past experience fills in the rest (squirrel). This ability for the brain to fill in the blanks and quickly compile a complete picture from a few visual clues is useful in daily life, but sometimes it's a detriment for artists because, in our normal mode of seeing, there is so much that we fail to notice. For example, how many times do we see shadows in addition to the trees? Our brains are keyed to notice the trees. But if we are drawing a landscape and omit the shadows, it will look all wrong.

When I am preparing to draw, I switch to critical seeing, the artist's mode of seeing. Critical seeing is evaluating an image for what is really there rather than what we expect to see. It involves looking at an image as a series of shapes, lines, and values without regard to what they represent. After all, when we draw we don't draw a squirrel, we draw a series of shapes, lines, and values that, taken together, the eye interprets as a squirrel.

When working from a photograph, I use critical seeing in evaluating the photograph to understand what shapes, lines, and values I will draw to represent the images in the photo. I again use critical seeing to evaluate whether I was successful in drawing what I intended to draw. If I wasn't, then I must see what is wrong, and correct it. Drawing, then, becomes an iterative process: see the photo, draw something, see and evaluate the drawing, and correct the drawing, repeating the process until I'm happy with my work.

While I am actually drawing – laying pencil to paper – I use another type of seeing. My tendency is to focus on the individual little stroke I am placing at the moment. But it is useful to see both the small and the whole simultaneously. Seeing the small means watching the little bit that I'm placing on the paper to be sure the shape and value are correct. Seeing the whole means seeing how the little bit fits within the whole drawing. Another way of expressing this idea is to use the analogy of the forest and the tree – to see the forest I'm creating at the same time I'm seeing the tree I'm drawing.

Both forms of seeing – critical seeing and seeing the small and the whole simultaneously – require practice. But they are invaluable.

Photo credit, Jerry Walter, 2005

Drawing Housekeeping

Graphite smudges easily, and smudges are hard to erase. By following these four simple housekeeping guidelines, I am able to keep my drawings smudge-free.

- **Don't rest your hand on the paper.** I never rest my hand directly on the drawing paper. Instead, I fold a paper towel in half and always keep it under my hand while I draw. When I need to move my hand, I never slide it across the drawing; I carefully pick up the paper towel and reposition it, then rest my hand again on the paper towel. From time to time I check the bottom of the paper towel to see if I'm picking up graphite from the drawing. If I have, I replace the paper towel with a clean one.

- **Don't wipe away erasings.** I never wipe away erasings with my hand – I either blow them or shake them off the paper. If they cling stubbornly to the paper, I lightly whisk them away with a soft brush.

- **Protect the drawing.** Since I share my house with five cats whose behavior is always lovable but can be unpredictable, I always put my drawing away if I am leaving the room.

- **Use a fixative.** I use a spray fixative to set the graphite between layers. This prevents my fresh work from smudging previous layers.

IDENTIFYING PROBLEMS

Sometimes you may be unhappy with a drawing but not know why. Before you can correct the problem, you must identify it. Here are some tricks I find helpful in identifying problems:

- **Isolate the parts.** Evaluating one part of the drawing at a time, without interference from the other parts, can sometimes help. (This is especially helpful with evaluating faces.) Cover everything but the left eye. Carefully compare it to the photograph. Does it look correct? Then proceed to the right eye, then both together. Sometimes one eye will be fine, but the other will be wrong. Then proceed to the nose, mouth, and ears. When all the features look good on their own but there is still something wrong, it could be their positioning relative to each other. Re-check the proportions as well as vertical and horizontal alignments.

- **Study the negative space.** When I view a photograph of, say, a squirrel, I see the shape of the squirrel. But, at the same time, am also seeing the shape of the space around the squirrel – the negative space. If you have trouble getting the shape of squirrel correct, you may be unconsciously hindered by seeing what you expect to see rather than what's actually in the photograph. One approach to solving this problem is to switch to drawing the negative space – the space around the squirrel – instead. Because this is a task of drawing an abstract shape, you'll have no expectations. If you can successfully draw the negative space around the squirrel, you have, at the same time, successfully drawn the squirrel!

- **Use a mirror.** We've all had the experience of thinking that a photo of ourselves just doesn't look right. Psychological reasons aside, this is because we are used to seeing ourselves in a mirror – the mirror image of ourselves! I often make positive use of this phenomenon when checking my drawing and looking for problems. Viewing a drawing in a mirror can make a problem pop out; because you are looking at a mirror image of what you drew, you foil your inherent tendency to see what you want to see.

- **Take a break.** Taking a break is a simple way of identifying a problem in a drawing. The break itself is refreshing, and your fresh eyes often are able to locate a problem that tired eyes are simply too weary to see.

 Use your artistic license.

If there's something in your source material that you want to change, change it! If there's something you want to leave out, leave it out! Add a bow around your cat's neck when you know that she would never accept it in real life! Photographs and other source material are only the starting point. Your imagination provides the rest.

3 The Drawing Process

This chapter shows my method for drawing animals, using a chipmunk as a demonstration. I create drawings by dividing the process into a series of manageable steps. Each step builds on the previous one.

My drawing process has two parts: creating the line drawing and finishing the drawing with texture and tone. The line drawing is created in two steps. First I establish a framework that fixes the basic elements of the animal in proper proportion. (Once I solve that problem I generally don't worry about proportion for the rest of the drawing process.) Then I refine the drawing by adding detail.

Creating a line drawing can be an end in itself if the line drawing is intended as a basis for a painting or needlework, for example. Or you can develop the line drawing, adding tone, texture, and shading to create a finished work of art worthy of framing.

Working from Photographs

When working from photographs, the idea is to create a drawing based on the photo – not to simply copy it – so the first step is to study the photo and evaluate how to use it in the drawing. There likely will be pieces you will omit. You may also crop the image and add or rearrange elements.

In the case of this chipmunk, I am going to draw the entire animal and most of the feeder, but I will omit the foliage in the background. For the feeder, I will use a vignette style, fading off at the edges, rather than drawing the sharp edges in the photo.

To get a large copy of the photo that will be easier to work from, scan the photo into a computer or load it from a digital camera, then print a full-page version on a piece of photo quality paper. Slip this enlargement in a clear sheet protector. (You can draw on the sheet protector, if need be, without drawing on the photo.)

Establishing the Framework

At this stage, you are working with large shapes. Proportions are critical, as is the accuracy of the basic shapes, but detail is not an issue. The goal is to have a generally accurate drawing of the main forms that you can later detail with confidence.

There are several methods for establishing the initial framework. I call the methods I use most frequently **grid**, **basic shapes**, and **anchors**. It's perfectly okay to mix the methods (use more than one method in a single drawing) or modify them to your use. The methods are simply aids in analyzing the image. For example, you could use the basic shapes method for the body and the grid method for the face. If you're a beginner, use the grid method to develop your line drawing – it will probably give you the best results. TIP: Because there will be a lot of erasing and re-working at this stage, you can use a draft quality paper.

GRID METHOD

The grid method is easiest for beginners and tends to be quite accurate, but it's also a little cumbersome and mechanical.

1. Draw the grid.

 For a drawing the same size as the printed photograph, draw a grid of 1" squares over the chipmunk photo. (The image fits within a grid that is 8" tall and 4" wide.) Draw the same grid (8" tall by 4" wide in 1" squares) on drawing paper. Because the face and front paws are more detailed, further

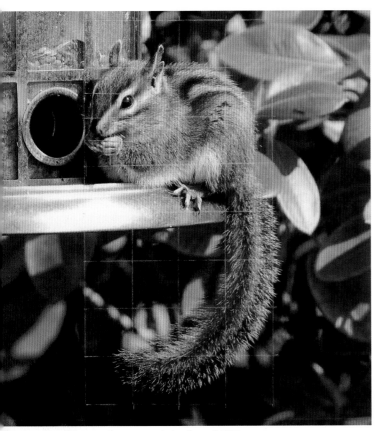

Photo credit: courtesy Janine Russell, 2005

divide these two squares into 1/2" squares. A smaller grid is good for more detailed areas, while a larger grid is sufficient for the simpler shapes of the body and tail.

For a smaller drawing, make the grid on the paper smaller than the one on the photograph. For example, drawing a 1" grid (8 squares tall and 4 squares wide) over the photograph and a 3/4" grid (still 8 squares tall and 4 squares wide, but with smaller squares) on the drawing paper will give a drawing that is three-fourths the size of the photo.

For a larger drawing, make the grid on the paper larger than the one on the photograph. Drawing a 1" grid (8 squares tall and 4 squares wide) on the photograph and a 2" grid (still 8 squares tall and 4 squares wide, but with larger squares) on the drawing paper will give a drawing twice the size of the photo.

For a drawing of a specific size, use a photocopier to enlarge or reduce the photo to the size you want the drawing to be. Draw a grid on the photograph and the same size grid on your paper.

2. Copy the photograph onto the paper one square at a time, drawing small abstract shapes. The order in which you copy the squares isn't important. I usually begin with the eye, then proceed to the head and, finally, the body.

Continued on page 26

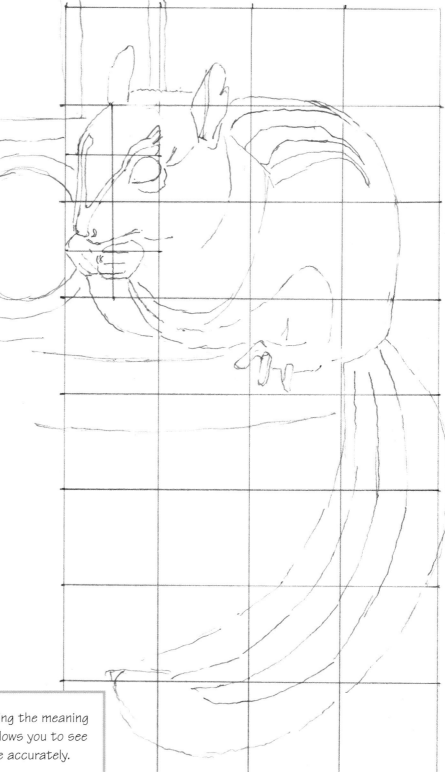

Grid Method. The grid is smaller in detailed areas.

Tip Sometimes divorcing the meaning from the shape allows you to see the shape more accurately.

Establishing a Framework, continued

BASIC SHAPES METHOD

This method involves visually breaking down the animal into a series of simple shapes – eggs, spheres, cones, cylinders, and so on. Represent as much of the animal as possible with these basic shapes, add lines for orientation, and then draw other parts, such as ears, paws, and tail, in a very simple, blocky manner.

1. Draw the shapes, striving for correct proportions. For example, I see the chipmunk's head as a pointed egg shape, the rear of the body as a sphere, and the front part of the body as an upright, fat egg.

2. Add lines. On the head, draw a vertical centerline to indicate the direction the animal is facing (the chipmunk is mostly in profile, but slightly facing the viewer) and a cross-wise centerline. From the photo, note that the eye is located on the horizontal centerline of the head, in line with the nose and the base of the ear. The nose end of the head is pointed. The forehead is rounded, but the profile between the eyes and the nose is flat. Draw lines to indicate this flatness. The centerline of the body is the dark stripe that runs down the center of the body.

3. Roughly sketch in the arms, paws, and tail.

4. Use a compass to measure the proportions. Open the compass to the length of the head on the photo (the length from the top of the forehead to the nose). Keeping the compass open, lay it against other parts of the photo. You may be surprised to find that this length is the same as the distance from the nose to the hollow in the side just behind the arm, the distance from the hollow in the side just behind the arm to the rear edge of the body, the distance from the eye to the lower edge of the fur underneath the arm, and one-half the vertical length of the tail (i.e., the vertical length of the tail is twice as long as the head).

 I don't know why this is true, but often some significant distance (in this case, the length of the head) is repeated over and over again in the animal's pose.

Basic Shapes Method. Note the distances that are marked – they are the same as the length of the head.

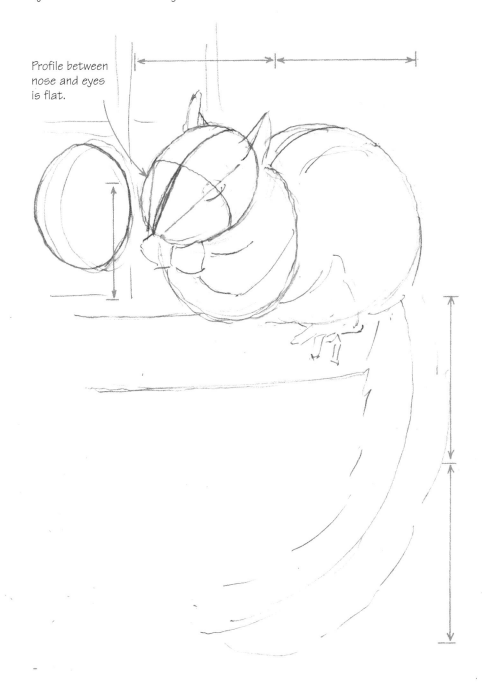

Profile between nose and eyes is flat.

ANCHORS METHOD

This method is the most abstract, and perhaps the most difficult. I prefer this method because it most exercises my powers of visual observation.

1. Choose an anchor – a prominent feature or line – as a starting point. What you choose as the anchor depends on how you see the subject. For example, I see a straight line connecting the chipmunk's nostril, both corners of the eye, and the lower tip of the notch in the ear as my anchor. So I begin by drawing this anchor line on my paper. If I want the drawing bigger than the photo, I draw this line longer than the one in the photo; if I want the drawing smaller than the photo, I draw this line shorter. Check the angle by laying the photo next to the drawing paper, and make corrections if necessary.

2. Notice proportions in the photo that act as clues for the drawing. For example, I find:
 • The back corner of the eye lies at approximately the midpoint of the anchor line.
 • The base of the ear is about halfway between the upper end of the anchor line and the back corner of the eye.
 • If I drop a vertical line from the back corner of the eye and mark a distance on it equal to the length of the anchor line, I locate the level of the forward toe on the foot.
 • The distance from the back corner of the eye to the tip of the forward ear is the same as the horizontal distance from the back of the eye to the center of the body where the back meets the shoulder. It is half the distance from the back corner of the eye to the back edge of the body at the same horizontal level.
 • The vertical length of the tail is a little longer than the horizontal width of the body overall.

3. Using these visual clues, draw simple outlines of the main features. As you proceed, check yourself by noticing vertical and horizontal alignments. For example, the back edge of the paw is vertically aligned with the front corner of the eye. The flat top of the foot is horizontally aligned with the lowest point of the white fur on the arm.

Continued on page 28

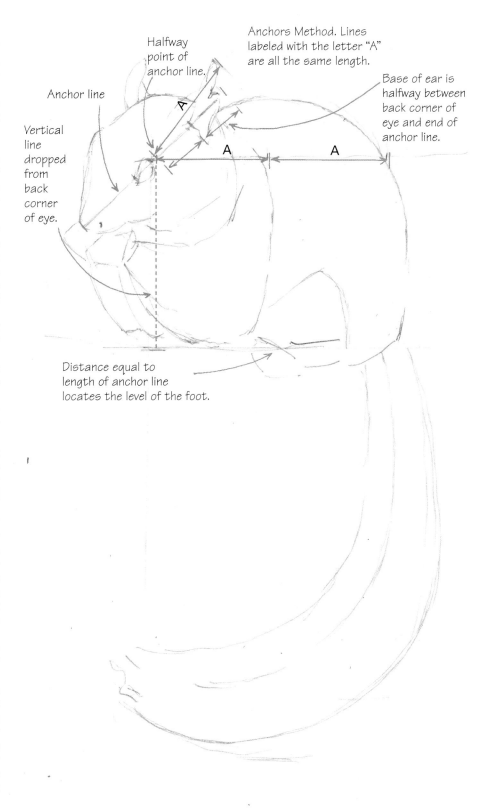

Anchor line

Halfway point of anchor line.

Anchors Method. Lines labeled with the letter "A" are all the same length.

Base of ear is halfway between back corner of eye and end of anchor line.

Vertical line dropped from back corner of eye.

Distance equal to length of anchor line locates the level of the foot.

Refining the Sketch

Once you have the framework for your drawing (regardless of the method you used to create it), the next step is to refine the sketch to create an accurate, detailed line drawing. This stage is a balancing act. At this point, absolute accuracy is important in some places, such as the shape of the eye, but not as relevant in others, such as the exact markings. It's a good idea to constantly refer to the photo for guidance and pay special attention to the features of the face, the paws, and aspects of the animal that are particularly characteristic.

Sometimes the question of accuracy poses a quandary for the artist. For example, this chipmunk has a notch in his left ear. If I wanted a portrait of this particular chipmunk, this notch would be important. If, on the other hand, I just want a convincing chipmunk, the notch is not important. I think the notch adds interest to the drawing so I decide to keep it.

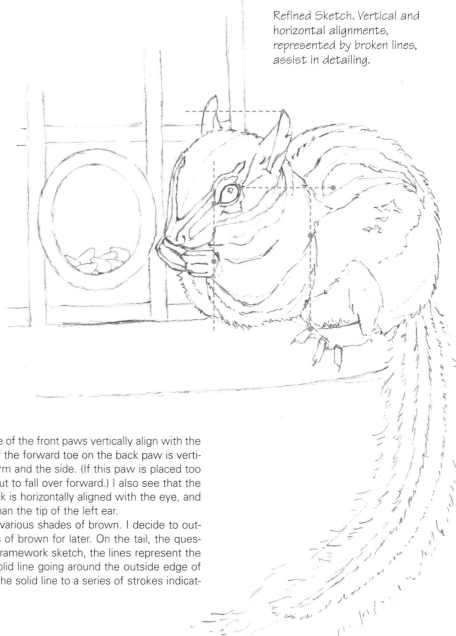

Refined Sketch. Vertical and horizontal alignments, represented by broken lines, assist in detailing.

In adding details, rely on vertical and horizontal alignments to help place them accurately. For example, I notice the rear edge of the front paws vertically align with the forward corner of the eye, and the knuckle of the forward toe on the back paw is vertically aligned with the division between the arm and the side. (If this paw is placed too far back, the chipmunk will look like he's about to fall over forward.) I also see that the beginning of the lower light stripe on the back is horizontally aligned with the eye, and that the tip of the right ear is slightly lower than the tip of the left ear.

The markings are complex, especially the various shades of brown. I decide to outline the main markings and leave the shades of brown for later. On the tail, the question is what my lines will represent. On my framework sketch, the lines represent the outer edge of the fluffy tail. I don't want a solid line going around the outside edge of the tail on my finished drawing, so I change the solid line to a series of strokes indicating individual hairs.

Adding Shading & Texture

Once you're satisfied with your line drawing, it's time to begin bringing it to life by adding layers of texture and shading. There are significant advantages to a layered approach. First, the transparency of graphite means all the layers are visible so multiple layers have a cumulative effect and increase the range of tone and subtleties of texture. Second, building layers is equivalent to taking it slow, thus increasing the opportunities to observe the photograph and make corrections while problems are still small.

To draw in layers, it's necessary to mentally break down the photo into a series of steps. This section shows you the method that works well for me. At this stage, I typically transfer my line drawing to a fresh sheet of paper.

FIRST TONAL LAYER

First Tonal Layer

This first layer is the foundation for all to come. I have two goals: to accurately establish the main areas of dark and light and to begin to build texture. In the process of texturing, I also establish the direction of the fur over all but the lightest areas of the animal.

Since I am working with darks and lights, I need to train myself to see value (lightness or darkness) and to mentally filter out the color when I refer to the photo. The value range of this first layer is pretty narrow, from white to a medium gray. I use an HB pencil. Generally, I do not work the lightest areas of the animal at all at this stage. On this chipmunk, that includes the light stripes on the back and face and the white fur on the belly and the underside of the arm.

Eye:

Begin with the eye. Carefully outline the eye with a thin, medium dark line. The texture of the eye is very smooth. Lay in a medium tone, avoiding the appearance of individual pencil strokes, but leave the highlight the white of the paper. I draw creases above and below the eye with small broken strokes to portray very short fur.

Ears:

Notice that there are white edges, and I am careful to preserve these as I draw. The fur is very short on the small ears. I just stroke in the lights and darks. Gradation of tone is important.

Face Fur:

Begin with the black stripes and lay in short lines in the direction the fur grows. To create the illusion of the fur's texture, I want the individual lines to show so I leave small, random white spaces between them. The fur is fairly short on the face. Use short lines that criss-cross slightly. The brownish fur down the center of the face is actually flecked with shades of cinnamon and black. For this first layer, sparsely cover the area with very short dark lines.

Next, work on the stripes in front of and behind the eye. For the stripe between the eye and the nose, work fairly short, slightly criss-crossing strokes in a light tone. As with the dark stripes, I want some white paper to show between the strokes, mimicking the texture of the fur. Work the medium-tone fur on the side of the face in the same manner. The stripe between the eye and the ear looks very smooth. Use a dull lead and try to avoid the appearance of individual strokes. The stripe is darker near the eye and lighter near the ear.

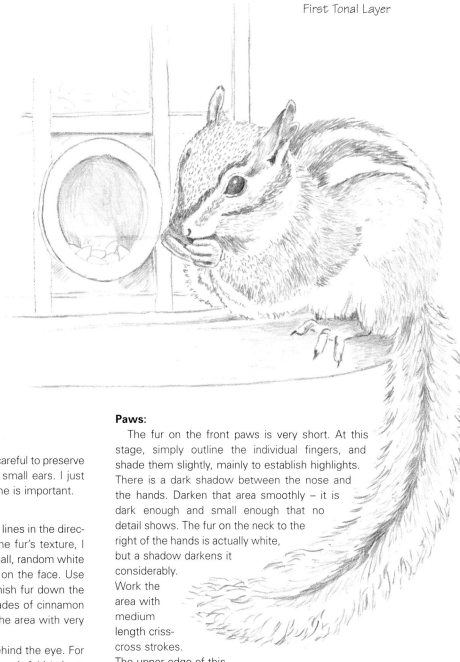

Paws:

The fur on the front paws is very short. At this stage, simply outline the individual fingers, and shade them slightly, mainly to establish highlights. There is a dark shadow between the nose and the hands. Darken that area smoothly – it is dark enough and small enough that no detail shows. The fur on the neck to the right of the hands is actually white, but a shadow darkens it considerably. Work the area with medium length criss-cross strokes. The upper edge of this shape defines the shape of the chin and lower face.

Arms:

The arm facing the viewer presents an interesting texture challenge. At the top, the hairs point straight towards the viewer. At the bottom edge, the hairs point downwards, and there is a gradation between these two edges. To portray this, draw little dots and very short lines at the top edge; at the bottom edge draw longer lines, and draw intermediate length lines in between.

Continued on page 30

Body Fur:

Draw the remainder of the body fur with medium to long criss-crossing strokes, varying their darkness or lightness according to the values in the photo. Make the strokes in the direction the fur grows. Leave the areas of lightest fur alone for now, but outline them with short, broken strokes.

Foot:

Draw the foot in the same manner as the front paws.

Tail:

Use longish, curving strokes. At this stage, leave a lot of white showing.

Feeder:

Keep the feeder simple, drawing its main features and the light shadows on the feeder under the chipmunk.

SECOND TONAL LAYER

With the first layer in place, you've established the placement of the major features, areas of dark and light, and the direction of the fur. In the second layer, build on this foundation and increase value contrast, enrich textures, and begin to add detail. Use a 2B pencil in the darkest areas (dark stripes, eye, deepest shadows, and dark areas of the ears) and an HB pencil for the rest. Proceed as in the first layer.

Eye:

To make the eye look bright, give it a secondary highlight. The secondary highlight is opposite the primary highlight, in the direction that the light is falling. In this case, the light is falling from above and the primary highlight is at the center top. Therefore, the secondary highlight will be in the center bottom. As I darken the eye in the second layer, I darken around the primary highlight, but also leave a secondary highlight. The edges of the primary highlight are sharp, but the edges of the secondary highlight are soft.

Fur:

The second layer of fur follows the first. Work the dark stripes, deepen them quite a bit, but preserve tiny light areas for the glisten of the sunshine falling on the chipmunk. Likewise, with the medium tone fur, add another layer, adding more strokes, but still preserving light flecks here and there. This second layer darkens the value. This is why I kept the first layer light – I wanted room in the second layer to add more texture without over-darkening the values.

There are a few things I do differently in the second layer. In the first layer, I left some areas white – the light stripes on the back and areas on the flank and side of the face where the fur is golden, but quite light in value. I lightly add texture now. The white fur on the inside and lower edges of the arms is in deep

Second Tonal Layer

Note the highlights on the edges of small folds of fur.

shadow. Add shadows to these folds of fur, preserving their shape by leaving narrow white edges. Add some texture lines to the lower part of the white on the belly above the back paw. As I work the second layer, I add detail that I see in the photo. For example, there is a darker area in the top center of the forehead; there are vertical bands of dark on the haunch just above the tail; I emphasize the triangular area of cinnamon fur on the side.

Tail:

Add a second layer to the tail, but am careful to leave a lot of white as the hairs on the tail have white tips.

Feeder:

Add a light tone to the metal parts of the feeder, and deepen the shadows under the chipmunk. Draw the tube on the feeder and darken it at the top, grading smoothly to a lighter tone at the bottom. Draw the outlines of the seeds visible through the glass in the feeder and then cover the area with a light, even tone.

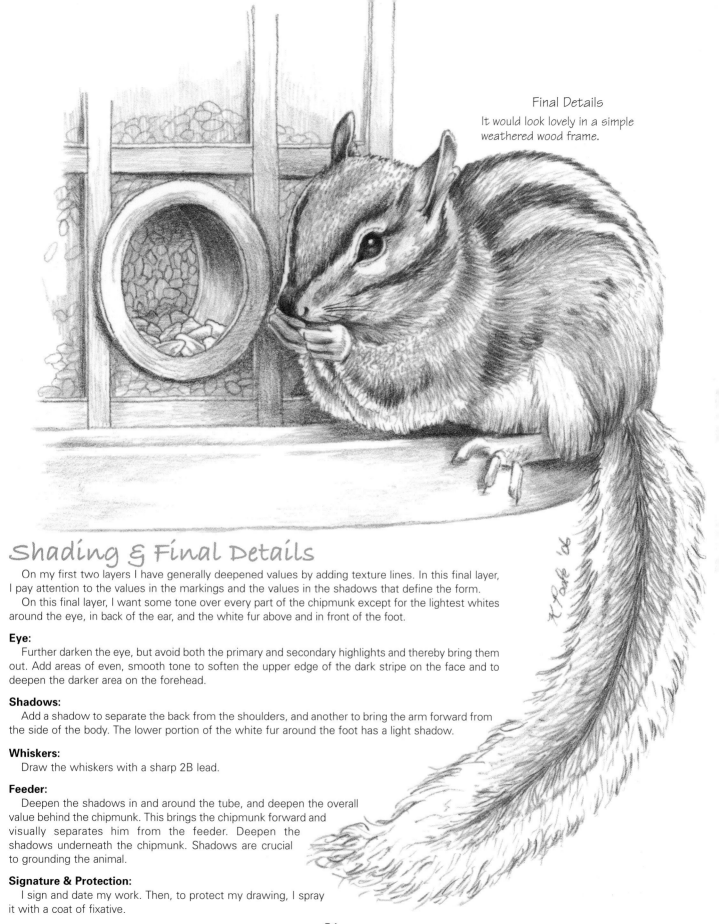

Final Details

It would look lovely in a simple weathered wood frame.

Shading & Final Details

On my first two layers I have generally deepened values by adding texture lines. In this final layer, I pay attention to the values in the markings and the values in the shadows that define the form.

On this final layer, I want some tone over every part of the chipmunk except for the lightest whites around the eye, in back of the ear, and the white fur above and in front of the foot.

Eye:
Further darken the eye, but avoid both the primary and secondary highlights and thereby bring them out. Add areas of even, smooth tone to soften the upper edge of the dark stripe on the face and to deepen the darker area on the forehead.

Shadows:
Add a shadow to separate the back from the shoulders, and another to bring the arm forward from the side of the body. The lower portion of the white fur around the foot has a light shadow.

Whiskers:
Draw the whiskers with a sharp 2B lead.

Feeder:
Deepen the shadows in and around the tube, and deepen the overall value behind the chipmunk. This brings the chipmunk forward and visually separates him from the feeder. Deepen the shadows underneath the chipmunk. Shadows are crucial to grounding the animal.

Signature & Protection:
I sign and date my work. Then, to protect my drawing, I spray it with a coat of fixative.

4 Cats

Cats' individual personalities are evident in their features, markings, gestures, and postures. They set good examples for us humans as they are masters of the art of relaxation, curling up in a favorite spot at every opportunity.

You may want to refer to the "Animal Anatomy" section and be sure you understand where the major joints are on cats. Like most quadrupeds, they walk on their toes, and their hips and shoulders are high on the body near the level of the spine.

Cats' eyes come in range of beautiful colors, from gold to green to blue to violet. Their irises are intricately flecked with bits of color, almost seeming to sparkle. The pupils expand from tiny dots, to vertical slits, to widening slits, to full circles, depending on the light and the animal's emotional state. Cats tend to not move their eyes much in their sockets, but move their heads to change the direction of their gaze.

The base of the each whisker (and eyebrow hair) is very sensitive to any movement of the whisker. They flare out from the face to the width of the body, giving the cat an early warning if he's entering a spot that's too tight for him. (The whiskers of well-fed, low-activity domestic cats are often not up to this task!)

Cats' noses are dainty triangles, with the nostrils showing as dark dots. There is a vertical indentation on the lower half that is an extension of the line between the nose and the center of the mouth. The nose, along with lips, eyelids, and foot pads are the color of the cat's skin. In calicos and tabbies, the skin color can change from place to place over the body so we may see different colors, especially in the pads.

The mouth has two definite halves, rather than being a single smooth shape, and it shows as a broken line because of the fur. There is often a shadow at the center.

A cat can command a wide range of motion in his ears, and can move them independently of each other. The position of the ears is a strong signal of emotion and attentiveness. The ears attach to the head in a deep semi-circle. There are two sets of distinctive tufts, one coming from the inner vertical edge of the ear, and the other coming across the base of the opening. These tufts, especially the ones along the inner ear, can be quite long and thick. Some cats have tiny little points of individual hairs at the ear tips. There is a vertical split at the bottom of the outside edge of the ear. The inner ear is often quite light and is covered with thin, very short fur. There is a deep shadow towards the base where the tunnel to the inner ear is located.

A completed drawing with color of "Mick, A Yellow Tabby." Drawing instructions begin on page 35.

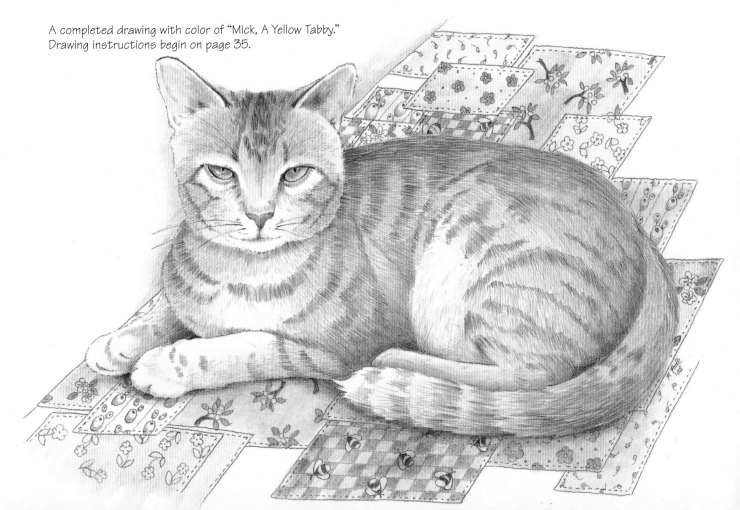

Cats Worksheet

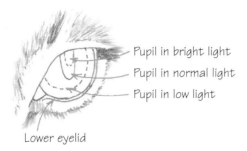

Pupil in bright light

Pupil in normal light

Pupil in low light

Lower eyelid

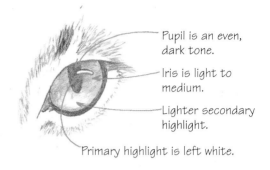

Pupil is an even, dark tone.

Iris is light to medium.

Lighter secondary highlight.

Primary highlight is left white.

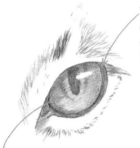

The upper eyelid casts a shadow over the upper part of the eye.

There is a darker halo around the pupil a small distance away. It shows if the eye is large enough and the iris is light.

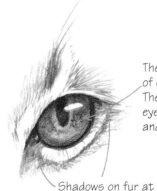

There are tiny flecks of color in the iris. They are visible if the eye is large enough and light enough.

Shadows on fur at corners of the eye

Note: The eye is often surrounded with light fur. Above the pupil is a light vertical stripe, and a darker one towards the center of the face. A few long eyebrow hairs, similar to whiskers, grow from this spot. This pattern is often present, even if it is extremely subtle, in cats with very light coats.

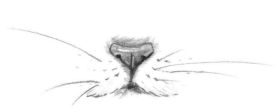

The base of each whisker appears as a little dimple.
There is often a band of darker fur above the upper edge of the nose.
Shadows are important in shaping the nose.

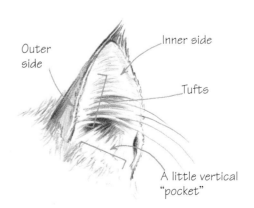

Outer side

Inner side

Tufts

A little vertical "pocket"

MOPSY,
A DOMESTIC SHORTHAIR

Mopsy is a lovely short-haired cat with a thick, luxurious gray coat and gorgeous green eyes. This photo captures her beautiful features in a serene pose. Because her markings are minimal, this photo is a good choice for beginners. I decide to just draw the head. Her face is lovely and will make a nice portrait.

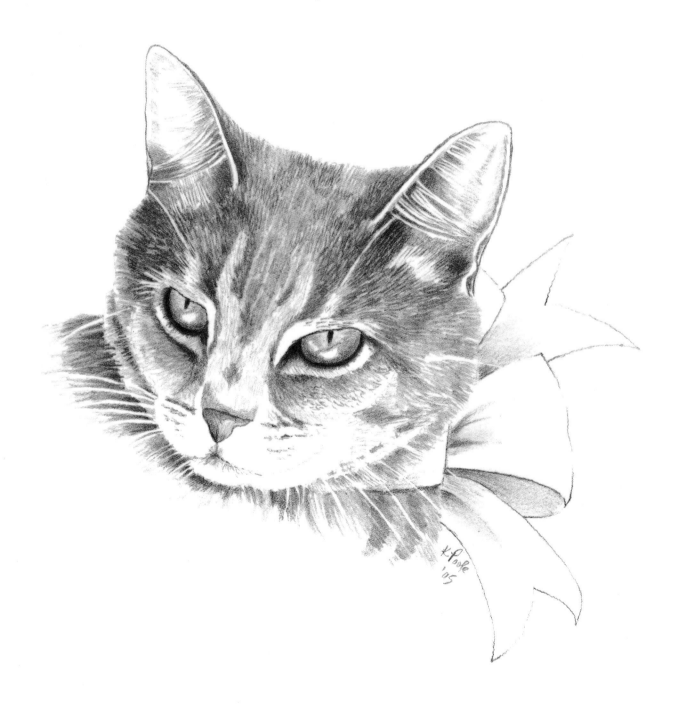

Supplies

- Light ivory acid-free drawing paper
- Near-white acid-free vellum drawing paper
- 5mm mechanical pencil with HB lead
- 5mm mechanical pencil with 2B lead

Observations

Notice her head is at a slight slant. This slant adds visual interest to the photo and suggests personality. It will be important to preserve this slant in the drawing, and to be sure that the various horizontals of her face – the top of her head, the imaginary line between the pupils of her eyes, the line on the top of her nose, and her mouth – are consistent.

Give her a nice bow to balance the composition. In the following sections, "right" refers to your right, and "left" to your left.

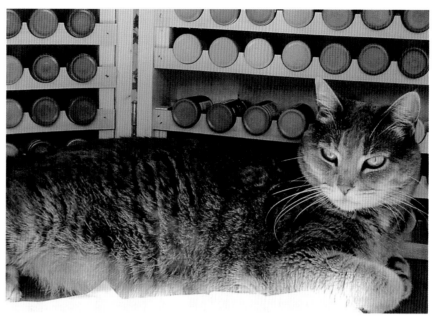

Photo credit: courtesy Kaaren Poole, 2005

Establishing the Framework

METHOD: BASIC SHAPES

Head:

Mopsy's head is a flattened oval slanting slightly downward from left to right. Using the HB pencil with a sheet of acid-free drawing paper, draw a line at the proper slant, then draw the oval centered horizontally on that line. Draw the vertical centerline of the oval as a point of reference and curve it slightly to the left, reflecting the fact that she is looking slightly left.

Muzzle:

Her muzzle is another flattened oval, and the nose is somewhat towards the top of this oval. Draw a line curving horizontally around the muzzle oval where you think the nose will go. Curve this line slightly downwards, reflecting the fact that she is looking slightly down. Draw the vertical centerline of the muzzle. This line is curved slightly to the left and lines up with the centerline of the head.

Eyes:

The eyes are somewhat below center. Tentatively draw in the pupils. Sketch triangles for the ears. Observe that the right one is more slanted and appears wider than the left one.

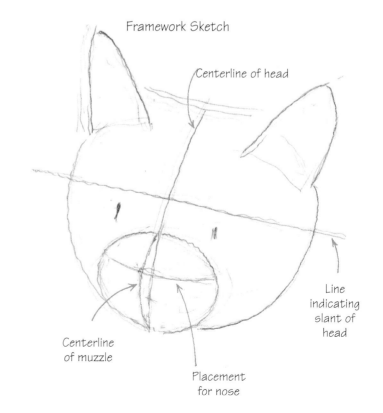

Framework Sketch

Centerline of head

Line indicating slant of head

Centerline of muzzle

Placement for nose

Refining the Sketch

Eyes:

First, draw the lines around the bottom of the eyeballs, then the lines across the top. Notice that the bottom line is very rounded while the top one is flatter. Pay careful attention to subtleties in the curves – they indicate the curvature of the eyelids over the spherical eyeballs. Mopsy is in bright light reflected up from the white paper in front of her, so her pupils are narrow slits.

The highlights are on the lower portion of the eyes. Lightly draw the outlines of the highlights to remind yourself not to draw over them later.

Eyelids:

Cat's eyelids are furred, so they appear thick. Since Mopsy is looking slightly downwards, you see the thickness of the lower lid, but not the upper. Draw the eyelids in. Also draw the edges of the areas of white fur above and below her eyes.

Nose & Mouth:

Begin with the line at the top. This line will be slightly slanted to match the overall slant of her face. If Mopsy were looking up, you would see that the top edge of the nose curves slightly upwards. But because she is looking slightly downward, the top edge of her nose appears nearly straight, but there are slight curves at both edges, curving very slightly downwards at the left and upwards at the right. The small vertical crease in the center of her nose slants slightly, forming a right angle with the line at the top edge of the nose. The nose is basically a triangle, interrupted by small notches for the nostrils. Notice that the nostril on the right shows but the one of the left does not. The mouth is a gentle curve.

Muzzle:

The part of the muzzle that the whiskers grow from puffs out slightly. Draw the edge of this area, then sketch light broken lines for the base of the whiskers.

Ears & Top of the Head:

The top of the head is pretty flat and slanted to mirror the slant of the head overall. At each side, the backs of the ears curve upwards to meet the ears' inner edges. The right ear appears wider than the left because we see that ear head-on, while the left ear faces somewhat to the side.

Other Refinements:

At this point, refine the lines defining the sides and her face and her chin. Study the photo for contours in the fur around her cheeks, muzzle, and chin. Add the bow.

Transfer Design:

Carefully transfer your line drawing to a fresh sheet of vellum drawing paper for your final drawing.

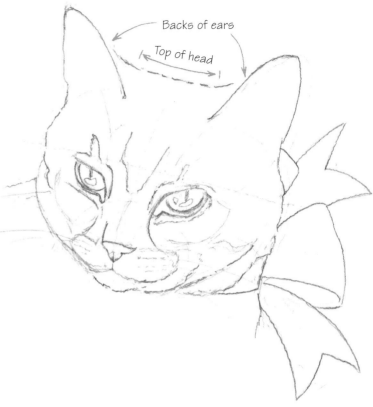

Refined Sketch

Backs of ears

Top of head

First Tonal Layer

The objective in this first layer is to begin to define the variations in value as well as the texture of her fur.

Eyes:

Carefully outline the eye with a thin dark line, then darken the pupils. The thickness of Mopsy's eyelids casts a shadow on her eyeballs. Since the light in this photo comes from below, the shadow is cast from the bottom eyelid at the bottom edge of the eye. Accordingly, add a light tone over the eye (avoiding the highlights), then deepen it slightly along the bottom for the shadow. Don't do too much at this stage. Her eyes are light, and you want to build up the tone slowly, layer by layer.

Eyelids:

Her eyelids are dark, and since she is looking slightly down, we see their full width along the bottom lids, but see the top lids only as very thin black lines.

Nose:

There is a dark line around the nose, but the nose itself is a light tone.

Whiskers:

Use the small end of a stylus to incise lines for her whiskers. Also incise the white hairs in her ears and at the outer portions of the light fur over her eyes.

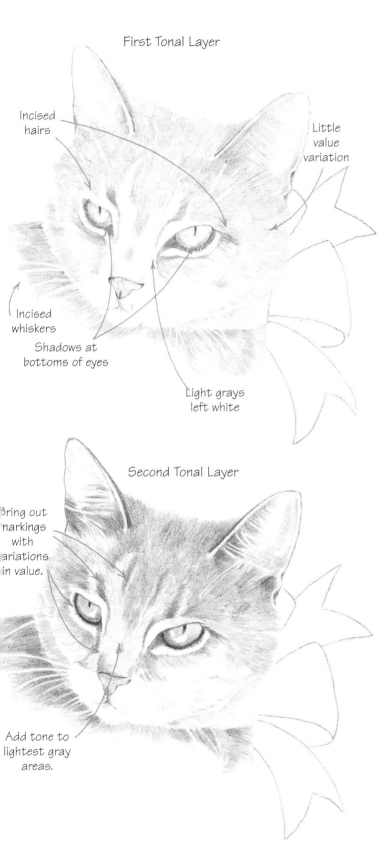

First Tonal Layer

Incised hairs

Little value variation

Incised whiskers

Shadows at bottoms of eyes

Light grays left white

Second Tonal Layer

Bring out markings with variations in value.

Add tone to lightest gray areas.

Inside Ears:

The inside of her ears are a light color with a thin white edge, but the color deepens at the base, behind the white hairs. Draw a very thin dark line around the edge of the ears to distinguish them from the background, then add tone to the inside of the ears, referring to the photo to place the lighter and darker portions.

Fur:

Use a dull lead and stroke lightly back and forth. This gives a very soft look that is appropriate for Mopsy's thick, fine coat. Work in short strokes, always in the direction the fur grows. Generally, lay the strokes very close to each other, but leave thin lines of white space occasionally and randomly. Cover only the areas that are dark or medium gray, varying the tone only slightly.

Second Tonal Layer

Fur:

Go back over the entire drawing, darkening the fur. This time, lay a light tone on the light gray areas that were left white in the first layer (such as on the nose), but still leave the white fur untouched. Paying careful attention to the subtle value variations in her coat, work the fur in the same manner as before, with short strokes in the direction of the fur growth using the flat edge of the lead.

Eyes:

Slightly darken the tones in the eyes, being careful to keep the eyes light overall and leave the highlights white. Also darken the lower lids, but concentrate the dark towards the eye, leaving the outer edges slightly lighter. Likewise, darken the nose.

Shading & Final Details

See completed drawing on page 34

Fur:

Continue to deepen and texture the fur, and emphasize the variations in value that develop the subtle tabby markings in her coat. As you work, be careful to leave tiny random lighter areas between your strokes. (You want to avoid an even tone to preserve the look of fur.) For this layer, keep turning the pencil, giving a sharper line than before.

Eyes:

Deepen the eyes, increasing the contrast with the highlights. Lightly draw broken lines at the base of the whiskers.

Bow:

The bow is very simple. Switch to the 2B pencil and shade the inside of the loop, areas where one piece of ribbon lies behind another, and the creases. Then gently smudge the shading with your finger, and erase any smudging that went outside the edge of the ribbon. Draw a very thin line around the ribbon, varying the pressure and, therefore, the darkness of the line for interest.

Finish:

Sign and date the drawing, then apply a layer of fixative to protect it. ❏

TRINA

A KITTEN

Carol, one of the technicians at my veterinarian's office, found this darling little kitten huddled under a shrub at the end of her driveway. She named her Trina. In this photo, Trina is about four weeks old, and at this young age she went to work every day with Carol. Like all healthy kittens, she is bright, curious, and lively.

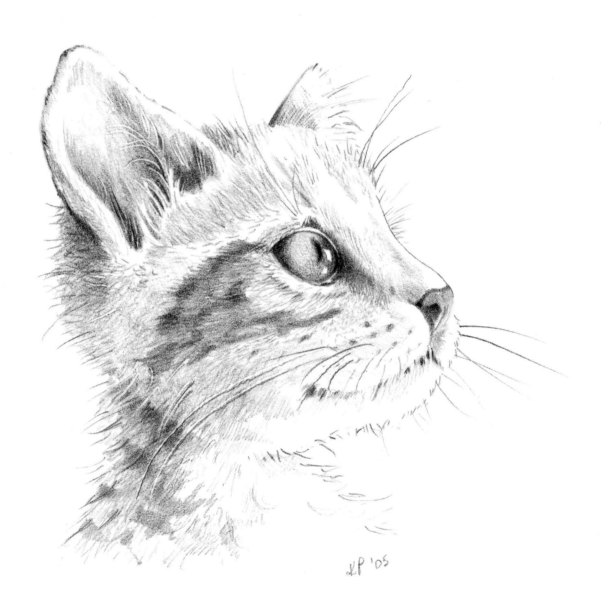

Supplies

- Light ivory acid-free drawing paper
- Near-white acid-free vellum drawing paper
- 5mm mechanical pencil with HB lead
- 5mm mechanical pencil with 2B lead
- Compass

Observations

When I first evaluated this photo, I was disturbed by the pencil neck look and thought I might change her pose somewhat to lessen it. But the more I thought about it the more I liked the pose as is. (After all, kittens are pencil necks!) I take a few minutes to absorb just what it is that makes her a young kitten – the large ears, large head, skinny neck, bright eyes, an expression of wonder, and a complete lack of self-consciousness.

Much of the photo's charm is its lighting. The light falling on the kitten's face, in contrast to the dark background, highlights her whiskers and fuzzy kitten coat and emphasizes her kittenish profile. This is a difficult effect to create with graphite since it is basically a dark-on-light process rather than the reverse. It would be nearly impossible to draw a dark background around all the hairs on her profile, and incised lines would not give sharp enough white lines against a dark background. Nor would white pencil give bright enough lines on a colored paper. I conclude that the fuzziness is more important than the lighting and decide to draw her against a light background.

In the following sections, "right" refers to my right, and "left" to my left.

Establishing the Framework

METHOD: BASIC SHAPES

Seeing the Shapes:
Evaluate the basic shapes that comprise Trina's head. Notice her head is wider than it is tall.

Drawing the Shapes:
Using a sheet of acid-free drawing paper and the HB pencil, draw a flattened oval to represent her head. Lightly sketch another oval for her muzzle.

Proportions & Alignments:
Use your compass to look for proportions and alignments. Notice that her pupil is at the center of a circle that touches the tip of her nose, overlays most of the curve of her mouth, and touches the point where the inner corner of her ear meets her head. Also, there's a pretty clear straight line from the tip of her nostril, along the dark shadow at the inner edges of her eye, and up the edge of the ear.

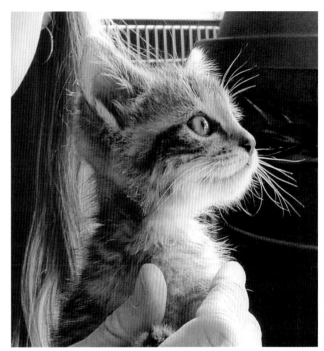
Photo credit: courtesy Kaaren Poole, 2005

Framework Sketch
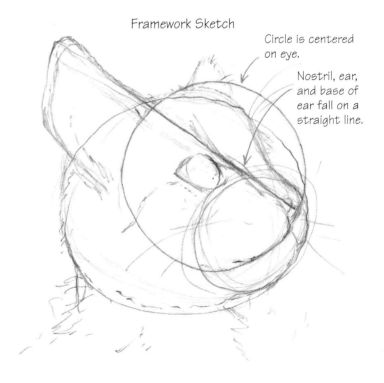
Circle is centered on eye.

Nostril, ear, and base of ear fall on a straight line.

Continued on next page

Continued fromp page 39

Draw the profile of her nose and place the eye. Now that you have the eye-to-nose distance, draw the circle centered on her pupil and the straight line from the nostril. From there, place the ears, mouth, and the rest of the main features.

Observations:

As I evaluated my framework sketch against the photograph, I realized I had her head too narrow. Her ear needs to be back a little, and the back of her head protrudes even beyond her ear. I also needed to extend the front of her face a bit and move her eye forward.

Refining the Sketch

Alignments:

Notice the corner of her mouth lines up with the center of her eye. The front edge of her neck is approximately even with the center of her eye as well. The back corner of her eye aligns vertically with the back edge of the far ear, and horizontally with the bottom of the near ear. Use these alignments to properly place the features.

Lines:

The lines of the profile, chin, ear, and back of her head are very important so check them carefully. Also verify that the tilt of her eye is appropriate for the tilt of her profile.

Details:

Draw the details of her nose and outline the markings on her face. The tuft of fur showing to the right of the bridge of her nose is the fuzzy hair above her left eye. Indicate this, as well as the tufts of hair in her left ear, sparsely.

Transfer the line drawing to a piece of vellum paper.

First Tonal Layer

Eye:

Begin with the eye, carefully darkening the outline. Add an even, medium tone, avoiding the highlights. The pupil is dark, but its edges are not distinct. Darken the area to the right of the eye as well as the tiny triangle above it, but leave a very thin line of white between these areas and the eye itself.

Nose:

Lay down the darks in the nostril, on the centerline, and the band across the top. Add a mid-tone value over the remainder of the nose, but leave a white highlight along the vertical edge of the nostril.

White Fur:

To begin, incise lines with a stylus. (They will show as white when tone is added over them.) The incised lines are inside her forward ear, above her eye, and the small hairs on her upper lip that overhang her mouth. Then incise the whiskers and eyebrow hairs.

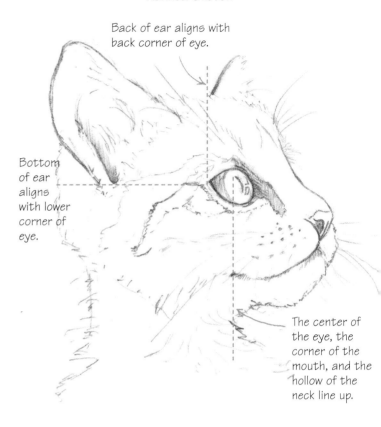

Refined Sketch

Back of ear aligns with back corner of eye.

Bottom of ear aligns with lower corner of eye.

The center of the eye, the corner of the mouth, and the hollow of the neck line up.

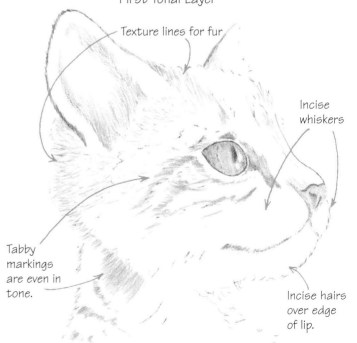

First Tonal Layer

Texture lines for fur

Incise whiskers

Tabby markings are even in tone.

Incise hairs over edge of lip.

Trina, continued

Second Tonal Layer

Darken dark areas.

Add more texture.

Add tonal variation to eye.

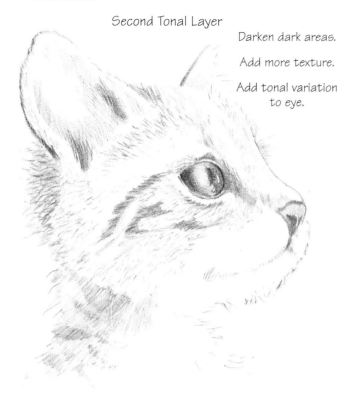

Ears:
The back edges of both ears are dark. On the left ear, use very short lines side by side, representing the individual hairs. On the right ear, simply draw a smooth line, dark at the base and lightening towards the tip. To bring out the lines incised earlier, add a light tone to the inside of the left ear.

Other Fur:
On the back of her neck and upper portion of her head, draw tiny lines in the direction the fur grows. The tabby markings on her cheek and neck are solid areas of medium-light tone.

Mouth:
Draw the light tone defining her mouth as a series of tiny lines perpendicular to the curve of the mouth.

Nose:
After slightly darkening the side of the nose, add a very light gray swath up the center of the bridge of her nose. Her nose is light, as is the background, so define the edge of her nose by darkening the line. This is a single smooth line as the fur on her nose is very short.

Muzzle:
Define the edge of her muzzle, chin, and neck with individual fur lines.

Second Tonal Layer

Eye:
To begin, darken the outer corner and inner portion of her eye, grading the tone smoothly to the lighter areas. As always, be careful to avoid the highlights. As you detail and darken the eye and area around it, leave a thin light rim across the right half of the top and bottom of the eye to suggest the edge of the eyelid.

Shadows:
Working over the tones and texture added previously, deepen the shadows in and behind the ear and on the left side of the neck. Also deepen the markings on her cheek and neck.

Fur:
Add texture to all the areas of fur except the brightest portions on the forehead, forward edges of the ears, muzzle, chin, and neck. Add an even, medium tone over the darker neck fur.

Shading & Final Details

See completed drawing on page 38

In this final layer, concentrate on deepening value and defining shadows by adding areas of even tone. Switch to the 2B pencil for this.

Eye:
Deepen the dark portions of the eye, increasing contrast.

Shadows:
Deepen shadows behind the ear, at the back of the neck, in the corners of the ears, and in the inside corner of the eye.

Add a light tone to the entire face and neck except for the highlight areas. The small shadows along the under side of the mouth and around the nose define the shape of her muzzle.

Observations:
The incised whiskers and eyebrow hairs on the left side of her face simply do not show up enough. Even though her whiskers are white, I decide to draw them in dark, just like on the right side where they are over the white background.

Whiskers & Eyebrows:
The first step for the whiskers is drawing the little splotches at their bases. With a very sharp lead, pull the whiskers and eyebrow hairs out from the right side of her face over the background. Then do the left side.

Finish:
Check that you have deepened the shadows sufficiently and have enough value contrast. Sign and date your work and preserve with a layer of spray fixative. ❏

MICK
A YELLOW TABBY

A cat on a quilt may be a cliche, but I think it's an endearing one, so
I was happy to be able to snap a picture of my cat, Mick, relaxing on my
patchwork quilt. I also like the traditional cat pose with his tail wrapped
around him. His eyes are partly closed, as if I have interrupted his reverie.
The colors in Mick and the quilt are so beautiful that I decided to add a
little color. The tinted drawing appears on page 32.

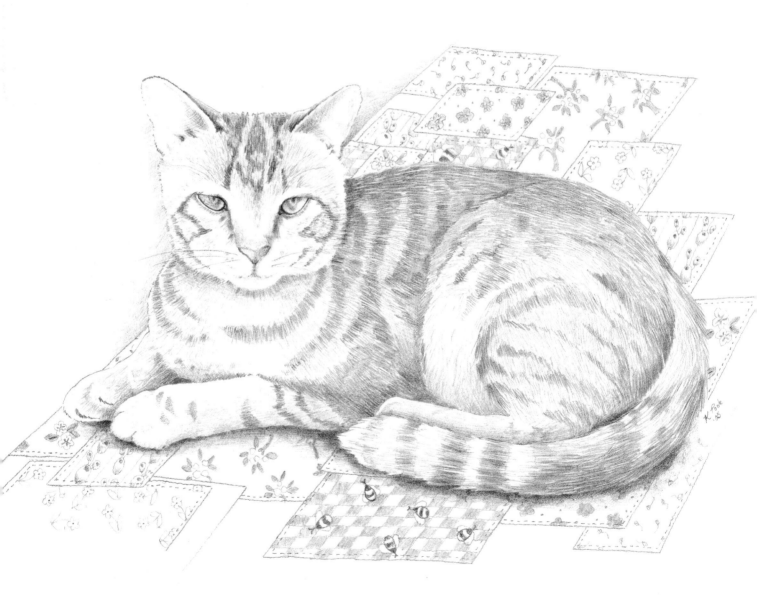

Supplies

- Light ivory acid-free drawing paper
- Near-white acid-free vellum drawing paper
- 5mm mechanical pencil with HB lead
- 5mm mechanical pencil with 2B lead
- Acrylic Craft Paints – Bright Peach, Sweetheart Pink, Cinnamon, Fresh Foliage, Bayberry, French Blue, Lavender, Burnt Sienna, Yellow Ochre, Yellow Light
- Paintbrush – #12 round
- Palette
- Water container
- Compass
- Ruler

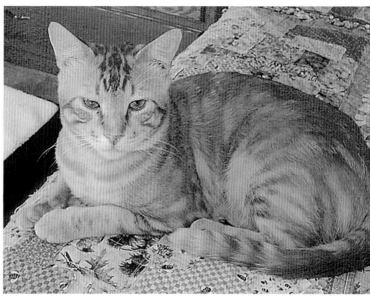

Photo credit: courtesy Kaaren Poole, 2005

Observations

The complex part of this drawing will be the face, the markings, and the detail on the quilt. But Mick's shape is pretty simple. Once I have the head, I should be able to draw the rest of the body pretty accurately just measuring proportions and noticing alignments.

Because Mick's head is tilted downwards, his features present a challenge – the tilt affects the shapes of the eyes, nose, mouth, and ears. I follow the photograph as closely as possible. When I have problems, I isolate the features by covering them one at a time to determine where the problems are. Then I erase and try again. It took several iterations before I was happy with the face.

The line of the upper eyelids cuts across the sphere of the eyeballs in a fairly flat curve. The lower edges of the eyeballs meet the outside corners of the upper eyelids at sharp angles. I find it challenging to draw the outline of the eyes without giving Mick an angry look because the line across the top of angry eyes is also flat. To counteract this, I must be careful to accurately draw other cues that invite the viewer to perceive the head as tilted downward. These cues include the rounded lower edge of the eyes, the shortness of the nose, the shallowness of the chin, the lines of the tufts of fur at the front of the ears, and the fact that we see a little bit of the tops of the ears. Additionally, from this angle the upper edge of the nose looks like a flattened heart, and we don't see the nostrils at all.

In the following sections, "right" refers to my right, and "left" to my left.

Establishing the Framework

METHOD: BASIC SHAPES

Head:

Using a sheet of acid-free drawing paper and an HB pencil, begin by sketching the head as a squared oval that is only slightly wider than it is long.

Proportions:

Using a compass, notice the body to the right of the head is two head-widths wide. Also notice the distance from the tip of the chin to the bottom of the arm is about two-thirds the height of the head. Also, the front edge of his hip is halfway between the left and right sides of the body. Using these proportions, draw the body, tail, legs, and paws.

Placing the Features:

Use a compass to discover basic proportions in the face. The center of the pupils is halfway between the top of the head and the bottom of the chin. From side to side, there is approximately one eye-width between the outer edges of the eyes and the outer edges of the head. The distance between the eyes is about one-and-one-half eye-widths. Notice the vertical alignments between the various features and the ears and chin. Make your first attempt at drawing the features.

Quilt:

Use a ruler to lightly draw a grid in perspective. To do this, first draw a slanted line representing the left edge of the quilt. Then draw a line at the far right that's not parallel to the first one but angles slightly towards it. (If the two lines were extended upwards they would meet at some point.)

Next, draw two horizontal lines, one towards the top and the other towards the bottom of the paper. Divide the upper line between the left and right lines into fifths, then do the same on the bottom horizontal line. Connect the corresponding marks on these two lines to create the vertical part of the grid. Then draw a series of horizontal lines. Note: If you were drawing an exact checkerboard, these lines would be further apart at the bottom and closer together at the top. But this quilt is made of random patches, so it doesn't really matter how far apart the horizontal lines are. Use them as guidelines to place the patches in the next step. In the photo, the horizontal lines are actually angled, but it simplifies things to ignore this.

Refining the Sketch

Observations:

With the small, complex markings on the face, I find it easier and less confusing to tone their shapes rather than outline them. Mick's markings are as important as his features in differentiating him from other yellow tabbies.

Markings:

Refer to the photo frequently to get the markings as accurate as possible. Indicate the markings on the forehead and cheeks. For the body markings, outline a few of the distinctive rings on the chest, body, and paws as well as the light areas on his side and the front edge of his knee.

Paws:

Draw the individual toes on the front paws. The farther paw is turned slightly towards the viewer, so the undersides of the toes, and the little slits where the claws lay sheathed, are visible.

Quilt:

Using the grid and the photo as guides, sketch in patches on the quilt around Mick. Note: Since the drawing will be vignette style, don't go to the edge of the paper.

Transfer Drawing:

Make a final visual check of your drawing, then transfer it to a sheet of vellum drawing paper for your final drawing.

First Tonal Layer

Mick's eyes are light – you can see a lot of detail in them. Try to preserve that look.

Eyes:

Carefully outline the eyes with a dark line. Darken the tiny pupils, then add a very light tone to the rest of the eyes, but avoid the highlights. Finally, slightly darken a halo area around each pupil, but leave a light ring between the pupil and this halo.

Tufts & Whiskers:

With the stylus, incise the tufts of white hairs inside the ears as well as the whiskers. (These will show in later layers.)

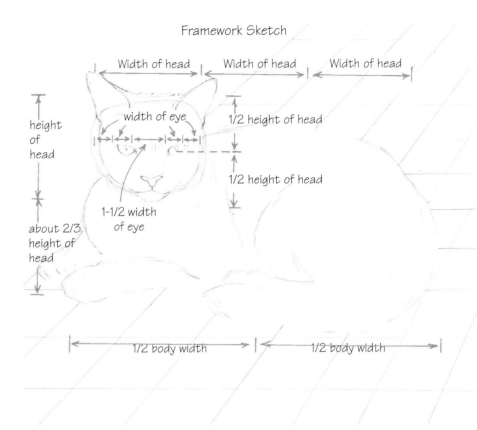

Framework Sketch

Width of head | Width of head | Width of head

height of head

width of eye

1/2 height of head

1/2 height of head

about 2/3 height of head

1-1/2 width of eye

1/2 body width | 1/2 body width

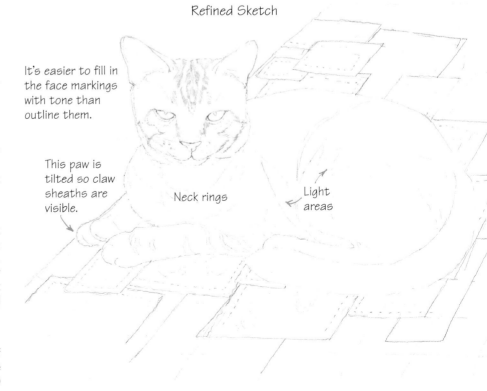

Refined Sketch

It's easier to fill in the face markings with tone than outline them.

This paw is tilted so claw sheaths are visible.

Neck rings

Light areas

Face Fur:

Draw tiny, closely spaced lines radiating around the lower edge of the eyes, but leave a light area close to the eyeballs to represent the lower lids. Darken the corners of the eyes, and draw the dark markings between the eyes and the upper corners of the nose.

Nose:

The nose is also very light, so go easy at this stage. The lower portion is darker then the upper portion, which should be left white. Emphasize the corners by darkening them.

Face Fur Texture:

Except for the lightest areas of the face around the eyes, muzzle, and chin, cover the face with tiny lines that begin to establish the texture of the fur. Varying the pressure gives you darker or lighter lines. In this way, begin to establish the facial markings.

Ears:

The ears have a dark edge, but the inner ears are very light. Add a very light tone along the inside edges and in the shadow areas.

Body Fur:

Work only the dark portions using medium length, medium tone parallel strokes, always working in the direction the fur grows. Place your strokes very close together, allowing some white of the paper to show through. Lightly indicate the major shadows with even areas of darker tone.

Quilt:

It is tedious, but the detail in the quilt is an important part of the drawing. Use the photo for ideas for the fabrics, but don't feel compelled to follow the photo exactly.

Second Tonal Layer

Shadows develop Mick's form and ground him on the quilt. The fabric details of the quilt are tedious but straightforward. The stitching adds a nice touch.

More Texture:

Deepen Mick by adding another layer of texture over the entire face and body, except for the bright highlights on the face, chest, knee, and upper edge of the forward front leg.

Shadows:

Place shadows under the chin and between the edge of the head and the back to bring Mick's head forward. Place shadows between the front paws to separate the front legs. Place a shadow on his side in front of his back leg to bring his hip and back leg forward. Add another shadow to separate the tail from the body. Place very dark shadows on the quilt underneath him along the lower portions of the body, legs, paws, and tail to help ground him.

Quilt:

Draw the details on the quilt. Add stitch marks.

Defining the Left Edge:

Add a very light tone in the background at the left edges of Mick's face and body and the quilt's left side so they don't get lost against the light background. Make this tone even and smooth.

Finish:

Sign and date your drawing, and protect it with a layer of fixative.

First Tonal Layer

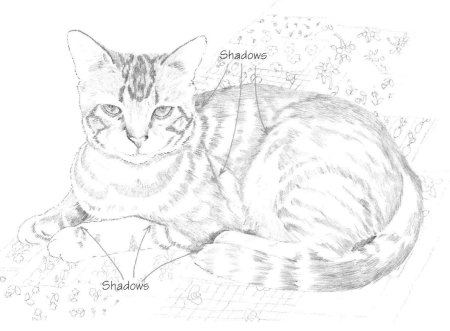

Shadows

Shadows

Adding Color

Refer to colored illustration on page 32.

Acrylic washes give the look of an old hand-tinted photograph. Guided by the photograph, choose a palette of soft colors for the quilt, Yellow Ochre and Burnt Sienna for the fur, Bayberry for the eyes, and Cinnamon for the nose. In tinting the drawing, use very thin paint.

Preparation:

To apply acrylic washes, the paper must be very well sealed, so apply another coat of fixative just to be sure.

Painting:

Thin the acrylics by mixing water into them on a palette. After you load your brush, test the color on a piece of scrap paper to be sure the paint is thin enough. Let dry.

Protection:

Spray a final coat of fixative. ❏

DUSTY
A CHINCHILLA PERSIAN

Dusty has big eyes and a most innocent expression. The main challenge
in drawing Dusty is portraying a white cat on white paper. I decided to subtly
color the background and chose watercolor pencils because they can give a
soft edge, appropriate for the edge between the background and Dusty's
very soft fur. This will be a minimalist drawing, emphasizing his eyes and
keeping the details soft and subtle.

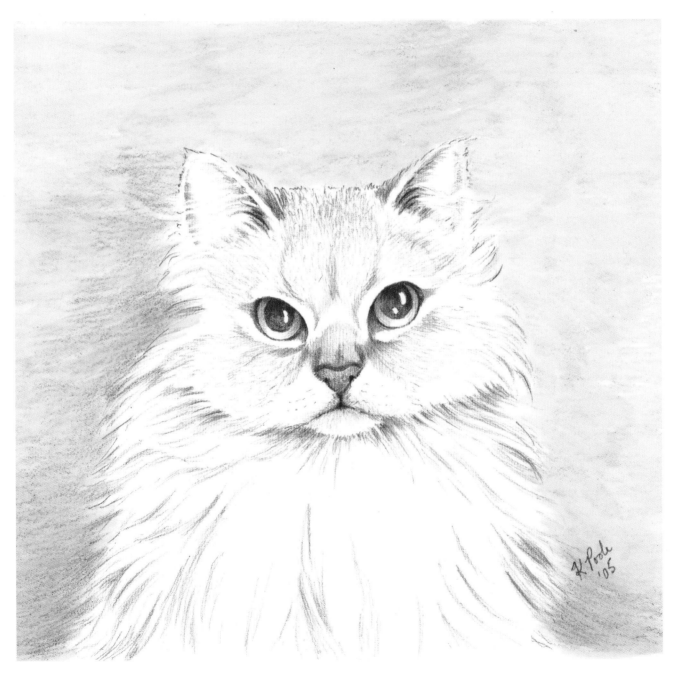

Supplies

- Light ivory acid-free drawing paper
- Near-white acid-free vellum drawing paper
- 5mm mechanical pencil with HB lead
- 5mm mechanical pencil with 2B lead
- Watercolor Pencils – Peacock Blue, Copenhagen, Spring Green, Terra Cotta
- Paintbrush – #12 round
- Water container

Observations

Dusty's fur is very long and fluffy, giving his head the appearance of being quite broad. As a result, his features seem concentrated in a relatively small part of the center of his face. His eyes are very large, distinctly larger than his nose. Because of all the fur around and in them, his ears appear smaller than the ears of short-haired cats. Actually, we just see less of them!

In the following sections, "right" refers to my right, and "left" to my left.

Establishing the Framework

METHOD: BASIC SHAPES

Shapes:

Dusty's head is a flattened oval at a slight tilt. Also see the small circle around his muzzle. Draw these two basic shapes, using the HB pencil on a sheet of acid-free drawing paper.

Proportions:

Use your compass to look for proportions in the photograph. The top edge of his eyes is midway between the top of his head and the tip of his chin. The eyes and nose form a triangle. The centers of the eyes are equi-distant from the lower tip of the nose, and the distance between the centers of the eyes is a little greater than this. Using these proportions as guidelines, sketch in the features.

Continued on next page

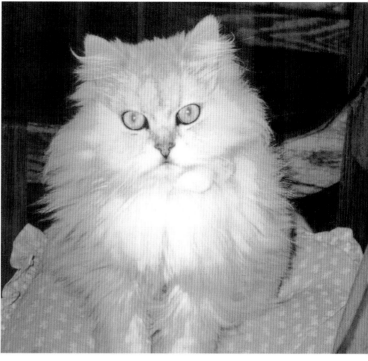

Photo credit: courtesy Kaaren Poole, 1998

Framework sketch

Height of head is about three-fourths of the width.

Half of head height

Half of head height

Eyes are slanted from corner to corner.

C

A B

Thirds of muzzle

A=B

C is a little longer than A or B.

Refining the Sketch

Eyes:

Begin by drawing the eyes. Note that Dusty's natural "eyeliner" is very narrow at the tops of the eyes, wider around the bottoms and sides, and quite wide in the inner corners. His right eye appears a tiny bit wider than the left. Add highlights to each eye, then a second smaller one in the right eye.

Ears:

Although most of the ears are covered by large tufts of fur, sketch the entire shape.

Nose & Mouth:

Draw the nose, being careful to keep it small. The mouth follows a subtly inverted curve.

Outlines:

Lightly outline the head and shoulders, the major sections of fur, and the pale markings on Dusty's face.

Transfer Drawing:

Carefully transfer your drawing to a sheet of vellum drawing paper for final drawing.

Refined Sketch

The "eyeliner" at the tops of the eyes is very narrow.

Since they aren't visible in the photo, it's necessary to guess where to place the bottoms of the ears.

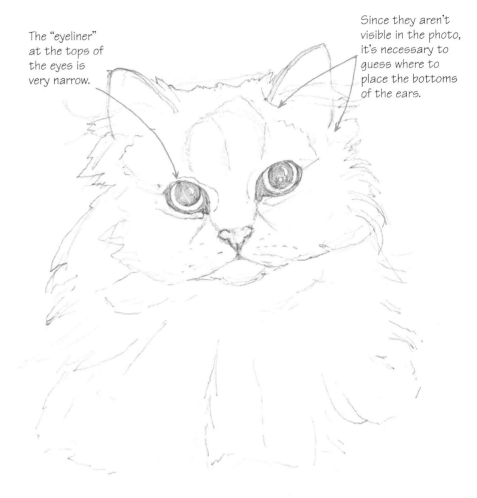

Tip

Using a Watercolor Pencil

Using a watercolor pencil is a tricky technique because water really intensifies the color – practice first on a piece of scrap paper. Start light or you will get too much color. If you need to, you can always add more, but there's no way to remove the color if it's too much.

First Tonal Layer

Spray with fixative.

Adding Color:

Lay down a very light layer of Peacock Blue watercolor pencil, striving for even coverage. Keep the watercolor pencil strokes 1/8" to 1/4" away from the edge of the fur. (This will allow for a soft edge when you brush on water to blend the pencil.)

Adding Water:

When you have laid in all the watercolor pencil, use the round brush loaded with clear water to pull strokes from the background area towards the cat. Work quickly, and be careful not to get too much water on the brush or you'll end up with a puddly mess! Let dry completely.

Eyes:
Draw precise, thin lines all around the eyeballs. Add a dark tone in the areas around the eyes and the pupils, carefully avoiding the highlights. Lightly add tone to the irises, making it very light in the lower center areas.

Nose & Mouth:
The nose is a light tone outlined with a thin dark line. The nostrils are dark. Darken the center of the mouth and draw in the vertical line between the nose and mouth, extending it partway up the nose. Next, darken either side of the line between the nose and mouth, fading away to nothing.

Markings:
With a dull pencil lead and a very light stroke, add the markings, always pulling your strokes in the direction of the fur. The key to making the fur look soft is to use a dull pencil lead and avoid the look of sharp-edged individual lines. Depict the areas of light gray fur on his forehead and the top of the head with very short, light, closely set strokes.

Second Tonal Layer

For the second layer, switch to the 2B pencil.

Features:
Begin by deepening the darks in the eyes, nose, and mouth. Darken the upper parts of the pupils and around the eyes until they are as black as you can get them, but avoid an even dark tone – subtle variations add interest.

Shadows on Eyes:
Dusty's eyelids are very furry and thick, so they cast a shadow on the upper part of the eyeballs. Lightly add these shadows.

Fur:
Add very light, short fur strokes on the face wherever it is not pure white, primarily the forehead and cheeks. As you work, refer to the photograph so you can place additional, subtle markings. Also deepen the insides and backs of the ears.

Shadows on Fur:
Use long smooth strokes to deepen shadows between the clumps of fur and under the chin. Note: The photo shows some matted fur under the right side of the chin – leave this out.

Fix Drawing:
When you are satisfied with your pencil work, spray the piece with fixative.

Adding Color:
Add more **very light** tints with watercolor pencils – Peacock Blue and Copenhagen along the left side and the lower right, the slightest touch of Spring Green on the upper parts of his irises, and very light Terra Cotta on the nose. Dampen these areas carefully.

Finish:
When the watercolor is completely dry, sign and date your drawing. Apply another coat of fixative to preserve it. ❏

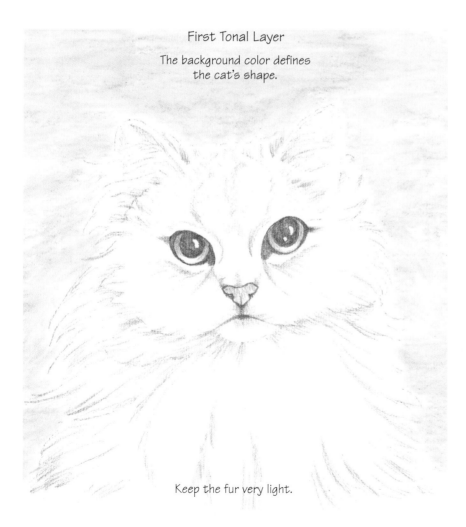

First Tonal Layer

The background color defines
the cat's shape.

Keep the fur very light.

BONNIE
A MAINE COON

Bonnie and her sister, Belle, are lovely Maine Coons that I was fortunate to adopt from a local shelter a few years ago. Not only are they beauties, but they have calm, loving dispositions. Bonnie's fur is the softest I've ever felt – as soft as whipped cream! And here she is in a classic glamour pose. It reminds me of a yearbook photo.

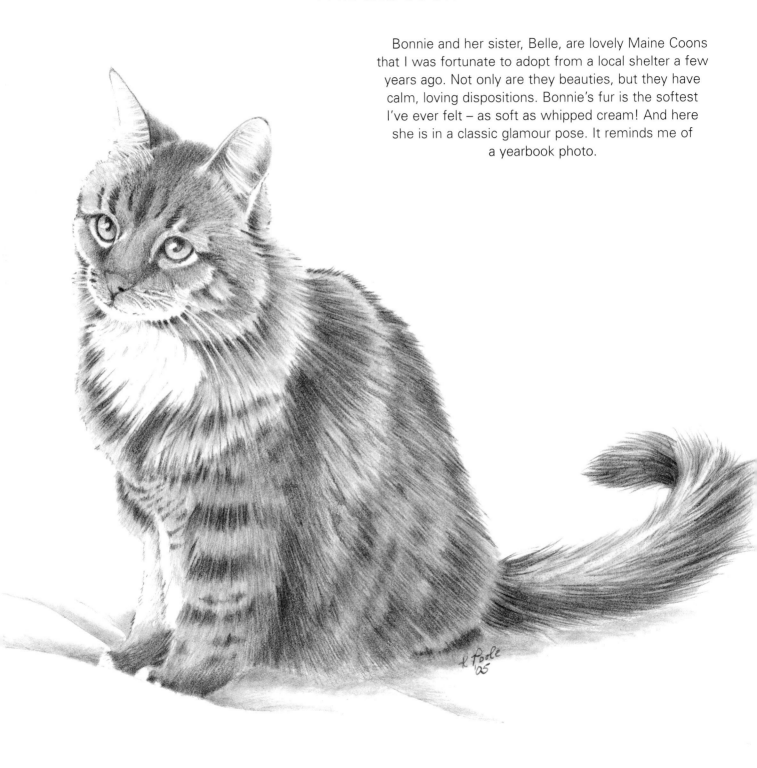

Supplies

- Light ivory acid-free drawing paper
- Near-white acid-free vellum drawing paper
- 5mm mechanical pencil with HB lead
- 5mm mechanical pencil with 2B lead

Observations

In evaluating the photo, I remembered one rule of thumb of composition – the viewer's eye should not be drawn out of the picture. If Bonnie were looking slightly to the right, her eyes (the natural focal point in an animal drawing) would draw us into the picture and thus satisfy this rule of thumb. Since she is looking to the left, her eyes tend to direct us out of the picture. To solve this problem, I placed her as far to the right in my drawing as I could without cropping her tail.

In the following sections, "right" refers to my right, and "left" to my left.

Establishing the Framework

METHODS: BASIC SHAPES, ANCHORS

Head:

Starting with the HB pencil and a sheet of drawing paper, draw the head as a circle. Draw the centerline to help you place the features. Note that the centerline curves to the left because she is facing left. The muzzle is a wide oval with a circle in the center, but the center is to the left because she is facing left. Draw the centerline of the smaller circle to help you place the nose. The tops of the eyes are about halfway down the head. Draw this line to guide you.

Body:

Her body below the head is two-heads tall, and the body to the right of the head is just over one-head wide. Place these marks with a compass, and draw vertical lines down from the center of the head and slightly to the right.

Tail:

The tail is a little less than one-and-one-half-heads wide.

Continued on next page

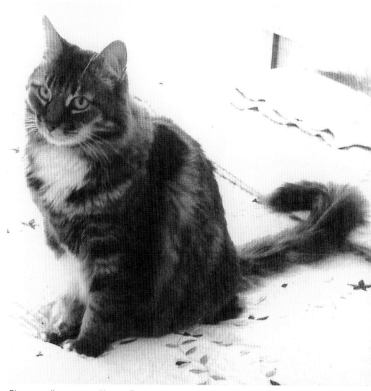

Photo credit: courtesy Kaaren Poole, 2006

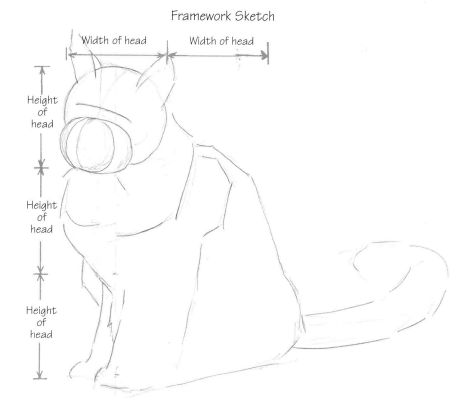

Framework Sketch

Width of head Width of head

Height of head

Height of head

Height of head

Refining the Sketch

As always, refining the sketch is a process of trial and error. The most important thing is placing the eyes, nose, and ears correctly. Begin with the eyes, then place the other features relative to them.

Face:

The centers of the eyes are halfway between the top of the head and the tip of the chin, and they line up along an imaginary line that has the same tilt as the top of the head. The distance between the outside corners of the eyes is half the height of the head. The imaginary line connecting the centers of the eyes is the same as the distance between that line and the bottom of the nose.

As you place the features, constantly check the photograph for vertical and horizontal alignments. For example, the left edge of the nose vertically lines up with the pupil of the left eye.

Body:

Block in the outlines of the body and legs. Once again, look for vertical and horizontal alignments. (For example, the outside corner of the left eye is vertically aligned with the leftmost toe.)

Fur:

Outline the major color areas in the fur.

Transfer Drawing:

Re-check your drawing and, when you're satisfied, transfer it to a sheet of vellum drawing paper for final drawing.

First Tonal Layer

Your objective in the first tonal layer is to begin the facial features and establish the main blocks of tone. You also want to be sure to achieve a very soft look in the fur.

Eyes:

Draw a dark line around the eyeballs, darken the pupils, and add a lighter tone to the irises. Be sure to leave the highlight areas untouched.

Whiskers & Ear Hair:

With the narrow end of a stylus, incise smoothly curving lines for the whiskers and the hairs in the ears.

Nose:

Outline the nose and darken the nostrils. Fill in the nose with a medium light tone.

First Layer of Fur:

Leave the white fur untouched. For the medium and dark fur, use a dull HB pencil and side-by-side strokes. On the face, where the fur is short, place short strokes very close together so that they are virtually indistinguishable from each other. This gives a very even tone with a soft look. Soften it further by rubbing lightly with the blending stump.

Long Fur:

For the long fur on the body, legs, and tail, use longer strokes, allowing some white to show between the strokes here and there. Use varying pressure to achieve relatively darker or lighter tones. Focus on the larger markings – the smaller, more subtle variations come later. Be careful to always run your strokes in the direction the fur grows. When you're finished, smudge with the stump for a smooth, soft look.

Housekeeping:

Erase any graphite that smudged on the background. Because there is so much graphite on this drawing, spray a layer of fixative to prevent smudging while you work the next layer.

Tail:

Work the tail the same way as the body fur, but use the click eraser to remove the highlights before smudging.

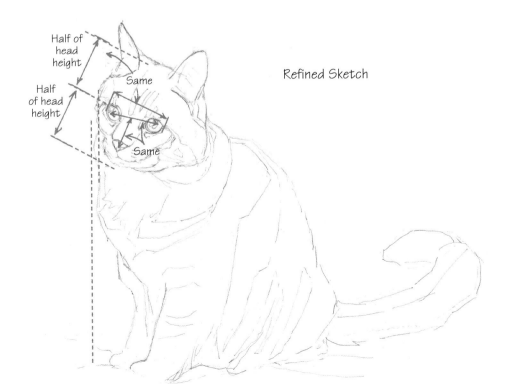

Half of head height

Same

Half of head height

Same

Refined Sketch

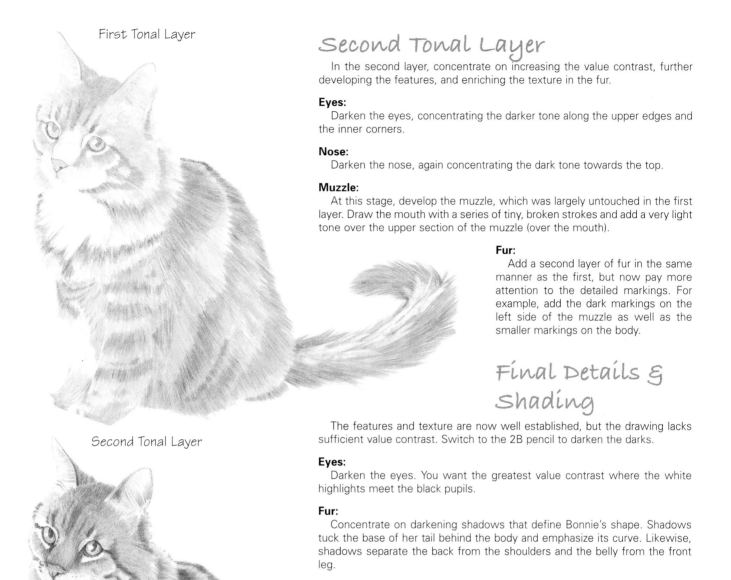

First Tonal Layer

Second Tonal Layer

Second Tonal Layer

In the second layer, concentrate on increasing the value contrast, further developing the features, and enriching the texture in the fur.

Eyes:
Darken the eyes, concentrating the darker tone along the upper edges and the inner corners.

Nose:
Darken the nose, again concentrating the dark tone towards the top.

Muzzle:
At this stage, develop the muzzle, which was largely untouched in the first layer. Draw the mouth with a series of tiny, broken strokes and add a very light tone over the upper section of the muzzle (over the mouth).

Fur:
Add a second layer of fur in the same manner as the first, but now pay more attention to the detailed markings. For example, add the dark markings on the left side of the muzzle as well as the smaller markings on the body.

Final Details & Shading

The features and texture are now well established, but the drawing lacks sufficient value contrast. Switch to the 2B pencil to darken the darks.

Eyes:
Darken the eyes. You want the greatest value contrast where the white highlights meet the black pupils.

Fur:
Concentrate on darkening shadows that define Bonnie's shape. Shadows tuck the base of her tail behind the body and emphasize its curve. Likewise, shadows separate the back from the shoulders and the belly from the front leg.

Shadows:
You need shadows to ground her. Add them under her body and tail. To give the illusion of a soft quilt under the concentrated pressure of her front feet, add shadows to suggest radiating folds. **Note:** I didn't put shadows directly under her front paws because I imagined the quilt puffing up in front of them.

Finish:
Sign and date your work. Spray with a coat of fixative to preserve it.

Postscript:
Imagine a tattered stuffed mouse at Bonnie's feet – adding one would totally change the feel of this portrait. As is, it's elegant, but add the mouse, and it's playful, suggesting a story. What happened just before this moment? What will happen next? ❏

5 Dogs

If I had only two words to describe dogs, I would choose loving and loyal. Dogs are highly socialized pack animals. Their expressive faces and body language serve them well.

Dog breeds vary widely in size and shape, but all dogs share the same anatomy. Their spines run along the neck and back and down into the tail. Both shoulders and knees are high on the body close to the spine. Knees and elbows fall along the lower side. Dogs walk on their toes.

Dogs' eyes are large and round. They move freely in their sockets, and the whites of the eyes often show. A group of muscles just above the inner portion of the eye is similar to the inside corners of our eyebrows. These muscles shape the upper line of the eye to portray a range of emotion.

The eyes are most often a rich medium to deep brown, but sometimes they are lighter brown or even blue. There is a dark ring around the outside edge of the iris. The eyes are often bordered by dark fur, a natural eyeliner. The eyelids, nose, and lips are the color of the skin, which tends to be dark in dogs with brown and dark fur and pinkish in dogs with light fur. But there are exceptions – I have a beautiful white dog with black eyelids, lips, and nose.

A dog's nose is bulbous with prominent nostrils

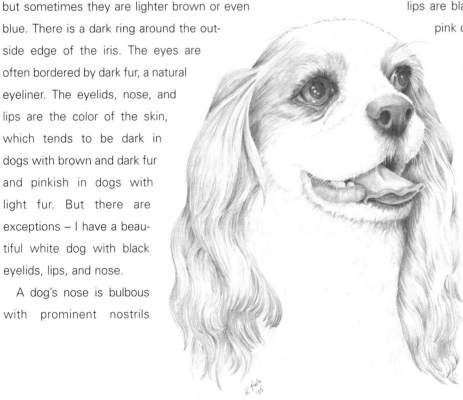

opening to the front. There is a clear vertical crease down its center. The bottom is pointed. The fur around the nose and between the nose and the mouth often appears dark – this can be dark skin showing through short light-color fur or a combination of dark fur and skin.

If you learn the language, you can pretty much understand what a dog is feeling by the position of the ears. The ears attach to the head in a wide semicircle. If they are short enough, they will stand up; otherwise they'll flop over.

Dogs do not perspire – they dissipate body heat through panting. (Panting can also be a sign of stress.) Many photos of dogs, therefore, show the mouth open and the tongue lolling out. If you are drawing a dog with an open mouth, take some time to study the photograph and identify the position of the lips and gums. Even when the lips are black, the skin of the gums may be pink or even pink and black spotted.

The canine teeth (from *canis,* Latin for dog) are the four long sharp teeth at the front sides of the mouth – two upper and two lower. The teeth between the canines are much smaller. Moving back from the canines are the molars, getting progressively larger towards the back of the mouth. The tongue has a distinct indentation along the center.

Dogs Worksheet

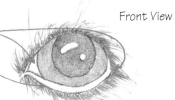

Edge of upper eyelid (skin)

Edge of lower lid (skin)

"Eyeliner" fur is very short.

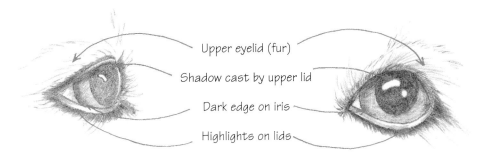

Upper eyelid (fur)

Shadow cast by upper lid

Dark edge on iris

Highlights on lids

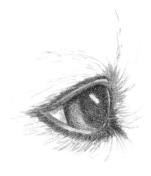

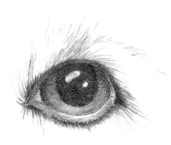

Eye is dark overall, without a
lot of value range (except
highlight in pupil).

Highlights on dark lids are
dark.

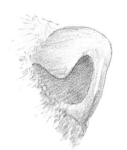

Side view of nose

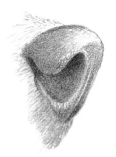

DALY

A PUG/CHIHUAHUA MIX

Linda, my friend and Daly's Chief of Staff, calls her "Mighty Mouse," an accurate description of a tremendous dog wrapped in a tiny package.

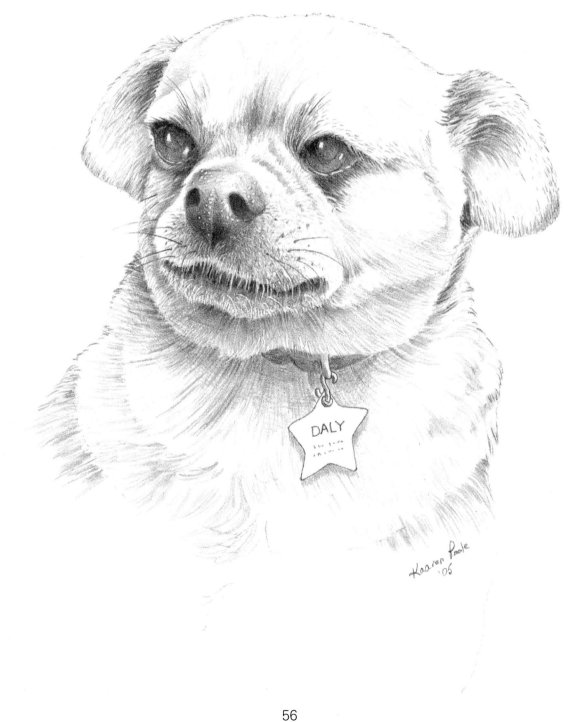

DALY

Supplies

- Light ivory acid-free drawing paper
- Near-white acid-free vellum drawing paper
- 5mm mechanical pencil with HB lead
- 5mm mechanical pencils with 2B lead

Observations

Daly's body is a little on the chunky side, so I thought the most flattering portrait would be a bust. I begin by enlarging the photo.

In the following sections, "right" refers to my right, and "left" to my left.

Establishing the Framework

METHOD: BASIC SHAPES

Head:

Using the HB pencil and a sheet of acid-free drawing paper, block out a rectangle that snugly fits around her head and chest, and then draw a similarly proportioned rectangle on your paper. Loosely sketch her head as a flat oval slightly wider than it is tall. Place a rounded triangle for the muzzle and two circles for the eyeballs. Use the photo and a compass to place them properly. Block in the nose.

Ears:

The ears are simple rounded shapes. Because her head is slightly turned to the left, the right ear appears to stick out more than the left one, and the base of the left ear is hidden behind the side of her face.

Shoulders:

Finally, draw the outlines of her shoulders.

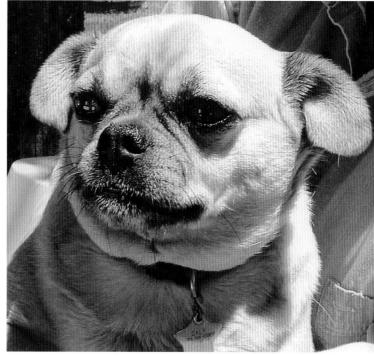

Photo credit: courtesy Kaaren Poole, 2005

Framework Sketch

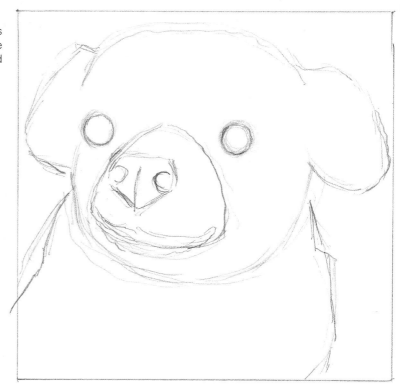

This initial sketch looks sort of goofy, but it also looks like Daly.

Refining the Sketch

As you refine your sketch, use vertical and horizontal alignments to fine-tune the placement of the features. For example, the right corner of her mouth is vertically aligned with the center of the right eye. As usual, the eyes are very dark in the photo and it's hard to see detail.

Eyes:

Draw the outlines of the pupils and irises with her eyes looking the same direction as her head is facing. Study the photo carefully, observing how the upper and lower eyelids curve around the spheres of her eyeballs. The eyelids have a definite thickness. Verify the proportions with a compass: the relative width of the eyes, distance between them, and distance to the edges of the head. Because her head is slightly turned, the portion of the left eye that we see is narrower than the right. Also, the left eye is partially outlined against the side of her head.

Muzzle:

Sketch the fold lines around her muzzle and between her eyes to guide you later, when you texture the fur and place shadows.

Nose:

The shape of the nose is clear from the photo. The centerline is slightly tilted because her nose turns up.

Lips:

Her lips are black so her mouth looks like a very dark area surrounded by highlighted hairs. At this point, just draw the outline of the dark area, being sure to capture the curve at the end. Outline the left edge of the muzzle against the cheek behind it.

Neck:

Since Daly's neck laps over her collar, draw the portion of the collar that is showing, as well as the edge of the lap of her neck. The star tag is charming, so be sure to include it, along with her engraved name and a suggestion of the other writing.

Ears:

The ears are simple shapes. Indicate the edge of the flap of the inner ear. Draw the narrow folds of skin behind and beneath the right ear.

Shoulders:

Option: To include the upper part of her shoulders, continue the drawing beyond the original rectangle and indicate major breaks in the fur on her chest.

Housekeeping:

Carefully check your drawing for proportions. Erase any stray lines. When you're satisfied with your line drawing, transfer it to a sheet of vellum drawing paper.

Refined Sketch

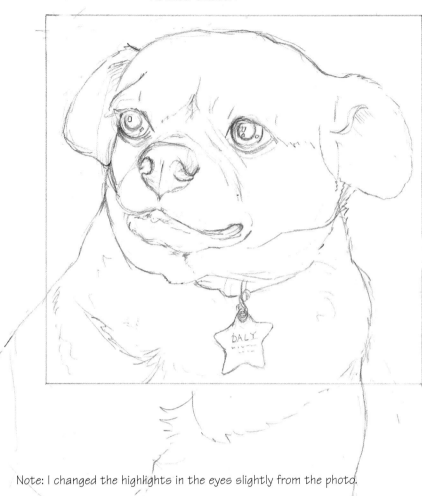

Note: I changed the highlights in the eyes slightly from the photo.

First Tonal Layer

Incisings:

Individual light hairs are an important indicator of form in this photo, especially around her muzzle and mouth, as well as at the flap of the right ear and around the eyes. Use the narrow end of your stylus to incise small, individual hairs in these areas as well as over her ears and in the shadow areas above her eyes. With the thick end of the stylus, press small dots on the upper and right areas of her nose for texture. The incisings will show later as white when you put tone over them.

Eyes:

Begin by carefully outlining the eyeballs and pupils, then add a light tone to the irises and a slightly darker tone to the pupils, but avoid the highlights. Darken around the eyes, leaving the edges of her lower eyelids white to allow for highlights later.

Nose:

Add a dark tone in the nostrils. Leave light highlights around the edges of the nostrils and down the center of the nose. Add a light tone to the rest of the nose that is somewhat darker at the pointed base.

Mouth:

Before working on the mouth, check that you have enough individual hairs incised, then begin darkening the area. The mouth is darkest just beneath the line of the upper lip, then graduates to a lighter tone moving downwards. Leave a large highlight in the center of her lower lip.

Collar:

Draw the collar as a smooth medium tone.

Fur:

Establish the darks and lights by drawing individual lines for the hairs. Guided by the photograph, vary these lines in sharpness (dull or sharp pencil lead), length, direction, and value. Begin with the face and ears then proceed to the chest. Do not incise any hairs on her neck or chest – instead, texture this area by drawing close parallel curved lines for individual hairs, leaving uneven white spaces between them. Begin with the lap of her neck and work downwards – again leaving large highlight areas. The fur on the chest fans out and follows the curve of her shoulder on the left.

Second Tonal Layer

In this layer, increase the value contrast and deepen the textures.

Eyes:

Deepen the tones you added in the first layer, but leave light areas for the secondary highlights. The upper portions of the eyes are darker still because of the shadows cast by the upper lids.

Fur Around Eyes:

Darken the areas around her eyes, paying careful attention to the shapes of these dark areas. The fur around the eyes is dark and the eyes protrude somewhat, creating shadows beneath her eyes.

Nose:

Further darken the nose, especially the nostrils. Deepen the shadows on the front and lower portions of the nose, and darken the left top edge.

Muzzle:

Her muzzle is covered with very short brown hairs and the dark skin shows through. To texture this area, cover it with tiny, irregular splotches. The area between the nose and mouth is darker, so draw it with a smoother tone.

The First Tonal Layer

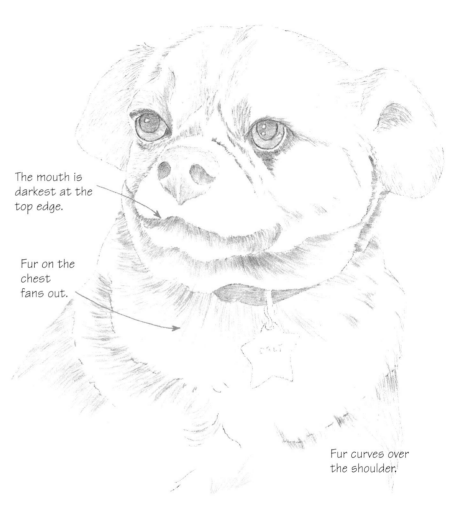

The mouth is darkest at the top edge.

Fur on the chest fans out.

Fur curves over the shoulder.

Mouth:

The mouth needs to be darker. Add a second layer of tone, again graduating it from dark at the upper edge to light at the bottom.

Fur:

Add another layer of fur texture, varying the pressure on your pencil to darken the folds around her muzzle and between her eyes. Add shadows in her ears, to the right of her mouth, and behind the protrusion of the left eye. As before, leave large highlight areas on the top of her head, the top of her muzzle, and between the folds around the muzzle.

As you work the chest and shoulders, intensify the shadows beneath the folds of fur. In this stage, work most of the chest and shoulders areas, limiting the white highlights to the right side of the chest and body.

Collar & Tag:

Deepen the collar, and outline the tag and hook.

Continued on next page

Shading & Final Details

See completed drawing on page 56

The Second Tonal Layer

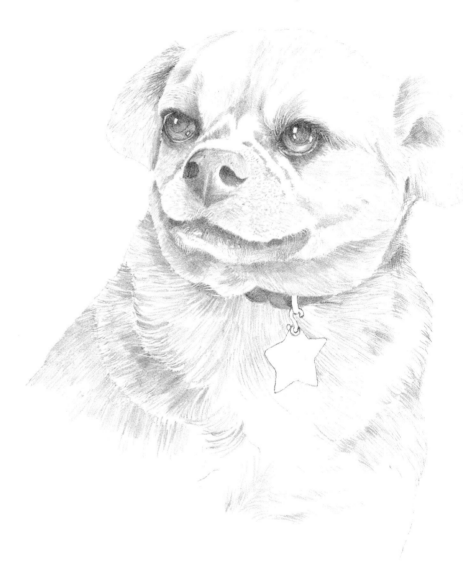

For this final layer, deepen the dark areas and add more detail to the midtone areas. (Detail tends to be washed out in the highlight areas.)

Eyes:

Darken the eyes until the distinction between the pupils and irises is very faint. Break up the highlights along the edges of the lower eyelids by darkening portions, leaving broken, uneven highlight lines.

Face Fur:

Draw dark, individual hairs to darken the area around her eyes, the folds between her eyes, and her muzzle. Draw small hairs over her ears and the right side of her face behind the muzzle. Use these lines and their placement to darken shadow areas and the lower edges of her ear. **Note:** In the photo, there are no shadows at the lower edges of the ears, but adding them helps separate the ears from the background.

Nose:

Darken the nostrils, as well as the lower V-shape of the nose.

Observations:

Compared to the photo, I have left the upper edge of her nose too light, but I like it this way. Sometimes exaggerating the darkness of shadows or the lightness of highlights works well to add drama. In general, as I build up my darks, I am evaluating both how my drawing compares to the photo but also the drawing on its own merit. In drawing, our only tools are line and value, and we must use them, especially value, well.

Muzzle & Mouth:

As you darken the muzzle and mouth, leave a light bottom edge on both the upper and lower lips. The lower edge should be slightly darker than the upper one because it is in shadow.

Neck & Chest:

Add another layer of texture on Daly's neck and chest. Deepen the shadows in this area.

Tag:

Add a small shadow behind her tag, and put the writing on the tag.

Final Touches:

Add spots on her muzzle at the base of the whiskers, and then draw the whiskers themselves, using the sharpest edge of your pencil lead. **Note:** I have more spots than whiskers. Too many whiskers or whiskers that are too thick can be distracting.

Finish:

Sign and date the drawing, then spray with a coat of fixative to protect it. ❏

JAKE

A KING CHARLES SPANIEL

I met Jake at the groomer, and his owner was kind enough to let me take his picture. Jake's ears are magnificent, especially just after his grooming appointment!

Instructions begin on page 62

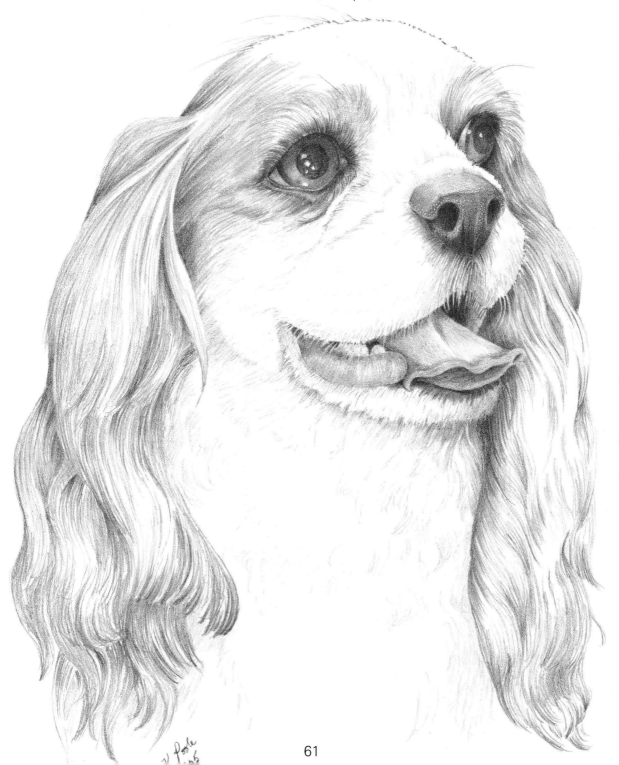

Supplies

- Light ivory acid-free drawing paper
- Near-white acid-free vellum drawing paper
- 5mm mechanical pencil with HB lead
- 5mm mechanical pencil with 2B lead

Observations

Unfortunately, my photograph is slightly out of focus, but I will be able to work from it. His open mouth will be a challenge, but it adds to his expression of joy and enthusiasm. As I studied the photograph looking for a place to start, the circle of Jake's face jumped out at me.

In the following sections, "right" refers to my right, and "left" to my left.

Establishing the Framework

METHOD: BASIC SHAPES

Head & Muzzle:

Using the HB pencil and a sheet of acid-free drawing paper, draw a large circle for the head, then a rounded shape for the muzzle. Jake is looking up, so the nose is high on the head – nearly at the same level as the eyes. Block in the nose first, placing it as best you can.

Eyes:

Draw a line for the center of his head up and back from the top center of the nose. The shape of this line mimics Jake's profile – flat along the snout, angled upwards between the eyes, and curving gently over the forehead. Draw a line at the level of the eyes, curving it slightly. (It's easier to begin with this line rather than trying to place the eyes individually.) As you place the eyes along this line, notice that the right eye is directly above the nose, and the left eye is about an eye's width from the nose.

Mouth:

Block in the shape of the open mouth, a line for the chin, and the basic shape of the tongue.

Ears:

Sketch the outlines of the ears.

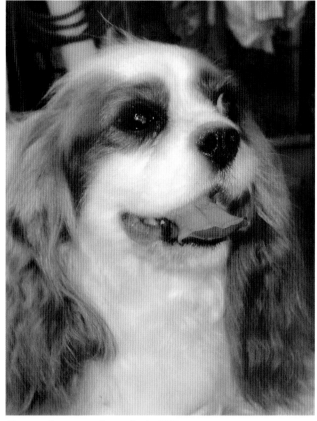

Photo credit: courtesy Kaaren Poole, 2005

Framework Sketch

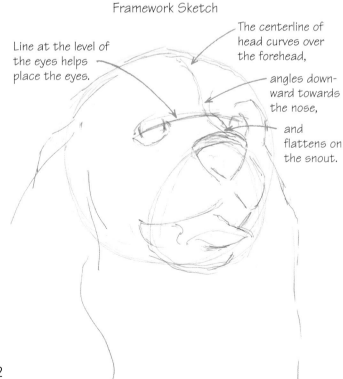

Line at the level of the eyes helps place the eyes.

The centerline of head curves over the forehead,

angles downward towards the nose,

and flattens on the snout.

Refining the Sketch

Nose:

The position of the nose is critical because it is a prominent visual clue to the fact that Jake is looking up. Use your compass to see that the point at the bottom of the nose is vertically aligned with the edge of the chin. When you draw this line, you'll also see that the point of the nose is halfway between the edge of the chin and the point where that line cuts the top of the head. The top of the nose is not flat, but gently rounded; the bottom is a sharp point, and the left edge is a gentle inverted curve. The vertical centerline of the front of the nose is angled slightly.

Eyes:

First, place them accurately relative to the nose. The eyes are very dark and show little detail, but draw both the pupils and the irises. There are several highlights in the left eye. They add sparkle to Jake's face. Draw them so you won't forget them later. The "whites" of dogs' eyes often show, and in this case you see a sliver of white on the left edge of the right eye, and a tiny triangle of the white (it's actually a light brown) on the left edge of the left eye. This shows that Jake is looking slightly to the right.

The edges of the irises are very round. The eyelids curve over the round eyeballs, ending in points at both corners. The bottom lid of the left eye curves down from the left corner, then about halfway across, curves upwards then levels off into the right corner. This gives a smiling look that's important to preserve.

Mouth & Tongue:

The open mouth and tongue are tricky. To begin, check the photo with your compass to see that the distance from the top of the nose to the tip of the "V" in the upper lip is the same as the distance from the tip of the "V" to the bottom of the lower lip. The width of the chin is the same as the distance between the bottom of the nose and the "V" in the upper lip. The left corner of the mouth is vertically aligned with the outer corner of the left eye. Using these guidelines, work (and re-work) the mouth until you are satisfied.

For the tongue, begin with the bottom curve, placing it by noticing vertical alignments. (The left edge of this curve is even with the left edge of nose; the right edge is a little farther to the right than the right edge of the nose.) From there, draw the three lines representing the left and right edges and the center crease. Finally, draw the outline of the ridge at the tongue's tip.

Fur Outlines:

Carefully sketch the outline of the brown and white areas in Jake's coat.

Ears:

The luxurious fur on Jake's ears falls in gentle curves. They may be characteristic of Jake as an individual – try to represent them faithfully.

Transfer Drawing:

Transfer your drawing to a sheet of vellum drawing paper for final drawing.

continued on next page

Refined Sketch

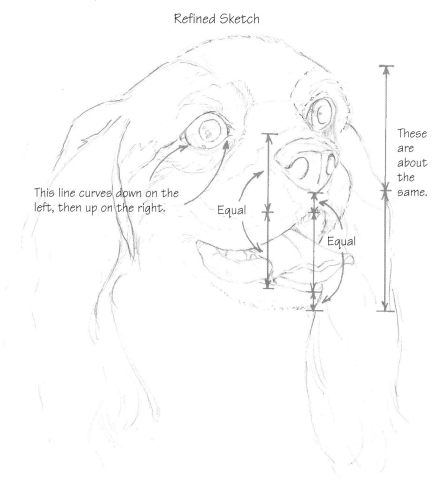

This line curves down on the left, then up on the right.

Equal

Equal

These are about the same.

First Tonal Layer

As Jake's features will take more work than his fur, we'll concentrate on the features in this first layer. At this stage, even the dark tones are pretty light. They are enough to establish the shapes, but still give us plenty of room later to adjust the values.

Eyes:

Carefully outline them, then fill in the pupils with a medium tone and the irises with a lighter tone, working around the highlights. The "white" in the right eye is very light so leave it untouched for now, but add a light tone to the little triangle of white in the left eye because it is darker.

Fur Around Eyes:

Begin the dark fur around the eyes by drawing individual fur lines the length and direction the fur is growing.

Incising and Nose:

Incise tiny dots in the highlight areas of the nose by pressing with the tip of your stylus. Guided by the photograph, incise many light hairs and whiskers around the mouth. These will show as white when you add tone later. Add a medium value to the front of the nose. Darken the nostrils

Mouth & Tongue:

The goal for the mouth and tongue is to establish value differences by laying in areas of smooth tone. You will fine-tune these values later, but for now apply medium tones to the underside of the tongue, the upper area of the open mouth just below the upper lip, the shadow on the fur to the right of the mouth and tongue, and the narrow shadow under the chin. The darkest tone is the black portion of the lower lip. The top of the tongue and the gum are the lightest – carefully leave highlights in each.

Second Tonal Layer

In this layer, we begin to detail the features and work on the fur. Jake's fur is medium length on his face, longer on his chest, and quite long on his ears.

The First Tonal Layer

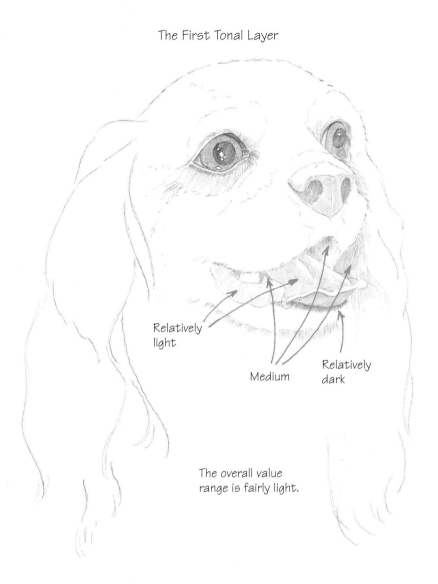

Relatively light

Medium

Relatively dark

The overall value range is fairly light.

Brown Fur:

Work in the direction the fur grows, and match the length and sharpness of your strokes to the varying texture areas. For example, the fur on the left temple between the eye and ear is very soft, so use a dull lead and lay your strokes very close together. The individual hairs on the ears are rather distinct, so use a sharper lead and leave space between them so the individual strokes are more apparent.

Shadows:

Apply more pressure to get a darker tone in the shadow areas. The main shadows are on the right ear behind the face and on the face under the left ear. Even though the ears are solidly brown, leave plenty of highlight areas that will help you shape the curls later.

Eyes:
Deepen the upper portion of the eyes to indicate the shadows cast by the upper eyelids. Also deepen the outside edges of the irises.

Fur Around Eyes:
The dark fur around Jake's eyes makes them seem even larger, so work this fur carefully, deepening it and adding texture. It's important to be accurate with all the subtle changes in direction of the fur in this area.

Nose:
Deepen the nostrils, especially the upper areas that are in the deepest shadow. Add a light tone over the top, deepening it slightly over the curve at the side. Also deepen the forward face of the nose, especially at the base and in the center crease. The fur immediately around the nose is short and the dark skin shows through. As you deepen this area, leave some highlight white hairs.

Shadows:
Shadows in the deep part of the mouth and on the tongue begin to define these shapes.

Shading & Final Details

See completed drawing on page 61

Now that you have the features and texture of the fur established, you need to increase the value contrast to bring this drawing alive. To do that, switch to the 2B pencil.

Eyes:
Darken the eyes until the highlights jump out, but be careful to leave a secondary highlight.

Nose & Mouth:
Work on the nose and mouth, deepening the tones to the point that the darkest darks in the nose and mouth are as dark as the pupils. (The dots you incised on the nose really show now.) As you deepen the tones in the mouth, also add shadows and leave highlights to form the various shapes. The shadow in the depth of the open mouth, just below the upper lip, is critical for the mouth to look convincing. As you work it, the hairs you incised on the upper lip begin to show.

The Second Tonal Layer

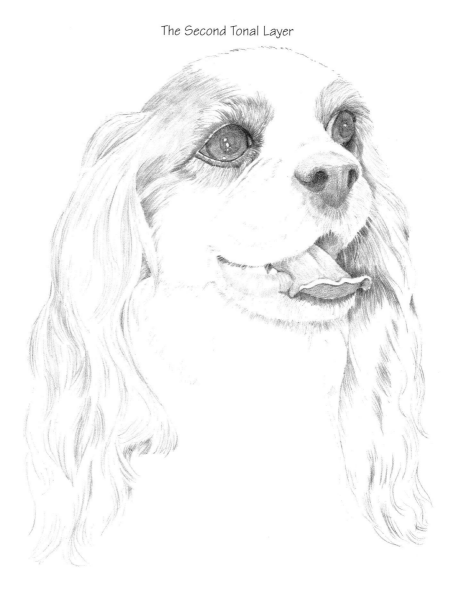

Brown Fur:
To finish the brown fur, add many more individual texture lines, then go back over it and add light even tones over all but the highlight areas to darken it further.

White Fur:
Using the photo as a guide, lightly add texture to the white fur in the shadow areas. To differentiate the head from the background, outline the top of the head with small, broken lines, then add a few light fly-away hairs.

Finish:
Sign and date your work. Protect it with a coat of fixative. ❏

LUCY

A BROWN & WHITE DOG

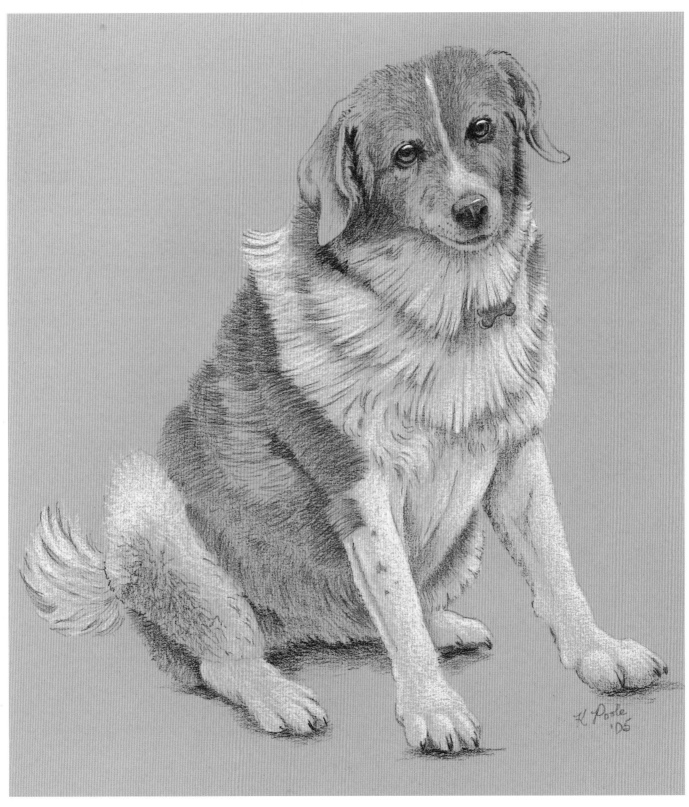

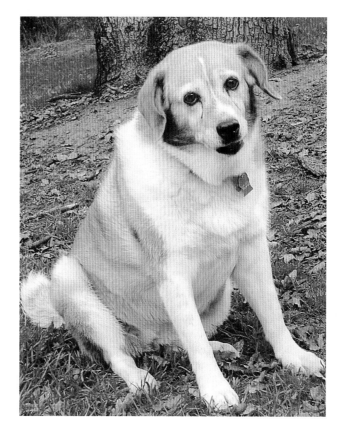

Photo credit: courtesy Kaaren Poole, 2005

Supplies

- Light ivory acid-free drawing paper
- Lightly textured drawing paper – Antique Camel Brown
- 5mm mechanical pencil with HB lead
- 5mm mechanical pencil with 2B lead
- White chalk pencil
- Compass

Observations

To bring out her gleaming white fur, I decide to do my drawing in graphite and white chalk on a camel-colored background. I intend to make a few changes from the photograph. Her mouth will be more attractive closed. Also, I will omit the fire-hydrant tag and emphasize the bone-shaped one instead.

In the following sections, "right" refers to my right, and "left" to my left.

Establishing the Framework
METHODS: BASIC SHAPES, ANCHORS

Seeing the Shape:

In this pose, Lucy is basically a triangle. Use your compass to discover that this triangle is more than three head-heights tall and more than three head-widths wide. Her head is just slightly taller than it is wide. If you imagine a vertical line from the top of her head to her forward paw, you'll find that her right-most paw is about one head-width to the right of this centerline.

Drawing:

Arbitrarily choose a size for the head height. Beginning with the HB pencil and a sheet of acid-free drawing paper, draw a vertical line to represent the line from the top of her head to her forward paw and use the compass to mark off more than three head-heights. Narrow the compass slightly (because her head is slightly narrower than it is tall) and mark one head width to the right of the line and two head widths to the left.

Use these marks to rough in the basic shapes, paying attention to vertical and horizontal alignments.

Placing the Features:

Draw a line down the center of her head. Because her head is turned ever so slightly to the right, this centerline is slightly to the right, making the left side of the face slightly wider than the right side. Notice that the pupils are a little higher than the vertical center of the face, and draw a line at that level for the eyes. This line is parallel to the lines at the top of the head and the chin, and all the lines reflect the tilt of Lucy's head. To place the pupils, notice that the left one appears to be halfway between the centerline and the left side of the face, and the right one is the same distance from the centerline as the left one.

Continued on next page

Framework Sketch

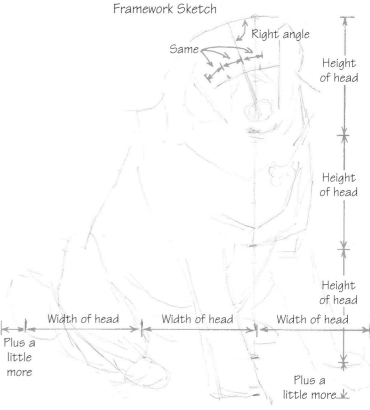

Right angle

Same

Height of head

Height of head

Height of head

Width of head | Width of head | Width of head

Plus a little more

Plus a little more

Refining the Sketch

Eyes:

Draw the pupils as small circles, then draw the outlines of the eyes and the "eyeliner." Note that the eyes are slightly pointed at the outside corners, and their shapes are slightly different from each other. Follow the photograph as accurately as you can – her eyes are her most important feature.

Nose:

The nose is pretty big – about twice the width of the eyes.

Mouth:

The only difference between a closed mouth and an open one is the lower jaw. Use my drawing as a guide for drawing the closed mouth.

Ears:

The flippy curves of the ears contribute significantly to Lucy's perky look. Pay careful attention to how the ears align relative to her features so as not to get them either too long or too short.

Markings:

Sketch in the markings on her face. Lucy's coat has several

Refined Sketch

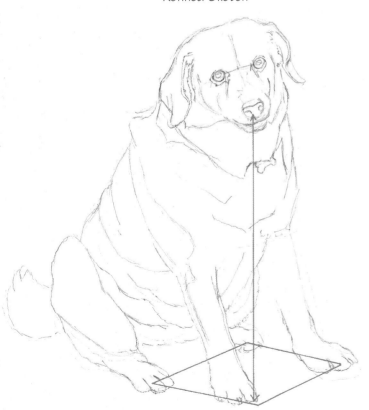

divisions in addition to the brown versus the white fur. Within both the brown and white sections are various breaks where the fur lies in "rolls" and appears to change direction. Sketch these lines to help you detail the fur later on.

Legs & Feet:

Draw the legs and feet, observing their vertical alignment with her features and the rest of her body. For example, the center of her nose is directly over the front edge of her forward paw, and the four paws form a diamond on the ground.

Transfer Drawing:

Transfer the completed line drawing to a sheet of antique camel brown drawing paper.

First Tonal Layer

Eyes:

Darken the pupils and lay in a light tone over the rest of the eyes, avoiding the highlights. Darken the "eyeliner" but leave a narrow highlight on the inner edges of her lower eyelids.

Nose:

The nose is a medium tone with dark nostrils. Leave the upper edge light, and leave a vertical highlight just to the left of the crease in the center of her nose.

Mouth:

Draw the mouth with a series of tiny vertical lines representing fur texture. Darken the area beneath her nose in the same manner.

Brown Fur:

Draw her brown fur with the HB pencil, varying the length, darkness, and direction of your strokes to mimic the fur growth in the photograph. Use short strokes on her head, very short strokes on her ears, and long strokes on her sides. Draw your strokes dark and close together in the deep shadow areas around her face and ears.

White Fur:

Switch to the white chalk pencil and draw the white fur, likewise varying the length, direction, and lightness of the strokes, using the photo as a guide. Note that when you press hard with the white pencil, you get a white stroke; when you lessen the pressure the pencil lays down less color, more of the paper shows through, and the stroke appears darker.

First Tonal Layer

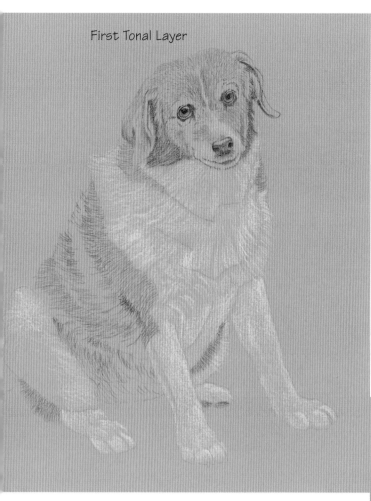

Final Shading & Details

At this point, you have enough texture but need to continue to build tone and deepen shadows. When the drawing is complete, very little of the brown paper should show through.

Brown Fur & Shadows on White Fur:
Work with the 2B pencil to deepen tones and shadows.

Shadows:
Ground Lucy by drawing shadows underneath her body and paws, using horizontal strokes to draw the shadows.

Face:
Deepen the darkest portions of her eyes and nose.

Highlights:
Use the white chalk pencil to brighten the brightest highlights on the white fur. Add tiny white highlights in her eyes and on the top of her nose.

Finish:
Sign and date your drawing. Spray it with a coat of fixative to protect it. ❏

Second Tonal Layer

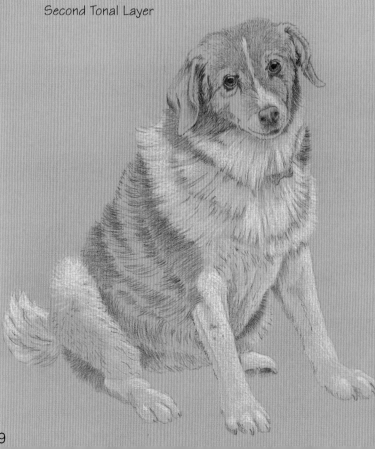

Second Tonal Layer

Face:
Using the HB pencil, darken the darks in the eyes, nose, and mouth.

Brown Fur:
Deepen the texture and tone by adding another layer of individual fur strokes. Then add an even, medium tone over the darkest areas around her face and on the rolls on her side.

White Fur:
Using the white chalk pencil, brighten the lightest fur.

Shadows:
Switch back to the HB pencil and draw individual strokes over the shadow areas in the white fur.

Details:
Outline her claws, and add a few spots on her front leg.

BRUNO
A KUVASZ

Bruno was our miracle dog. She came into our lives one dark and stormy night by simply walking in the front door, which had blown open during the storm. I discovered her curled up on the sofa when I got up in the middle of the night for a drink of water. She was with us for 11 wonderful years.

A Kuvasz is a Hungarian sheepdog breed similar in appearance to a Great Pyrenees, but always pure white. True to her sheepdog heritage, she was great with people (whom she must have considered the sheep), but a terror with strange dogs (the wolves).

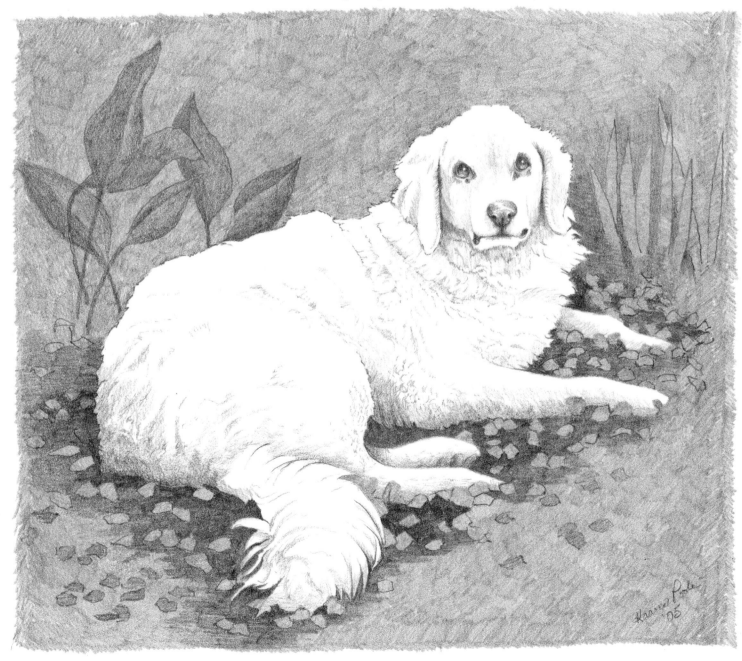

Observations

I wanted to draw Bruno not just because of my personal attachment, but also because drawing a pure white animal is challenging and rewarding. You cannot rely on markings to convey a likeness, and much of the actual drawing is in the background. A relatively simple treatment is usually the most effective.

In the following sections, "right" refers to my right, and "left" to my left.

Establishing the Framework

METHOD: BASIC SHAPES

Seeing the Shapes:

Begin by photocopying and enlarging the photo. To avoid being distracted by the background, identify the rectangle that fits snugly around her. Her body can be broken down into a few simple shapes: an egg shape for her head, another larger egg shape for her shoulders and chest, a doughnut around her middle, and an oval for her lower back and hips.

Drawing the Shapes:

Using an HB pencil and a sheet of acid-free drawing paper, draw these shapes and work with them until you are satisfied with the proportions.

Proportions & Alignments:

Using a compass, notice that the height of her head is equal to the distance from her chin to the middle of her forward leg. Also, the length of her body behind her head is about twice as long as the width of her head in the widest part from ear to ear.

Loosely block in a rough outline using the simple shapes as guides.

Photo credit: courtesy Kaaren Poole, 1997

Framework Sketch

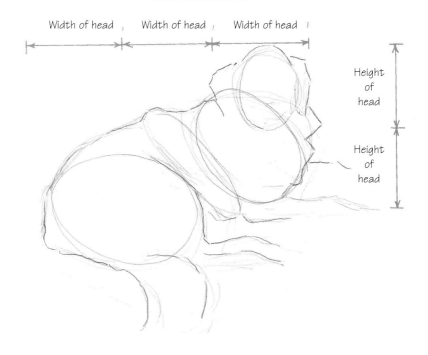

Width of head Width of head Width of head

Height of head

Height of head

Refining the Sketch

Head:
Draw the outline of her head, making sure it is long enough. The eyes appear as dark triangles, with rounded lines defining the edges of the eyeballs. Sketch in the eyes and the shape of the nose, then use a compass to be sure they are positioned properly. The distance from the top of the head down to the middle of the eyes is the same as the distance from the middle of the eyes down to the bottom of the nose. The tops of the eyes and the top of the nose form an equilateral triangle. The distance from the bottom of the nose to the bottom of the chin is a little smaller than the height of the nose. Notice also that there is a slight tilt to the head which makes the right eye appear higher than the left. The mouth is an interesting shape, with her dark lips sagging in the corners of her mouth.

Ears:
The forward edge of her ears clearly shows their thickness. The fur is fine and curves tightly around the edges.

Legs:
Because of the plants covering the ground, you only see the top edges of her legs, but their shape is important as this is what suggests the position of the wrists. Notice that her far rear leg is tucked under her and that the foot twists slightly towards the viewer so a few of the pads on her toes show.

Refined Sketch

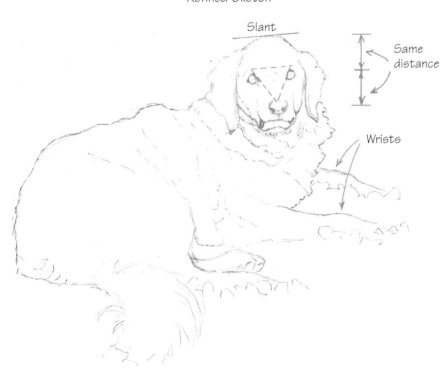

Slant

Same distance

Wrists

Tail:
The thick tail has very long hair and lies in a luxurious curve.

Fur:
The texture of her fur varies from place to place. Under her chin, under her elbow, and along her upper side, medium length fur clumps in slight curls. The fur on her back and haunch is longer and just barely wavy. Draw just a few lines to indicate the boundaries of the rows of curls.

Ground:
Rough in the random leaf shapes to cover the lower portions of her legs.

Transfer Drawing:
Transfer the line drawing to a sheet of vellum drawing paper for final drawing.

First Tonal Layer

Background:
Draw a medium gray tone all around Bruno, making the area as even as possible. (The toned background establishes the dog's white shape.) Be careful to keep a paper towel beneath your hand as you draw because the graphite will smudge badly. When you are finished, spray the drawing with a coat of fixative before proceeding.

Face:
Work the dark areas of her eyes, nose, and mouth in a medium tone, carefully avoiding the highlights in her eyes and on the top of her nose. In the photo, both the eyes and nose appear to be nearly solid black, but use a wider variety of tone to depict detail in these areas.

Eyes:
Work carefully around the highlight. The upper portion of the eye is darker than the lower portion where the secondary highlight is. The overall shape of the eyes is somewhat triangular and the eyelids are very dark. By varying the pressure on the pencil, you can achieve a variety of shades of gray.

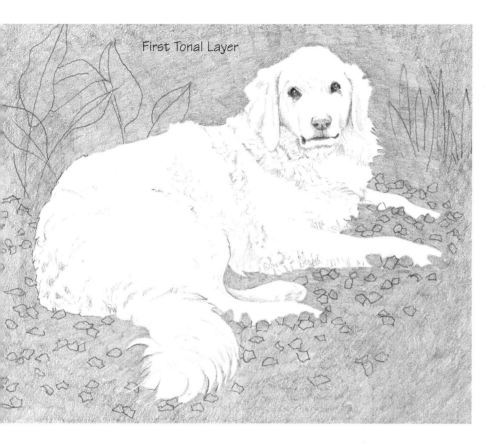

First Tonal Layer

Final Layer

See completed drawing on page 70

Background:

Begin with the background, adding depth and detail. The background to the sides of and beneath the dog is very dark. Deepen it, but work around the leaves. Place the darkest areas closest to Bruno. Outside of the darkest areas, instead of deepening the area around them, deepen the leaf shapes. This makes an interesting transition from the darker to the lighter areas of the background. Deepen the background between the iris leaves on the right, and darken the calla lily leaves on the left.

Face:

As in the first layer, first concentrate on Bruno's face, deepening and detailing the eyes, nose, and mouth – but be careful to leave highlights.

Face Shadows:

Draw tiny lines to build up light shadows between her eyes and at the lower sides of her mouth. (These shadows make her muzzle appear to move forward.) The shadows between the ears and the head and underneath the ears are very dark. Build them up slowly to avoid overdoing it. Add light shadows to form the gentle folds in her ears.

Fur:

Add more texture lines to her fur. Then shade the larger areas of clumps of fur such as the rolls of curls on her neck and sides. To ground her, shade along all the bottom edges – the bottoms of her haunch, tail, and legs. Notice there are large areas of her fur that are left completely blank. Detail tends to fade out in brightly highlighted areas.

Finish:

Sign and date your drawing, then spray it with a coat of fixative to protect it. ❑

Nostrils:

The nostrils are the darkest part of the nose. The top is lighter than the front because light falls on it. Leave small highlights along the upper edges of the nostrils. Indicate the indentation down the center front of the nose with a darker area.

Mouth:

The mouth is dark. The fur between the nose and mouth and around the mouth is also dark.

Fur:

Bruno's fur is white, and the only way to draw it is by drawing the shadows, which indicate both the dog's form and the texture of her fur. Indicate the form of her head with light shadows between the ears and head. For the fur texture, concentrate on the curly areas under her chin, on her neck, around her body just behind her front legs, and on the bottom portion of her front leg. Closely following the photo, draw small curved lines suggesting the shadows between clumps of fur. Notice that they vary in length and degree of curl. Finally, draw shadow lines on the rump and tail. The lines on the rump are only slightly curly, and on the tail they are very gently curved.

Foliage:

Draw the outlines of individual leaves in the ground cover and taller plants in the background.

6 Horses

Horses and humans have shared 6,000 years of history. Different cultures have relied on horses for transportation, drayage, sport, companionship, and food, as well as clothing and shelter fashioned from their hides. The result is today's wide range of breeds suited for varying environments and uses. Two models in this chapter are Quarter Horses, and the third is an American Paint. If you are interested in specializing in horses, there are many books available that can help you understand anatomy, conformation, and the characteristics of the breeds.

Horses have highly developed senses of hearing and sight. A horse can rotate his ears from facing fully front to facing directly to the rear, and he can rotate them independently of each other. A horse's ears are pointed and upright. They attach to the head in a nearly complete circle. Depending on direction and stiffness, they give clear messages about the animal's point of attention and state of mind. Riders are finely tuned to horses' ears.

The eyes, which are set on the side of the head to give a wide lateral view, can also be rotated independently. A grazing horse has 360-degree vision without having to lift its head! Horses' eyes are large, expressive, and set high on the head. The irises are usually dark brown,

although sometimes Paint horses have blue eyes. The whites sometimes show, depending on the direction of the gaze.

To increase stamina, the large nostrils face forward, providing the animal with the maximum amount of air when running.

The massive lower jaw is hinged to the skull at a very high point – close to the base of the ears. The cheek muscle is large and powerful.

Horses are strong and muscular. Their short coats show off their surface muscular structure. Sometimes the legs seem impossibly slender to support the massive bodies, but the legs are all muscle and heavy bone.

Horses have hooves that are essentially fused toes. Otherwise, a horse's anatomy corresponds to that of the other mammals in this book. The shoulders and hips are high on the body, with the elbows and knees at the level of the belly. The feet are quite elongated. The rear-pointing joint on the back leg is actually the "heel" and the forward-pointing joint on the front leg is actually the "wrist."

Manes and tails, in most breeds, are long and flowing. Humans often trim and sculpt them for appearance or utility.

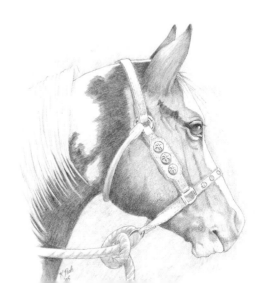

Horses Worksheet

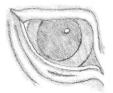 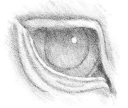 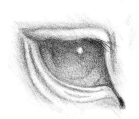

Horses' eyes are large and expressive. When the head is in a forward relaxed position, the upper lid is nearly horizontal. There are many folds around the eye that allow a wide range of motion.

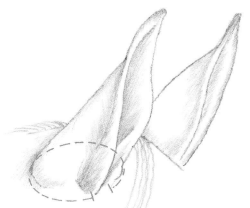 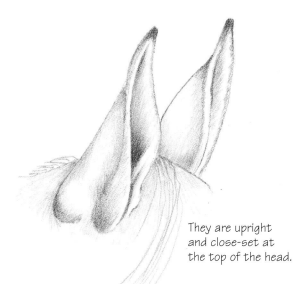

A horse's ears attach to the head in a near circle.

They are upright and close-set at the top of the head.

Spots on the short coats of horses have a mid-tone "halo" around the spot where the two colors overlap,

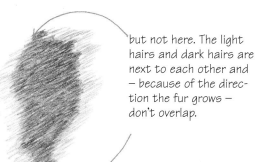

but not here. The light hairs and dark hairs are next to each other and — because of the direction the fur grows — don't overlap.

LE JEUNE FILLE

A YOUNG GIRL

I used to pass this horse pasture every day on my way to work, and when the foals began arriving in the spring it was a real treat. Usually the moms were careful to stand between their foals and the fence, but one special day this little girl was unattended and I snapped her picture.

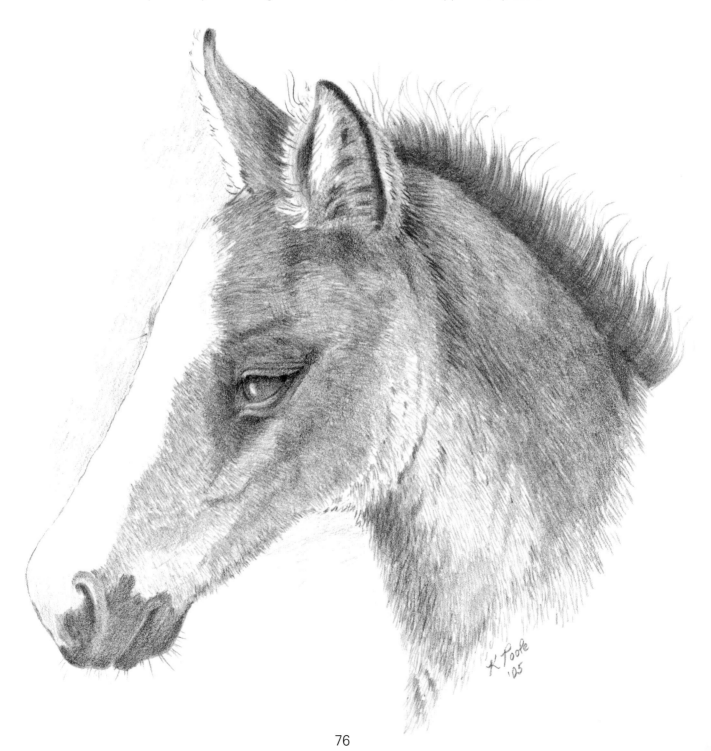

K. Poole
'05

Observations

To me, foals are special because they combine the elegance of adult horses with sweetness and innocence. And their fuzzy coats, soft curly manes, and stubby little tails are just plain cute.

In the following sections, "right" refers to my right, and "left" to my left.

Establishing the Framework

With subjects like this one that don't have easily recognized basic shapes (like circles or ovals) and where the proportions are complicated ("one-half of this" or "one and one-third of that"), there are two options for simplifying the task of establishing the framework:

Option #1 – Use a base line as an anchor (as detailed below) but enlarge the photo to the same size you want your finished drawing to be and use actual measurements rather than proportional relationships.

Option #2: – Working with the HB pencil, draw a grid on a sheet of acid-free drawing paper.

METHOD: ANCHORS

First Line:
The foal's head and neck are simple shapes. Notice that a straight line runs from the base of the right ear, along the bottom of the eye, and to the bottom of the nostril. Start with this line.

Proportions:
Use a compass to look for proportions in the photo. See that the distance from the middle of the eye to the tip of the nose is about one and one-third times longer than the distance from the middle of the eye to the back of the neck. Mark the line where you want the eye to be, then mark it again where you want the back of the neck. Finally, place a mark for the tip of the nose, preserving the ratio (one and one-third times the distance between the eye mark and the back of the neck mark).

Second Line:
Draw a line at the tip of the nose at right angles to the base line. See that the width of the nose at this point is half the distance from the middle of the eye to the back of the neck. This is also the length of the ears.

Drawing:
Using these proportional relationships and lines, draw the outlines of the main shapes. Observing the negative space between the lower edge of the face and the front edge of the neck helps place the neck.

Continued on next page

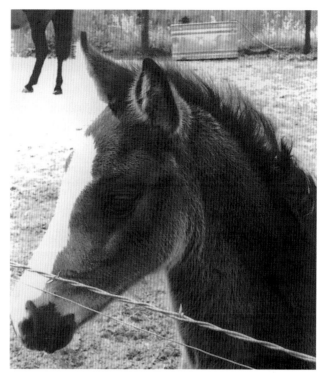

Photo credit: courtesy Kaaren Poole, 1998

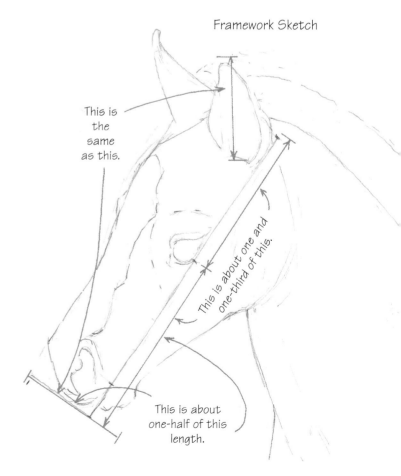

Framework Sketch

This is the same as this.

This is about one and one-third of this.

This is about one-half of this length.

Refining the Sketch

Observations:

My initial drawing has a sweet look, but something just isn't right. The foal's face looks longer in the photo. I discover two problems. First, the mark at the top of the base line was supposed to be the back of the neck. Instead, I have drawn the back of the neck beyond this point. Also, I see that the nose is too short. After correcting these two problems, it looks a lot better.

Eye:

There are three creases above the eye and two below. The upper lid is nearly horizontal, and the front curve of the eyeball is aligned nearly vertically. The bottom lid is quite rounded. The upper and lower lids meet at the back in a point.

Ears:

We see the left ear in profile. It has a thick rim which shows at the tip. The other ear is facing the viewer, but at a slight angle so we also see a portion of the back of the ear. Indicate the fuzziness around the edges of the ear, and also the shape of the light portion within.

Nose:

The nostril has a fleshy, curved rim and opens to the front. The mouth pretty much aligns with the base line.

Outlines:

Carefully draw the front edge of the face – try to portray the subtle curves in the photo. Lightly sketch the outline of the blaze as well as outlines of particularly light or dark patches of fur.

Transfer Drawing:

Carefully transfer your drawing to a sheet of vellum drawing paper for final drawing.

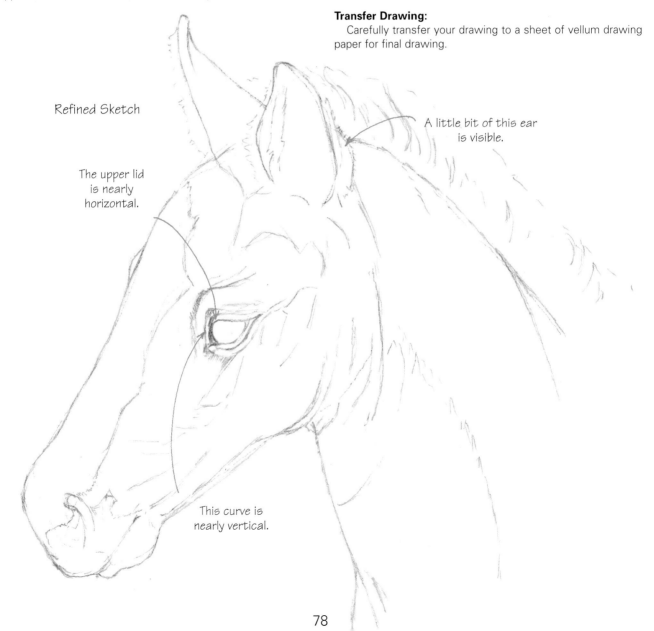

Refined Sketch

The upper lid is nearly horizontal.

A little bit of this ear is visible.

This curve is nearly vertical.

First Tonal Layer

Eye:

Outline the eyeball with a dark line, then fill it with a light tone, avoiding the highlight and making it slightly darker along the top. Darken the lines of the creases in the lids. Lightly shade each crease on both sides of the line.

Muzzle:

The muzzle is a smooth light tone. Shade slightly along the chin and the under side of the mouth.

Ears:

The forward-facing ear has a pronounced dark edge. Draw around the light fuzz both on the outside and inside of the ear.

Fur:

To render her fuzzy baby fur, use layers of individual small hair lines. To create the first tonal layer, cover the areas of brown fur with short, individual lines, drawing them in the direction the fur grows. Criss-cross them slightly and leave some of the white of the paper showing through.

The *dark areas* of brown fur are above and to the sides of the eye, along the center of the cheek, the shadow under the right ear, just behind the ear, and lower on the neck. There is also a narrow dark edge at the bottom of the face. The *light areas* of brown fur are on the forehead, the lower part of the muzzle, and the lower curve of the cheek. Leave the white fur the white of the paper.

Mane:

Work the mane with individual, close set, curvy strokes. Note that most only extend about halfway to the edge – these hairs curve upwards, defying gravity and adding to the look of innocence!

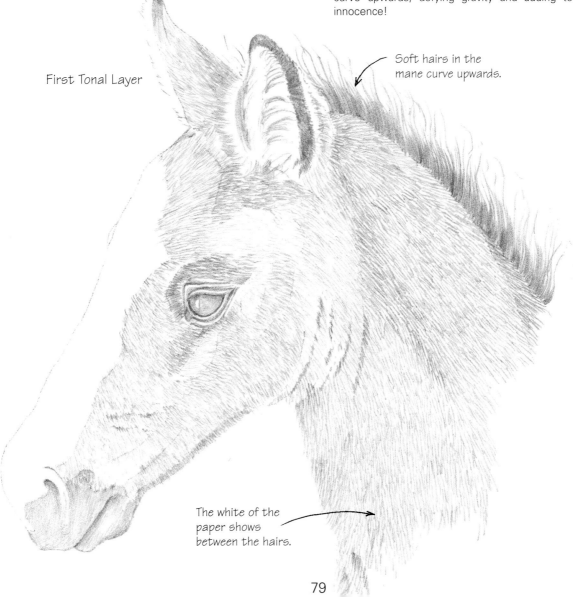

First Tonal Layer

Soft hairs in the mane curve upwards.

The white of the paper shows between the hairs.

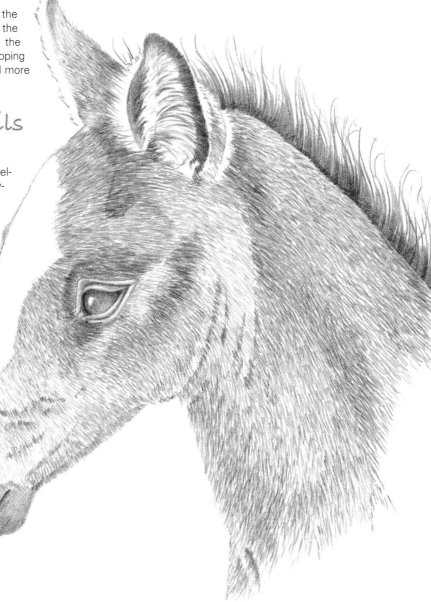

Second Tonal Layer

Second Tonal Layer

Two layers on the fur are important to develop the texture. To create the second layer, simply repeat the steps from the first layer. Concentrate primarily on the direction of the fur, focusing in this layer on developing the dark and light tones. Refer to the photo and add more shadow areas as you work.

Shading & Final Details

See completed drawing on page 76

Now that the texture is established, work on developing the form with lights and darks. Do this by laying in even tones over the texture lines of the coat.

Eye:
At this point, push back the eye by darkening most of the strong highlights on the creases around the eye and the entire area except for the highlight on the eyeball itself. Leave a few lighter areas on the forward edges of both the upper and lower lids.

Right Ear:
Darken the fuzz inside and outside the right ear except for the very lightest areas.

Muzzle:
Darken the muzzle, allowing a little random variation in tone for a slightly mottled look.

Mane:
Darken and thicken the mane.

Dark Areas:
Go back over the darkest areas lightly with the 2B pencil.

Whiskers:
With a very sharp lead, pull a few whiskers around the muzzle and the eyelash on the left eye, which barely shows.

White Edge:
Darken the thin line at the left (white) edge of the face.

Background:
To bring the head forward, add a very light tone in the background around the left side of the face.

Finish:
Sign and date your drawing, then protect it with a coat of fixative. ❏

BUCKSKIN MARE

A WORKING GIRL

I took this photo many years ago when we were privileged to live
in a rural area of northern California. One of our neighbors had
rounded up his new calves to vaccinate them and this beautiful
buckskin mare waited patiently in the barn nearby,
her morning's work done. (A buckskin, for those of you who
don't know, is a taupe horse with black mane and tail.)

Instructions begin on page 82

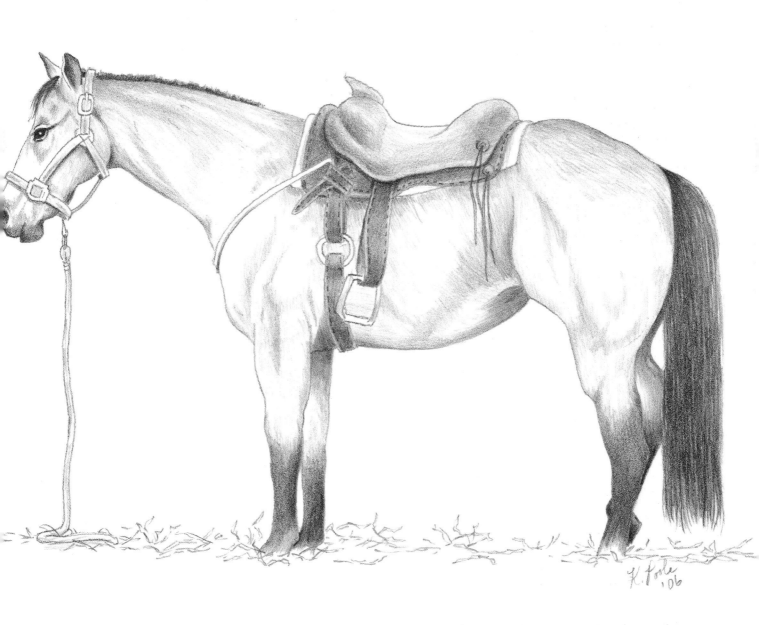

Supplies

- Light ivory acid-free drawing paper
- Near-white acid-free vellum drawing paper
- 5mm mechanical pencil with HB lead
- 5mm mechanical pencil with 2B lead
- White gouache

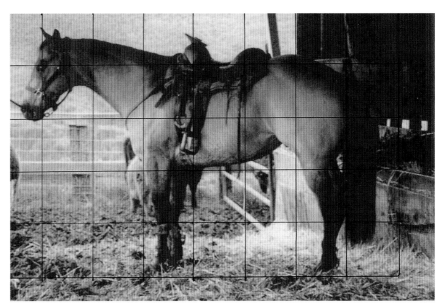

Photo credit: courtesy Kaaren Poole, 1998

Observations

This horse's mane is clipped to give the cowboy a better view of what's happening, but isn't her long tail gorgeous? The cowboy thoughtfully replaced her bridle with a halter to give her a break from the bit. This horse is obviously well loved and cared for.

Although it's hard to distinguish in the photo, she is standing on only one of her back legs, the one nearer the viewer. Even though she is resting, she has one ear forward and the other cocked to the side, listening to what's going on around her. The details of the saddle are hard to see in the photo. Some research (I went to a local feed store) provides me with insights on saddles that help me interpret the photo.

In the photo, the lead rope attached to the halter is tied to the wall of the barn, but this poses a few problems. First, it is confusing. With the lead rope in front of her mouth, it almost looks like she is wearing a bit, but this is clearly a halter and not a bridle. Second, I would rather not have part of her face obscured. So I decide to drop the lead rope to the ground instead.

In the following sections, "right" refers to my right, and "left" to my left.

Establishing the Framework

METHOD: GRID

Refer to diagram on page 81.

Preparing to Draw:

Enlarge the photo to the size you want your drawing to be. Draw the grid over it. Draw a corresponding grid on a sheet of acid-free drawing paper.

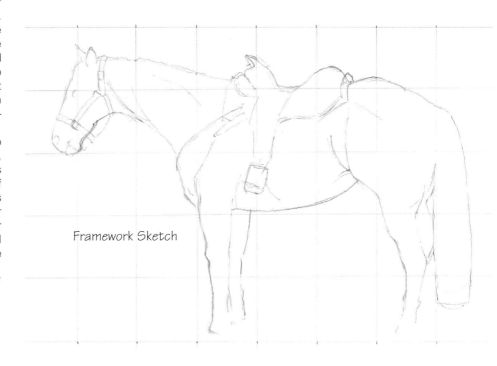

Framework Sketch

Drawing the Horse:

With the grid as your guide, use an HB pencil to block in the main shapes, leaving the details of the tack till the next phase.

Transfer Drawing:

The grid has served its purpose. Transfer your sketch to a piece of vellum drawing paper, and begin to refine your drawing.

Buckskin Mare, continued

Refining the Sketch

Eye:

Even though the eye is small, pay close attention to the shape and include the folds above and below it as well as a tiny highlight.

Body Shapes:

Guided by the photo, refine the shapes of the legs, back, head, and chest.

Saddle & Halter:

Using the photo as a guide, draw the outlines of the saddle and halter. Allow the lead rope to extend to the ground. Don't forget the saddle blanket.

Refined Sketch

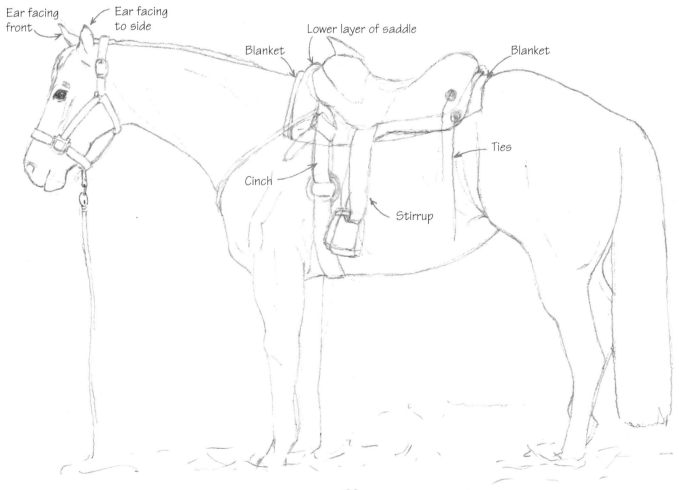

Ear facing front

Ear facing to side

Lower layer of saddle

Blanket

Blanket

Cinch

Ties

Stirrup

First Tonal Layer

This mare – despite her dark mane, tail, and lower legs – is primarily a solid-color horse. This means you must rely on accurate outlines, shadows, and highlights to correctly define the contours of her body and head and make your drawing convincing.

Shadows:
Begin with her head and work back over her body, lightly drawing in the shadows you see in the photograph. This is an exercise in close observation. The shadows on her neck, legs, chest, belly, and quarter (hip) reveal the large muscles underneath. Work with a dull pencil lead and keep the toned areas as smooth as you can. At this point, you are working very light.

Mane & Tail:
Darken the mane with very short vertical lines. Darken the tail with long lines, leaving white space between them.

Saddle:
Begin to define the complex form of the saddle by lightly toning a few shadows. but leave the overall form white. (You can decide how light or dark you want the saddle when the horse is nearly done.)

Second Tonal Layer

In this layer you are continuing to develop the coat.

Muzzle & Lower Legs:
Darken the muzzle and lower legs.

Coat:
Once again, begin with the head and move backward to the neck, front legs, belly, quarter, and back legs. Paying close attention to the photograph, lay a light tone over everything but the brightest highlights. These are on the face, the side of the neck, the chest, the side of the body, and the center portion of the quarter.

Shadows:
Slightly deepen the shadows. At this stage, with the main shadow shapes defined in the previous layer, look for smaller, more detail-level shadows.

Mane & Tail:
Deepen the mane and tail with a second layer, and add a light tone over the entire saddle, leaving the blanket white.

First Tonal Layer

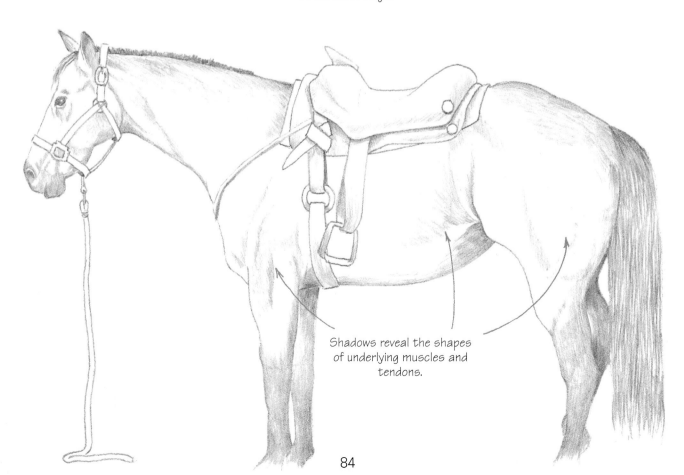

Shadows reveal the shapes of underlying muscles and tendons.

Shading & Final Details

See completed drawing on page 81

Straw:

To ground the mare, sketch some of the straw laying on the barn floor.

Shadows:

Switch to the 2B pencil. Deepen the dark areas established previously to increase the value range and add spark to your drawing. The deepest shadows, even though they are on light fur (for example, under the belly) are nearly as dark as the black mane, tail, and lower legs. **Note:** I chose to downplay some shadows that are very dark in the photo. The shadows on the top of the neck and rump are from the barn, and they don't make sense for this drawing because there is no barn.

Tail:

In previous layers you've left a little white space between the long strokes on the tail. At this point, add an even, medium tone over the entire tail. This darkens the tail appropriately, but still shows some texture.

Saddle:

Distinguish its two layers by making the lower one darker than the upper one. Continue to leave the blanket white, but add very tiny light shadows where it tucks under the saddle. Stitching on the straps is a nice detail.

Eye Highlight:

Since the eye is so small, it's likely you have not been able to preserve a highlight. Remedy this by dipping the small end of a stylus in a little white gouache and touching it very lightly to the paper to make a tiny white dot. It is important to keep the dot very small. A small dot adds sparkle to the eye, but a larger one is distracting.

Finish:

Sign and date your drawing. Protect it with a layer of fixative. ❑

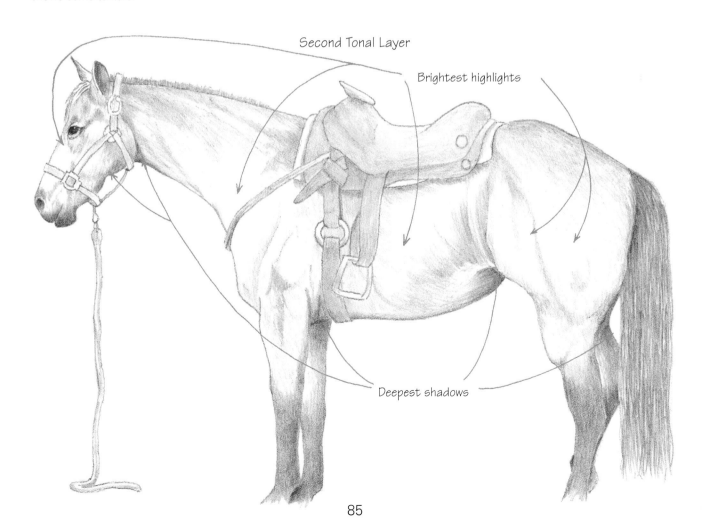

Second Tonal Layer

Brightest highlights

Deepest shadows

IN THE RING
A HANDSOME PAINT

I snapped this photo of a handsome paint horse at a local county fair a few years ago. It was so exciting to see the cutting and barrel racing. The horses clearly enjoyed the events as much as the riders or fans!

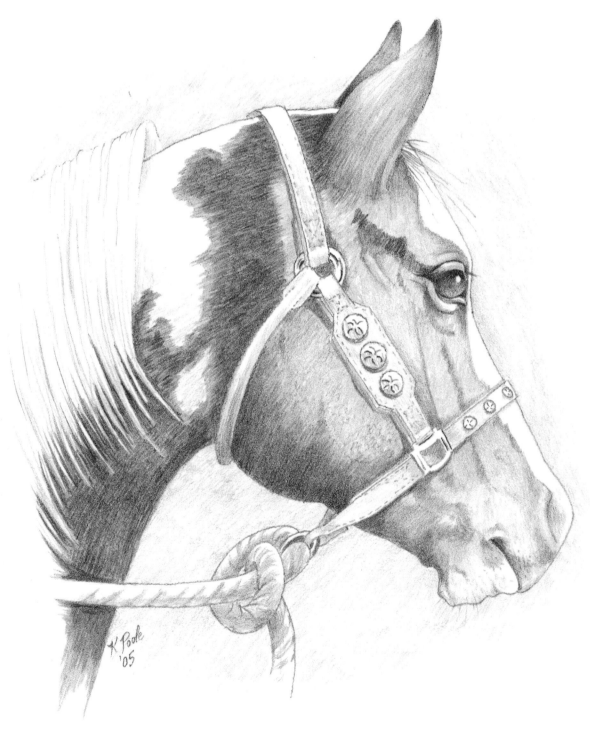

Supplies

- Light ivory acid-free drawing paper
- Near-white acid-free vellum drawing paper
- 5mm mechanical pencil with HB lead
- 5mm mechanical pencil with 2B lead
- Compass

Observations

The eye is the focal point of this drawing, so I study it carefully. There are many interesting little shapes along the tip of the nose and under the chin. I do not understand the musculature of a horse's face, but paying attention to these subtleties captured in the photo will help me get an accurate drawing. The ears are in a forward-facing, highly attentive pose. I can almost feel energy radiating from them!

This horse is tethered to a trailer that is out of the picture to the left. His body is facing the viewer straight on with the head turned, but I decide to omit the side of the body because I think it would look confusing in the drawing without the other horses that define the context of the photo.

As I study the photo I don't see a series of simple shapes, but the line of the halter jumps out at me, so I decide to base my sketch on this line.

In the following sections, "right" refers to my right, and "left" to my left.

Establishing the Framework

METHOD: ANCHORS

Preparation:

Enlarge the photo to the size you want your drawing to be.

Drawing the Outlines:

Using a sheet of acid-free drawing paper and an HB pencil, draw a slanted line for your base, being careful to get the angle the same as in the photo.

Use a compass to mark off three sections on that line: from the tip of the nose to the bottom link of the halter, between the two links on the halter, and from the top link to the back of the neck. To mark the sections, set your compass to the distance on the photo, then mark the same distances along the line in your drawing. Also use the compass to mark the width of the head at these three points. Notice that the line of the forehead is parallel to the line of the halter and that the eye is midway between the point where the halter comes over the front of the nose. The base of the ear provides the remaining information you need to block in the main shapes.

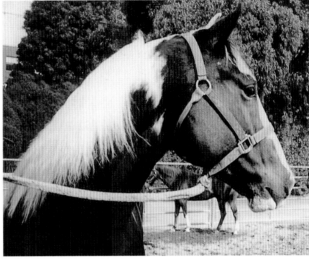

Photo credit: courtesy Kaaren Poole, 2000

Framework Sketch

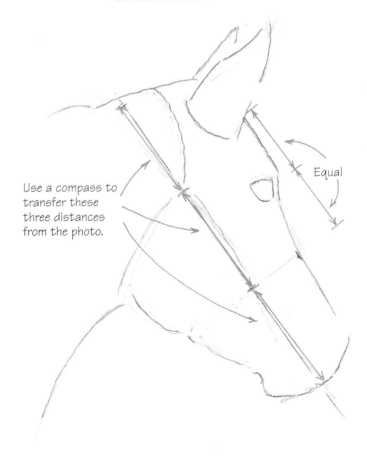

Use a compass to transfer these three distances from the photo.

Equal

Refining the Sketch

Observations:

The nostril is facing to the front of the head so only the side shows from this angle. I'll make it more apparent in the drawing than it is in the photo. There are a few things in the photo I decide to change. I'd like to dress up the halter a bit. I'll make it leather with silver medallions. Also, it's not clear to me how the lead rope is attached to the halter so I decide to clarify it by adding a big knot.

Eye:

Study the photo carefully to get the shapes of the eyeball and folds around the eye correct.

Ears:

The ears are in a forward-facing, highly attentive pose. Draw them.

Shadows:

The shapes of the shadow areas help define the detailed shape of the head. Sketch these in.

Nose:

Draw the nostril. (It's difficult to see in the photo.)

Transfer Drawing:

Transfer your drawing to a sheet of vellum drawing paper for final drawing.

First Tonal Layer

Eye:

The eye is very dark and the pupil is not visible. Fill the eyeball with a smooth tone, graduated from dark at the top to light at the bottom, avoiding the highlight. Clearly distinguish the folds around the eye – one above the eye and two below.

Fur:

The horse's coat is very smooth. Work with a dull lead and try to minimize the appearance of individual pencil strokes. For this layer, you are largely working with just two tones for the dark fur, a darker one in the shadow areas and a lighter one in the highlight areas. Leave the white fur untouched.

Second Tonal Layer

Eye:

Deepen the upper area to bring out both the primary and secondary highlights. Deepening the area to the right of the eye helps bring out the eye. Continue to develop the folds.

Fur:

On this layer, you are deepening your tones and increasing the contrast between the dark and light fur. As you work the shadows in the dark fur, pay attention to the difference in the shadows on smoothly rounded shapes (like the cheek) versus shadows on sharp angles (like the area on the forehead above and to the left of the eye). A shadow on a rounded shape has a very gradual change in tone while a shadow on an angular shape will have a sharp transition from dark to light.

Where there is a transition between dark and light fur, there is an intermediate area where we see both colors at once. This transition area occurs only on the edges of spots that are perpendicular to the direction the fur is growing. See the Horses Worksheet for an illustration.

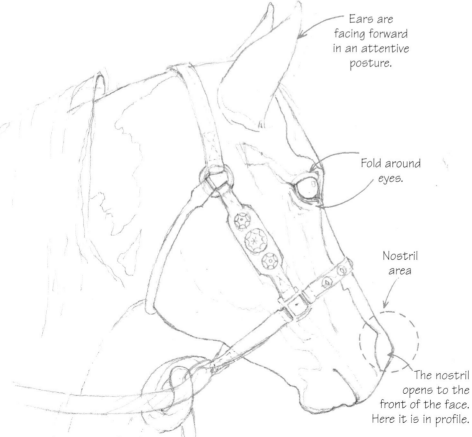

Refined Sketch

Ears are facing forward in an attentive posture.

Fold around eyes.

Nostril area

The nostril opens to the front of the face. Here it is in profile.

Supplies

- Light ivory acid-free drawing paper
- Near-white acid-free vellum drawing paper
- 5mm mechanical pencil with HB lead
- 5mm mechanical pencil with 2B lead
- Compass

Observations

The eye is the focal point of this drawing, so I study it carefully. There are many interesting little shapes along the tip of the nose and under the chin. I do not understand the musculature of a horse's face, but paying attention to these subtleties captured in the photo will help me get an accurate drawing. The ears are in a forward-facing, highly attentive pose. I can almost feel energy radiating from them!

This horse is tethered to a trailer that is out of the picture to the left. His body is facing the viewer straight on with the head turned, but I decide to omit the side of the body because I think it would look confusing in the drawing without the other horses that define the context of the photo.

As I study the photo I don't see a series of simple shapes, but the line of the halter jumps out at me, so I decide to base my sketch on this line.

In the following sections, "right" refers to my right, and "left" to my left.

Establishing the Framework

METHOD: ANCHORS

Preparation:
Enlarge the photo to the size you want your drawing to be.

Drawing the Outlines:
Using a sheet of acid-free drawing paper and an HB pencil, draw a slanted line for your base, being careful to get the angle the same as in the photo.

Use a compass to mark off three sections on that line: from the tip of the nose to the bottom link of the halter, between the two links on the halter, and from the top link to the back of the neck. To mark the sections, set your compass to the distance on the photo, then mark the same distances along the line in your drawing. Also use the compass to mark the width of the head at these three points. Notice that the line of the forehead is parallel to the line of the halter and that the eye is midway between the point where the halter comes over the front of the nose. The base of the ear provides the remaining information you need to block in the main shapes.

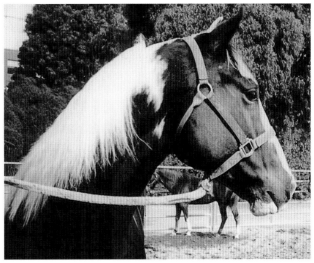

Photo credit: courtesy Kaaren Poole, 2000

Framework Sketch

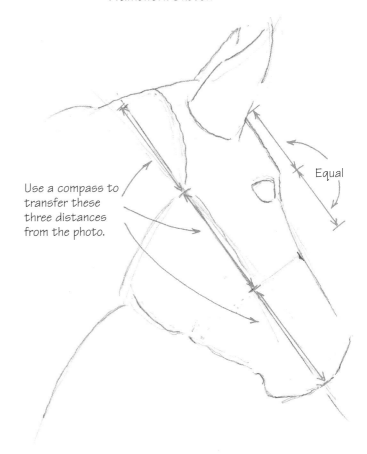

Use a compass to transfer these three distances from the photo.

Equal

Refining the Sketch

Observations:

The nostril is facing to the front of the head so only the side shows from this angle. I'll make it more apparent in the drawing than it is in the photo. There are a few things in the photo I decide to change. I'd like to dress up the halter a bit. I'll make it leather with silver medallions. Also, it's not clear to me how the lead rope is attached to the halter so I decide to clarify it by adding a big knot.

Eye:

Study the photo carefully to get the shapes of the eyeball and folds around the eye correct.

Ears:

The ears are in a forward-facing, highly attentive pose. Draw them.

Shadows:

The shapes of the shadow areas help define the detailed shape of the head. Sketch these in.

Nose:

Draw the nostril. (It's difficult to see in the photo.)

Transfer Drawing:

Transfer your drawing to a sheet of vellum drawing paper for final drawing.

First Tonal Layer

Eye:

The eye is very dark and the pupil is not visible. Fill the eyeball with a smooth tone, graduated from dark at the top to light at the bottom, avoiding the highlight. Clearly distinguish the folds around the eye – one above the eye and two below.

Fur:

The horse's coat is very smooth. Work with a dull lead and try to minimize the appearance of individual pencil strokes. For this layer, you are largely working with just two tones for the dark fur, a darker one in the shadow areas and a lighter one in the highlight areas. Leave the white fur untouched.

Second Tonal Layer

Eye:

Deepen the upper area to bring out both the primary and secondary highlights. Deepening the area to the right of the eye helps bring out the eye. Continue to develop the folds.

Fur:

On this layer, you are deepening your tones and increasing the contrast between the dark and light fur. As you work the shadows in the dark fur, pay attention to the difference in the shadows on smoothly rounded shapes (like the cheek) versus shadows on sharp angles (like the area on the forehead above and to the left of the eye). A shadow on a rounded shape has a very gradual change in tone while a shadow on an angular shape will have a sharp transition from dark to light.

Where there is a transition between dark and light fur, there is an intermediate area where we see both colors at once. This transition area occurs only on the edges of spots that are perpendicular to the direction the fur is growing. See the Horses Worksheet for an illustration.

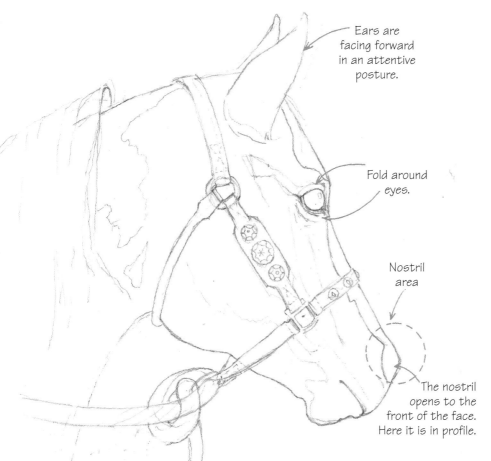

Refined Sketch

Ears are facing forward in an attentive posture.

Fold around eyes.

Nostril area

The nostril opens to the front of the face. Here it is in profile.

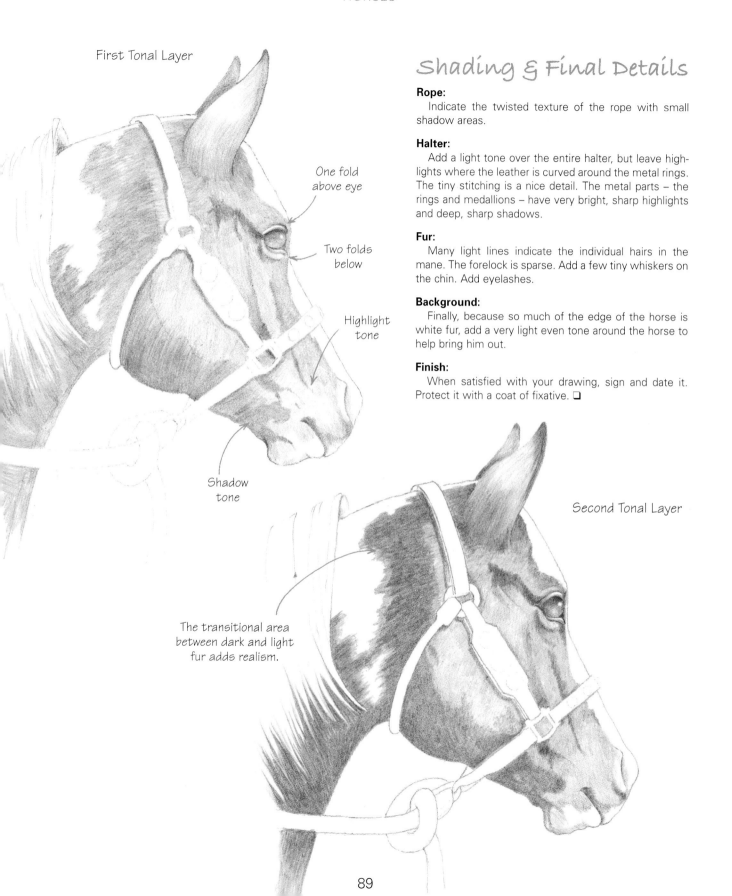

First Tonal Layer

One fold
above eye

Two folds
below

Highlight
tone

Shadow
tone

The transitional area
between dark and light
fur adds realism.

Shading & Final Details

Rope:
Indicate the twisted texture of the rope with small shadow areas.

Halter:
Add a light tone over the entire halter, but leave highlights where the leather is curved around the metal rings. The tiny stitching is a nice detail. The metal parts – the rings and medallions – have very bright, sharp highlights and deep, sharp shadows.

Fur:
Many light lines indicate the individual hairs in the mane. The forelock is sparse. Add a few tiny whiskers on the chin. Add eyelashes.

Background:
Finally, because so much of the edge of the horse is white fur, add a very light even tone around the horse to help bring him out.

Finish:
When satisfied with your drawing, sign and date it. Protect it with a coat of fixative. ❏

Second Tonal Layer

CHAPTER 7 Domestic Fowl

I enjoy drawing chickens and ducks. Although I personally do not find their faces particularly expressive, their interactions are fascinating. Additionally, their plumage is beautiful and often exotic. Visit the local county or state fair to see a variety of beautiful birds.

Not so long ago, when much of the population was rural, chickens were a powerful presence in people's lives. The "mother hen" carefully guarding and guiding her chicks is a quintessential symbol of motherhood. And the rooster's crowing is universally understood as a joyful greeting for a new day.

Distinctive features of chickens are their combs, wattles, and feet. Both hens and roosters have combs and wattles, but the males' are more prominent. Roosters' plumage is more spectacular than the hens', both in form and color. Roosters have large arching tails, whereas hens have a more compact shape.

A chicken has several different shapes of feathers – large wide feathers on the tail and wing, long pointed feathers on the neck, and round fluffy feathers on the chest. Individual feathers often have distinct patterns which, seen together, produce lovely patterns and textures.

Chickens' feet are large and strong, with three toes pointing forward, one pointing back, and a short "spur" higher on the leg. The claws are formidable. Chickens use their feet to scratch for food, as well as defensive and offensive weapons.

Do you treasure early childhood memories of feeding the ducks? Ducks are widely loved, as the well-fed flocks on local ponds everywhere testify. For me, their shape is so appealing, round and stable, and their eyes are gentle and bright. Their bottoms-up water feeding posture is amusing. Their plumage can be wonderfully colored and marked; males are usually more brilliant than females, but female plumage is often marked with complex, beautiful patterns that help camouflage her while she sits on her nest.

Although ducks' feet are webbed their basic structure is the same as that of chickens – three toes pointing forward and one pointing back. The front toes are webbed nearly to the claws. The back toe is short and there is no spur. The heel and knee are clearly visible.

A duck's bill is wide and flattened with nostrils near the top edge. A hard triangular area at the tip of the upper bill helps the duck grip food. The bill is very sensitive to touch. Ducks dabble in the mud and on the bottoms of ponds and streams looking for food. The inner edges of the duck's bill and tongue have small comb shapes that act as sieves, helping the animal separate food bits from the mud.

Both chickens and ducks have very round eyes with the iris visible all around the pupil. In chickens, the irises are often a golden brown, making the black pupil quite visible. Ducks often have dark irises and pupils that show little or not at all, but some types of ducks have lighter colored irises. Duck's eyes are very high on their heads.

Ducks Worksheet

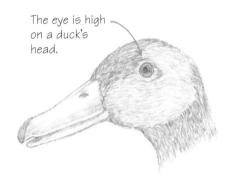

The eye is high on a duck's head.

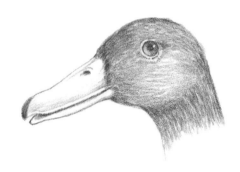

A duck's foot

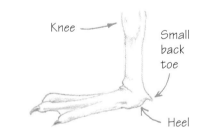

Knee

Small back toe

Heel

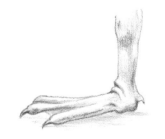

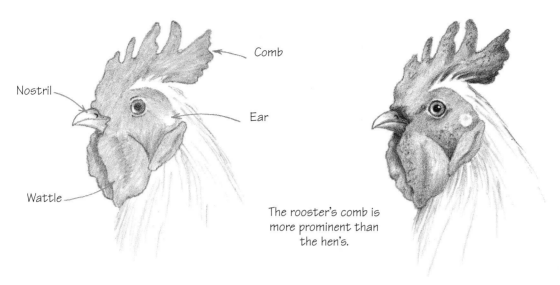

Comb

Nostril

Ear

Wattle

The rooster's comb is more prominent than the hen's.

Chickens Worksheet

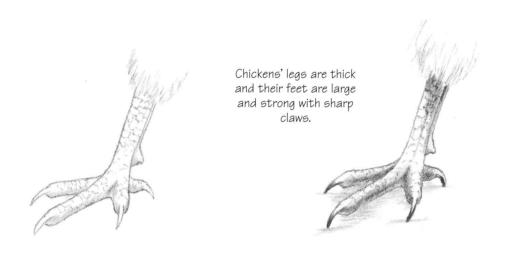

Chickens' legs are thick and their feet are large and strong with sharp claws.

Types of Feathers

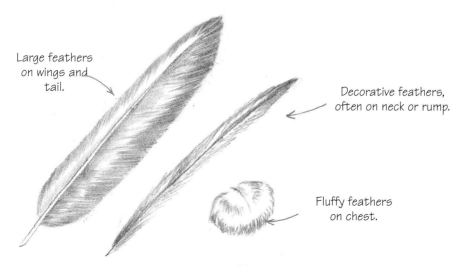

Large feathers on wings and tail.

Decorative feathers, often on neck or rump.

Fluffy feathers on chest.

DONNA'S GLAMOUR SHOT
A DUCKLING

An unusual and irresistible pose, this photo looks like a glamour shot or a yearbook photo. This is Donna, one of my ducklings. She's getting dried off after a swim in the bathtub. Ducklings' down is not waterproof, and she could become chilled if she were in the water too long. She was about a week old in this picture.

Supplies

- Light ivory acid-free drawing paper
- Near-white acid-free vellum drawing paper
- 5mm mechanical pencil with HB lead
- Colored Pencils – Yellow Ochre, Canary Yellow, Flesh, Dark Brown, Terra Cotta
- White gouache

Observations

At first glance, Donna appears pretty easy to draw. But her portrait is actually quite complicated because of the tilt of the head and the foreshortening of the bill, which is a complex and subtle shape. For these reasons, I decide to use the grid method. In this drawing, the pose is everything! Her down is very light so I won't have a lot of detail. I decide to add interest by adding very soft color to my finished drawing.

In the following sections, "right" refers to my right, and "left" to my left.

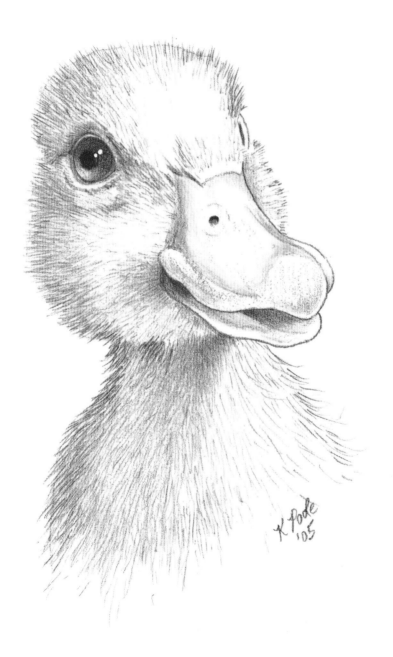

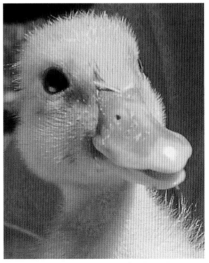

Photo credit: courtesy Kaaren Poole, 2005

Establishing the Framework
METHOD: GRID

Preparing to Draw:
Enlarge the photo to the size you want your drawing to be. Draw the grid over it. Using an HB pencil, draw a corresponding grid on a sheet of acid-free drawing paper.

Creating the Outline:
Carefully copy the squares, one by one.

Transfer Design:
At the end of this process, no refining is necessary. Since the grid is difficult to erase, at this time transfer your line drawing to a sheet of vellum drawing paper and begin developing the tonal layers.

First Tonal Layer

Donna is very pale, so you don't want a lot of tone. On the other hand, the texture of her down is soft and luxurious and will require more than one layer to capture. In this first layer, work very lightly.

Eye:
Darken the pupil first, then work the iris in a lighter tone. Carefully leave the large secondary highlight at the lower left untouched, but keep a soft transition between the white and gray areas. Outline her eye with a thin dark line, then stroke in a softer line along the back half of the bottom of the eye for the lower lid. Tiny strokes suggest the shadow under the ridge of tiny feathers beneath the eye.

Bill:
Work the shadows on the bill lightly with a dull pencil lead, then smooth them carefully with a stump. To avoid carrying graphite from the darker areas to the lighter ones, work the lighter areas first. TIP: An area that you smooth with a stump will appear darker after smoothing, so it's important to draw lightly – perhaps too lightly.

Down:
Stroke individual lines to represent the tiny feathers. (Duckling down looks more like hair than feathers.) Work with a sharp pencil lead to get very fine strokes.

Second Layer

In the second layer, develop the shadows.

Shadows:
For the shadows on her face to the left of the bill, inside her mouth, and on her chest, lay in a light tone with a dull lead. To deepen the left side of her body and face, add more texture lines.

Eye:
Deepen the eye, but again leave the highlight untouched.

Adding Color

Add just a hint of tint with colored pencils.

Down:
Use Yellow Ochre in the shadow areas and Canary Yellow in the highlight areas.

Bill:
The bill is very light Flesh and the inside of the mouth is very light Terra Cotta.

Eye:
Put a little Dark Brown over her eye. To add sparkle to her eye, dot two highlights with white gouache, using the tip of a stylus.

Finish:
Sign and date your work. Apply a coat of spray fixative to protect it. ❏

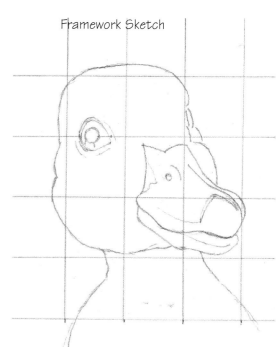
Framework Sketch

The Grid Method is a good choice for a challenging pose.

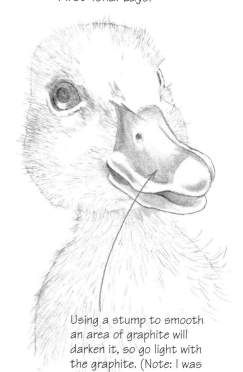
First Tonal Layer

Using a stump to smooth an area of graphite will darken it, so go light with the graphite. (Note: I was too dark here.)

93

SCHOOL CROSSING

HEN & CHICKS

The Dasher family has a menagerie of lovely animals. This is their beautiful hen, Fia, and her brood. Their pose reminds me of a group of youngsters heading off to school under mom's watchful eye.

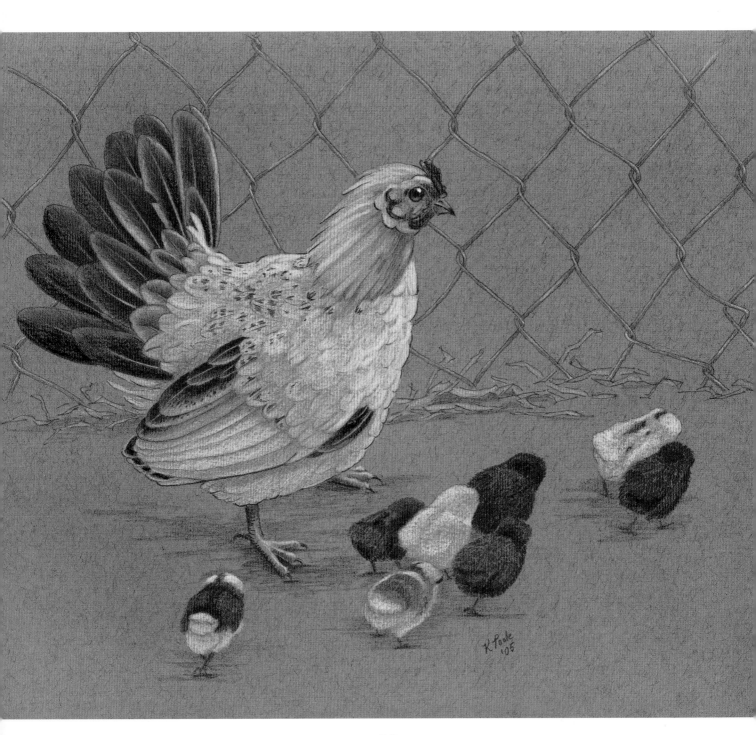

Supplies

- Light ivory acid-free drawing paper
- 5mm mechanical pencil with HB lead
- 5mm mechanical pencil with 2B lead
- Antique Camel Brown drawing paper
- Colored Pencils – Black, White, Cream, Poppy Red, Terra Cotta, Sand, Yellow Ochre

Observations

The contrast between the dark and light chicks and the dark and light portions of the hen is a striking feature of this photo. Since so much of the white portion of the hen is against the background, I risk losing this dramatic feature with a drawing on white paper so I select a medium-tone colored drawing paper. I develop the line drawing with a 5mm pencil on a sheet of acid-free white drawing paper, then transfer it to the colored paper.

The little chicks are all studiously headed in the same direction, clearly with some purpose in mind. The dark area behind the hen is another chick, but I decided to omit him from the drawing because his position doesn't fit my theme.

The hen's feathers are quite a challenge. It is important to get the large tail and wing feathers correct, but the detail in the remaining plumage will be difficult if not impossible to draw, so I need to find a way to simplify it while still being convincing.

In the following sections, "right" refers to my right, and "left" to my left.

Establishing the Framework

METHOD: BASIC SHAPES

Hen:

The hen is a fairly simple shape based on a circle. The tail is stiffly upright and slightly fanned. Her neck is extended and her head watchful. This stance expresses great attentiveness. The hen's forward leg is quite clear. The two linear shapes to the left of the central light chick look like her other foot, in which case her stance is wide and the feet are pointed slightly outward. Sketch them in this position.

Chicks:

The chicks are simple shapes as well. Their charm is their fluff. A chick is basically an egg shape with a little ball head. The tail and rump are two little puffs, with the rump puff larger than the tail puff.

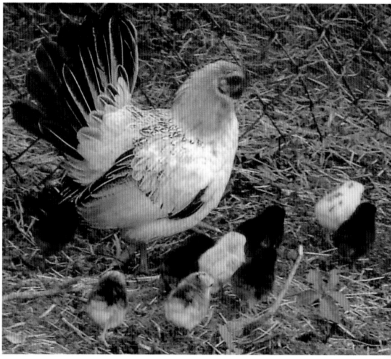

Photo credit: courtesy Karin Dasher, 2005

Framework Sketch

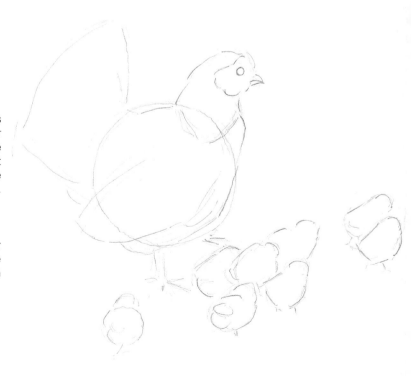

95

Refining the Sketch

Hen's Head:

Both the eye overall and the pupil are round. Draw her beak, beginning with the centerline. When you are satisfied with its position and curvature, draw the lines defining the top and bottom of the beak. From there, proceed to the wattle and comb.

Hen's Tail Feathers:

The first step in detailing the tail feathers is drawing the ribs. Once you're satisfied with their number and direction, fill in the outer edges of the feathers. Concentrate on the long feathers as well as the row of smaller medium-tone feathers at the base of the tail.

Hen's Wing Feathers:

Follow basically the same procedure with the wing feathers. Beginning with the top row, draw in the ribs, then outline them. After that, draw the edges of the remaining feathers. Draw the dark feathers at the front of the wing in the same way.

Hen's Small Feathers:

There are too many small feathers on the back, chest, neck, and upper wing to draw them all now, but draw several ribs, checking that you are orienting them in the proper directions.

Chicks:

Refer to the photo and check the shapes of the chicks. Improve them as necessary.

Background:

Sketch in the wire fence and a little of the straw along the bottom edge of the fence.

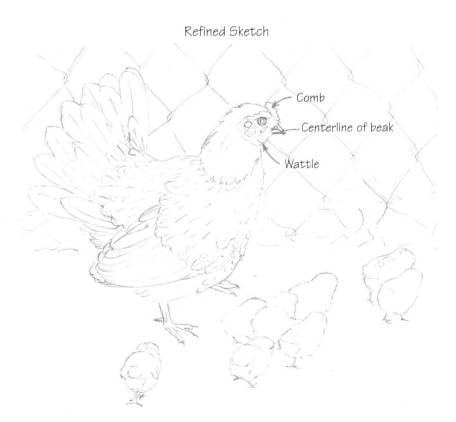

Refined Sketch

Comb

Centerline of beak

Wattle

Transfer Drawing:

Carefully trace the drawing and transfer it to the colored paper.

Selecting the Paper Color

The paper color is a critical decision. At first, I considered a gray-green, like some of the background color from the photo. But my gray-green paper had a medium texture that would resist my getting a solid color from my pencils but give me a grainy look (with the color of the paper showing through). This is a lovely effect, but it meant the color of the paper would essentially tint the entire drawing, including the shadows in the light areas and the highlights in the dark areas.

As I studied the photo, I didn't see any green tone on the hen – her light plumage is quite warm. So I chose an antique camel-colored paper to emphasize this warmth. The gray-green would have fought me all the way.

First Tonal Layer

The plan is to build up light and dark values in the first two layers, then add color in the final layer. For the first layer, work with HB lead and a Cream colored pencil. Begin with the dark tones.

Hen's Eye:

Add a medium tone to the iris, then a dark tone to the pupil, avoiding the highlight.

Hen's Beak:

Add medium tone to the beak, avoiding the highlight on the lower edge of the upper bill.

Hen's Dark Feathers:

For the dark feathers on the tail and wing, use a sharp pencil lead to draw a dark line on either side of the rib, leaving the center of the rib the color of the paper. Then outline the feather. Color in the feather, pulling parallel strokes out from the rib towards the edge, pulling these lines at an angle out and upwards, but avoiding the light edges.

Legs & Feet:

Work the legs and feet with tiny curved strokes coming inward from both sides of the leg and upwards from the undersides of the toes. The claws are two curved strokes outlining the top and bottom edges.

Next, work the light areas with the Cream colored pencil. Press harder for a lighter tone (the opposite of working with a graphite pencil).

Hen's Wattle & Comb:

Begin by covering the wattle and comb with an even light tone. (You need a light base for the red to show later. Similarly, you need a light base for the golden tones on the neck.)

Hen's Neck Feathers:

Use long strokes and a dull pencil to add a light tone to the neck, mimicking the long thin feathers that cover the neck. By pulling the strokes from the bottom of the feathers upwards and lessening the pressure on the pencil as you go, you get a graduated stroke, lighter at the bottom and darker at the top.

This gives the appearance of a shadow around the wattle. As you work, allow the paper to show through here and there.

Hen's Feathers:

Lay a light tone on the tips of the feathers on the back, chest, and upper wing. Then go back and cover these areas with a less-light tone. The feather tips should still show as lighter than the rest of the area. The belly is an even light tone.

Pull the long curved feathers below the tail. For the light long wing feathers, pull long strokes the length of the feathers, pressing harder on the lower edges to give a highlight. Add accents of cream on the edges and ribs of some of the wing and tail feathers.

Chicks:

The chicks are very simple fuzzy shapes. Use the HB and cream colored pencils to indicate the forms with short back and forth strokes, orienting the strokes perpendicular to the edges. Lightly draw the legs and feet with the HB pencil.

First Tonal Layer

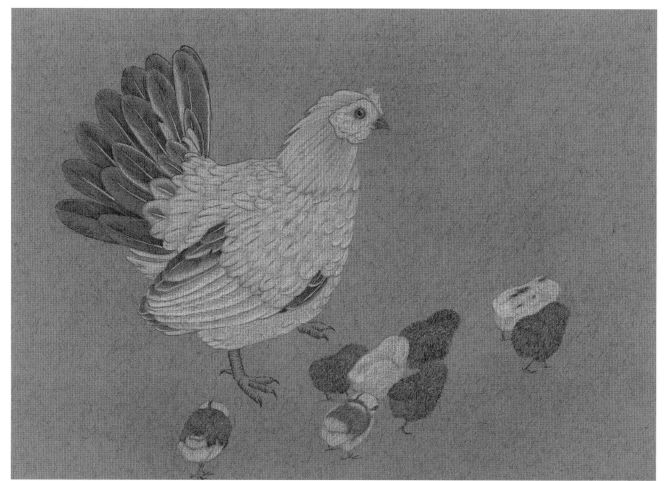

Second Tonal Layer

Fence:

With the HB pencil, draw the wire. Draw a single line along each edge. Have all the twists twisting in the same direction.

Hen & Chicks:

Switch to the 2B pencil and white colored pencil. Darken the shadows and lighten the highlights in the shadow and highlight areas. **Note:** It is important to have a very solid white under the red – otherwise, the red won't show up well.

Color Overlays & Final Details

See completed drawing on page 94

Fence:

To finish the wire, shade each section with a line of HB pencil on the shadow side, paying special attention to the twists. Use the Cream colored pencil to place highlights here and there.

Getting the shadows and highlights properly placed makes all the difference on the wire.

Comb & Wattle:

Overlay the comb and wattle with Poppy Red, avoiding the light areas.

Hen's Eye:

Overlay the iris with a little Terra Cotta.

Hen's Feathers:

On her neck, pull strokes of Terra Cotta, Sand, and Yellow Ochre, concentrating the Sand in the highlight areas and the Yellow Ochre in the shadows. Add a very light layer of Terra Cotta on the upper and lower long light feathers of the wing.

Hen's Feet:

Lightly overlay the highlights on the feet with Yellow Ochre.

Dark Shadows on Chickens:

Using the black colored pencil, deepen the darkest shadows on the hen's dark feathers and on the black chicks.

Ground:

Using the HB pencil, lay in the shadows under the hen and chicks with only horizontal strokes. Draw the squiggly strands of straw, then stroke in Cream and Sand here and there.

Light Shadows on Hen:

Using the HB pencil, add light shadows to the hen on the neck under the wattle, on the side under the neck feathers, under the lower feathers on the upper portion of the wing, and under the wing.

Hen's Eye Highlight:

The final step is to add a dot of white gouache for the highlight in the hen's eye.

Finish:

Sign and date the drawing. Protect it with a layer of spray fixative. ❑

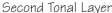

Second Tonal Layer

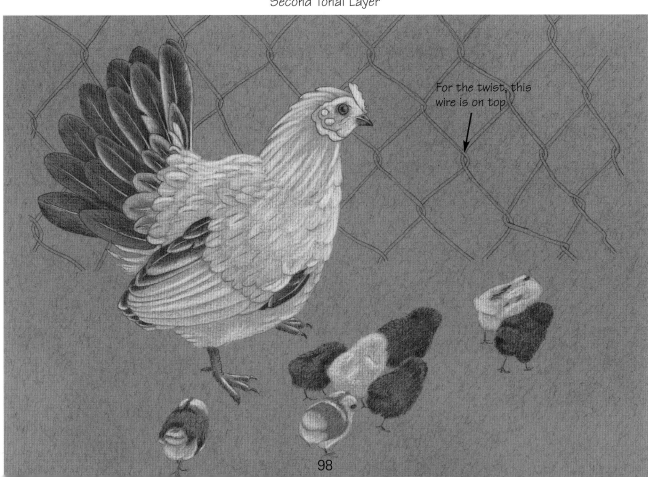

For the twist, this wire is on top

A QUIET MOMENT
DUCKS ON A POND

Such a tranquil scene. There is something particularly appealing about ducks – their plumage is both glossy and soft-looking, and the coloring and markings are spectacular.

Instructions begin on page 100

K Panke '05

Supplies

- Light ivory acid-free drawing paper
- Near-white acid-free vellum drawing paper
- 5mm mechanical pencil with HB lead
- 5mm mechanical pencil with 2B lead

Observations

This photo will make a wonderful drawing. The pose is interesting, with the two ducks at angles to each other, as is the contrast between the plumages of the male and female.

I see these two ducks as a series of modified ovals. The heads are egg shaped – his is vertical and hers on its side. Their bodies at the waterline are pointed ovals, much like boat hulls, with the point at the tail. Of course, we are looking down at them and they are at angles to the vertical and horizontal, so these oval shapes are modified accordingly.

In the following sections, "right" refers to my right, and "left" to my left.

Establishing the Framework

METHOD: BASIC SHAPES

Centerlines:

With an HB pencil, begin drawing on a sheet of acid-free drawing paper. Carefully place centerlines for both ducks, paying attention to the angle at which they meet. TIP: Drawing centerlines around curved or turned objects is helpful in placing features.

Male Duck:

Draw an egg shape for his head. It is turned slightly to the right, so draw a centerline around the oval to help you place the bill. Draw a slightly upward-curved line across the centerline as the base of the bill, which is also turned to the right. His cheek is remarkably round – draw a circle to represent it, then place the eye at the top of the cheek. His two wings together form an upside-down heart. The body is quite wide – nearly three head-widths – with a full head-width on the left and a little less on the right.

Female Duck:

Her head is pretty much centered on his. Draw a line parallel to her centerline and place the egg shape for her head on this line. Block in the neck and bill, then turn your attention to her body. Her back is gently arched upwards. Draw a centerline down her back, placing it towards the top of her body. Block in the shapes of the wings.

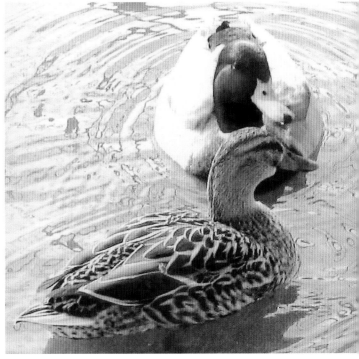

Photo credit: courtesy Melanie Jenkin, 2005

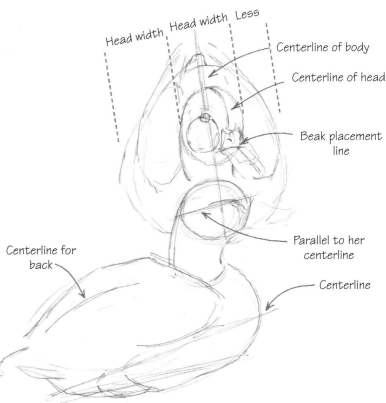

Framework Sketch

Head width · Head width · Less

Centerline of body

Centerline of head

Beak placement line

Parallel to her centerline

Centerline

Centerline for back

A Quiet Moment, continued

Refining the Sketch

When you're happy with your overall shapes, your task is to fill in the details.

Male:

Refine the shapes of head, eye, and bill. Lightly draw a few feathers on the wings.

Female:

Refine the shapes of head, neck, eye, and bill. Outline the major markings on her head.

Feathers:

The complexity of her feathers is pretty intimidating, so take them section by section. Draw the individual large feathers on the wings, back, and side. Where the feathers line up in nice rows, lightly sketch lines to guide you. Then draw the tips of the feathers, working with their positions until you're satisfied. Last, draw the sides of the feathers.

Housekeeping:

When you're satisfied with the feathers, apply a layer of fixative. That way, if you erase when you sketch the water ripples, you won't disturb the detailing on the ducks.

There are three separate elements in the water: the shadows of the ducks, the circular ripples, and seemingly random reflections that look like irregular rings.

Shadows:

Begin by sketching the outlines of the shadows. They are broken, corresponding with the rise and fall of the rippled water surface. TIP: Often when I'm drawing something complicated and intimidating, like the water, I find it helps to forget about what it is and just draw what I see.

Ripples:

Lightly sketch a few of the ripples. There are two sets – one centered on him and the other centered on her.

Rings:

Draw a few of the random rings.

Transfer Drawing:

Carefully transfer your line drawing to a sheet of vellum drawing paper for final drawing.

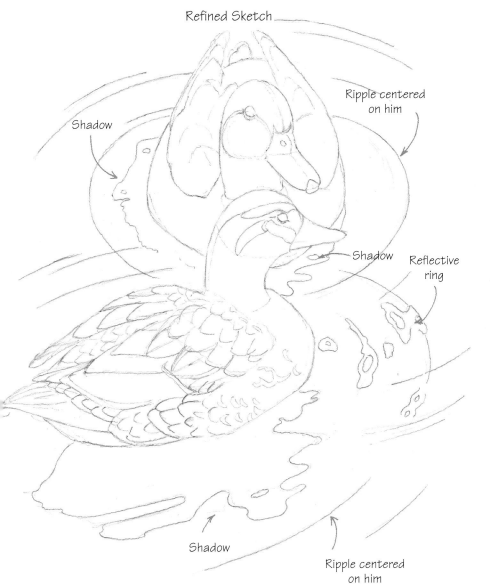

Refined Sketch

Shadow

Ripple centered on him

Shadow

Reflective ring

Shadow

Ripple centered on him

First Tonal Layer

Start with the male duck – the drake. Working the female is a study in patience – all those feathers!

Drake's Head:

The eye is too small for much detail, so cover it with a dark tone, leaving the highlight untouched. Darken the neck and head, being sure to leave light highlight areas on the top of the head, over the eye, and on the cheek. Note the light area along the bottom of the cheek. This is a reflected light. Even though the bottom of the cheek is in shadow, light bounces back up off the water onto this area.

Drake's Bill:

Lay in a light tone on the bill, leaving a large highlight over most of the flat part. Darken the nostril, but leave a highlight above it. (The duck uses the little dark bit on the end of the bill to dabble in the mud.)

Drake's Body:

The lower front of the body has a ruddy color, and the right side of the body is in shadow. Darken the deepest shadow areas with an even tone, but use texture to deepen the tone in the mid-tone areas.

Drake's Wings:

The wings are very light. Lay in the barest of shadows, keeping the strokes very smooth.

Female's Head:

Cover the eye with a medium tone but leave light primary and secondary highlights. Lay an even medium tone over the bill, darkening it slightly near the face. Darken the nostril, leaving a small highlight along the upper edge. Draw short, closely placed, slightly criss-crossed lines for the markings on her head and neck. Place them very close together for the dark patches. Leave the light patch above the eye the white of the paper at this stage.

Female's Feathers:

Work the feathers on the wings, back, and side, leaving a white edge, paying close attention to the way the feathers overlap. You don't see a light edge along the upper edge of the feathers on the far wing because those feathers curve around to the far side of the body and are out of sight. The feathers on the back of the body underneath the tail are very soft so individual feathers don't show. Just draw the markings as patches with very soft edges.

Female's Neck & Chest:

The neck and chest are textured with small strokes simulating small feathers. On the neck, stroke back and forth creating narrow patches roughly oriented in lines traveling down the neck. For the chest, work little C-shaped patches by stroking back and forth. Place them unevenly.

First Tonal Layer

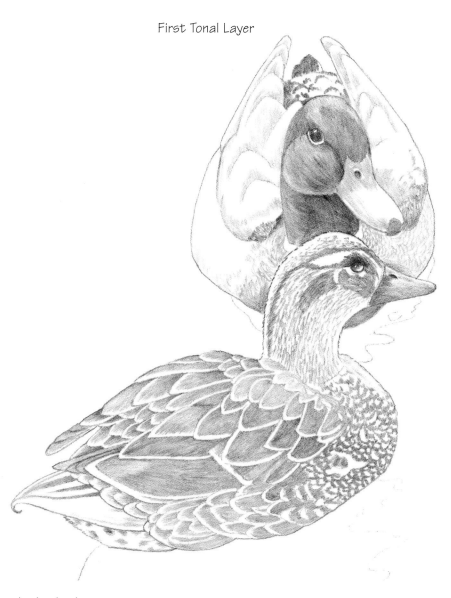

Second Tonal Layer

Drake:

Work on darkening the head and neck, suggesting form by leaving highlights and darkening shadows. Similarly, deepen the tail feathers and the textured area on the back, chest, and right side. Leave the wings as is.

Female Duck's Tail & Feathers:

For the wings, back, and side, repeat the previous layer, evening out any blotchiness from the first layer, deepening the color, and deepening the upper part of each feather where it tucks under the feathers above it.

Female Duck's Head, Neck & Chest:

Lay tone over the entire area, except for the brightest highlights on the face and upper forward chest. Develop the form by adding shadows. The texture applied on the first layer will show through.

Fix Drawing:

When you're finished with the ducks, spray with a coat of fixative. Allow it to dry thoroughly.

Water:

Lay in the shadows on the water beneath the two ducks, working as smoothly as possible. Even out these areas by dabbing with a small piece of chamois.

Housekeeping:

Erase any smudges that project beyond the shadow area and again spray with fixative.

Second Tonal Layer

Shading & Final Details

Your goals in this third layer are to add shading to round the forms (even though I'm satisfied with the female's plumage, her body lacks roundness) and finish drawing the water. Use the 2B pencil for the ducks.

Drake:

Deepen the darkest darks.

Female Duck:

To add roundness, lay in shadows. First, shade the bottom edge of her body. Laying a light tone over her back between the wings helps to visually lift the wings from the back. Since both wings are slightly curved down around her sides, shade the forward edge of both wings. Place the shadow that separates the neck from the forward edge of the wing. To further round the neck, darken the center part and make sure that there are highlights along both edges.

Water:

Use the HB pencil to sketch in the rings of ripples with a dull pencil lead, then add a few of the squiggly details with a sharp lead. The ducks' shadows look a little light – darken them slightly.

Observations:

What this drawing lacks is a focal point. I decide that I want the viewer's eye to settle on her eye. A rule of thumb is that the viewer's eye tends to settle where the darkest dark meets the lightest light. In this sense, the strong value contrast between the drake's neck and wings – and the strong contrast in his eye – work against me.

Details:

Dull him down a little by adding a light tone to his lower lid and to the highlight in his eye. Also add a very light tone on the white plumage of the wings where the wings lay against the dark head or neck. Bring her head forward by darkening his chest where it meets her head and neck. Add a light gray tone to the white ring around his neck. Because there is a strong highlight on the top of her head and on the front and rear edges of her neck, this works pretty well.

Finish:

Sign and date your work, then protect it with a coat of spray fixative. ❏

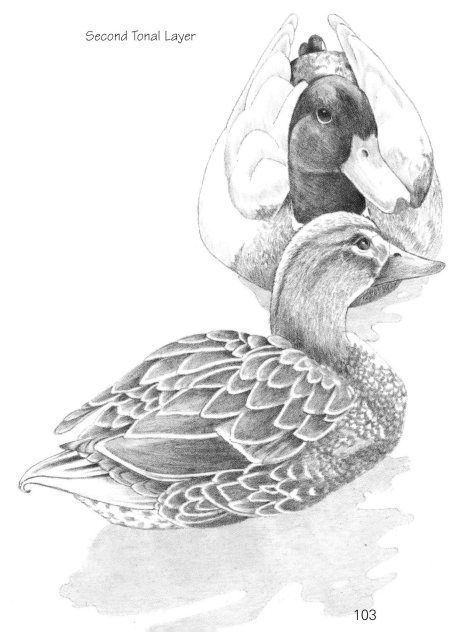

8 Rabbits

Rabbits, both domestic and wild, are familiar, beloved creatures. The distinctive features of rabbits include large ears, bright eyes, and small puffy tails.

In the wild, rabbits and hares inhabit nearly every kind of environment, from desert to marsh, from the heat of southern climates to the frigid cold of the north. Cottontails are probably the most familiar wild rabbits with their showy cottonball tails and light undersides. Hares differ from rabbits in that they have very large ears and large back feet. The jackrabbit is a familiar hare.

Wild rabbits have brown-flecked coats and generally light tails and bellies. The coats of northern species such as the arctic hare turn white in the winter. Their eyes are very round, and often have light markings around them. Although the eyes are often very dark, sometimes the irises are light enough for the pupil to show clearly. The large ears are close set at the top of the head. They are very thin, and prominent veins are visible when the ears are back-lit. The ears are highly sensitive and, along with speed, provide the primary defenses. When a rabbit senses a threat, he rapidly thumps his back feet as a warning to others.

Rabbits have been domesticated for centuries and have been bred for a variety of purposes, including meat, pelts, and for show. As a result, size, coloring, and coats vary widely. Floppy ears characterize the irresistible lops. Some domestic rabbits are albinos and have pink eyes. Domestic breeds range in size from the tiny short-eared Netherlands dwarf weighing in at two-and-a-half pounds to the 14-pound Flemish giant.

A county or state fair is a great place to see beautiful rabbits.

Rabbits Worksheet

Rabbits' eyes are very round, and their lashes often hang down over them.

The entire nose is covered with short, velvety fur.

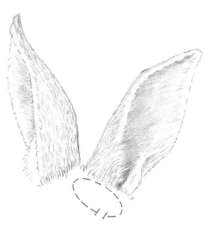

The ear attaches to the head in a nearly full circle.

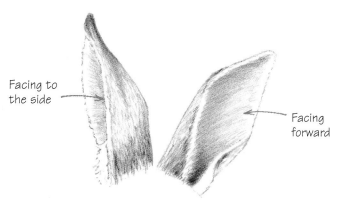

Facing to the side

Facing forward

Rabbits can rotate their ears independently of each other.

STRENGTH IN THE FIELD
EASTERN COTTONTAIL

This photo showcases the gorgeous thick coat of an adult eastern cottontail rabbit – I especially like it because of the interesting pose. Although this rabbit may not look as cute as a baby bunny or a domestic rabbit, he is an example of how the qualities of strength and beauty so often are combined in wildlife.

Instructions begin on page 106

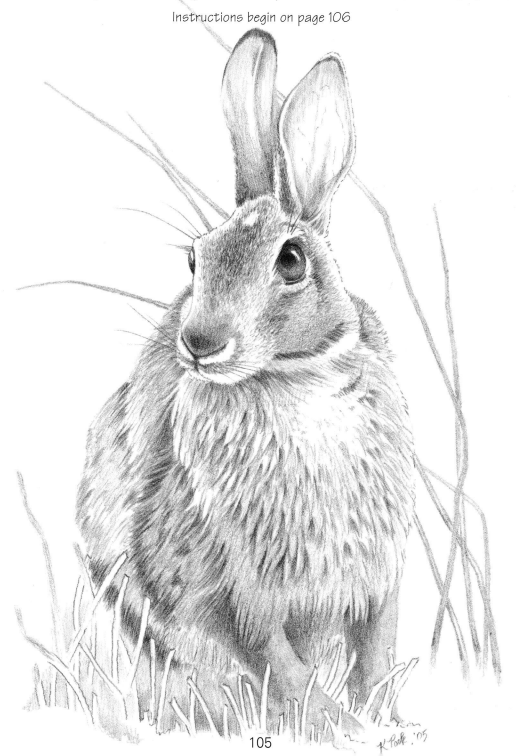

Supplies

- Light ivory acid-free drawing paper
- Near-white acid-free vellum drawing paper
- 5mm mechanical pencil with HB lead
- 5mm mechanical pencil with 2B lead
- Compass

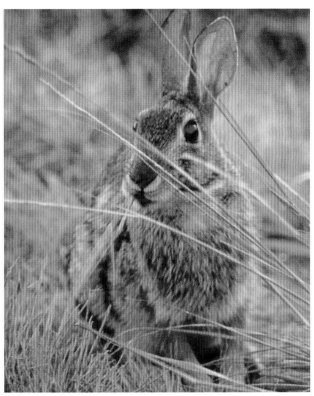

Photo credit: courtesy John White, 2001

Observations

Before I begin to draw I notice how large this rabbit's eyes are and how high they are on his head. He is looking slightly to the left while his body is oriented towards the right. His position is well balanced, but he looks like he could easily spring into action at any moment.

In the following sections, "right" refers to my right, and "left" to my left.

Establishing the Framework

METHOD: ANCHORS

Seeing the Lines:

Imagine a vertical line running downwards from the inner edge of the right ear. Notice that it touches the inner edge of the right eye and cuts through the left foreleg at about its mid-point. Using the compass, see that the ears are about the same height as the head, and that the total distance from the tips of the ears to the tip of the chin is about half the height of the animal overall.

Drawing the Lines:

Using an HB pencil and a sheet of acid-free drawing paper, draw this vertical line. Mark the center point as well as the center of the top half. These marks indicate the level of the tip and base of the ears, the chin, and the bottom of the forward foot.

Use your compass to find an anchor that marks the center of the body left to right – it turns out to be the left edge of the base of the ears. From this point, the body extends one-quarter of the body height to the left and to the right. Use these marks to block in the main shapes of the head, body, legs, and ears.

Refining the Sketch

Observations:

Although the rabbit's overall shape is rather simple, the details of the face and body fur are complex. The nostrils are at the bottom of the dark nose area. Beneath that are three puffs of fur – the top white one, the center light-colored one that the whiskers emerge from, and a lower white one that is the rabbit's upper lip. His mouth is slightly open in the photo, but I find the open mouth distracting, and draw it closed. The feet are obscured by grass and I will keep it that way in my drawing. I like the large blades of grass coming from the right, but decide to tuck them behind the rabbit.

Head & Neck Fur:

Indicate the nostrils and the fur between the nose and mouth. Draw the edges of the white markings around the eyes, in the top of the forehead, and at the base of the neck. Also indicate the dark band above the white at the base of the neck.

Chest Fur:

The chest fur is very thick. Put a few marks on your drawing to remind you of the directions in which it grows.

Framework Sketch

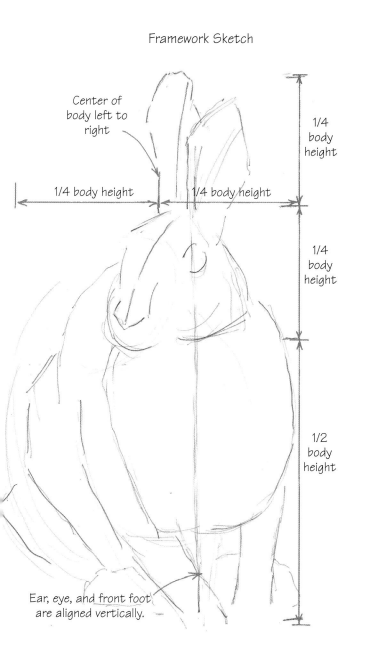

Center of body left to right

1/4 body height

1/4 body height

1/4 body height

1/4 body height

1/4 body height

1/2 body height

Ear, eye, and front foot are aligned vertically.

Refined Sketch

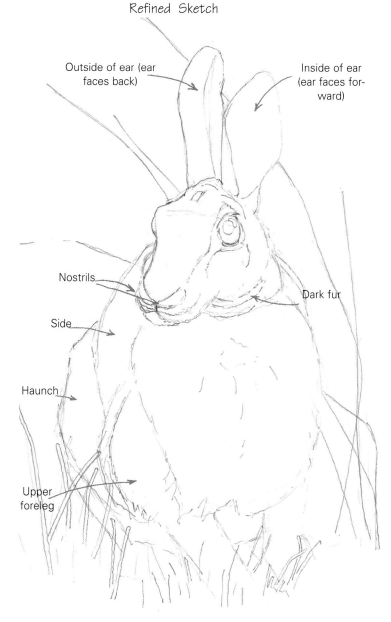

Outside of ear (ear faces back)

Inside of ear (ear faces forward)

Nostrils

Dark fur

Side

Haunch

Upper foreleg

Side Fur:

The rabbit's side is made up of three separate areas. The right-most one is the thick fur on the upper foreleg. The middle one is the rabbit's back and side, and the left one is the haunch. There are bands of dark fur between these sections. The legs are covered with short, smooth fur.

Grass:

Draw blades of grass around the base of the rabbit and behind him on the right side.

Transfer Drawing:

Carefully transfer your line drawing to a sheet of vellum drawing paper.

First Tonal Layer

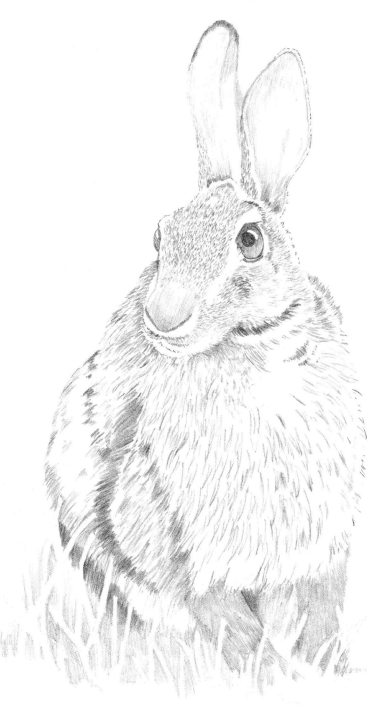

First Tonal Layer

Eye:
Carefully outline the eye, then darken the pupil. Cover the iris with a medium tone, avoiding the highlight.

Short Fur on Nose, Ears & Forelegs:
Use the blunt point of the pencil and soft back and forth strokes, striving to prevent individual pencil strokes from showing. **Note:** When working on the legs and lower body, be careful to not cover the grass blades.

Face Fur:
Next, work the fur on the face and outer parts of the ears, making very short back-and-forth strokes that criss-cross slightly. As you work, turn your pencil to give a consistently medium-sharp point. Leave the white fur areas untouched.

Chest Fur:
Use a dull pencil lead and narrow V-shaped strokes to represent tiny clumps of fur. As you work, refer to the photo to ensure that the Vs point in the proper direction. Be careful to leave the white "fringe" at the lower edge of the chest untouched.

Body Fur:
Complete the rest of the body fur, using a dull pencil lead with medium-length back-and-forth strokes.

Grass:
Lightly tone the areas behind and between the blades of grass.

Second Tonal Layer

Eyes:
Darken the eyes, making the upper portion darker than the lower portion.

Ears:
Darken the ears and draw in the veins on the right one. (The veins show in the right ear and not the left because the right ear is opening towards the viewer and the left one is not.) Leave the forward edges of the right ear white.

Nose:
Darken the nose, and as you do so add more color to the lower portions.

Face Fur:
Lay a second layer of fur texture over the face, referring to the photo to correctly place the darkest areas.

Second Tonal Layer

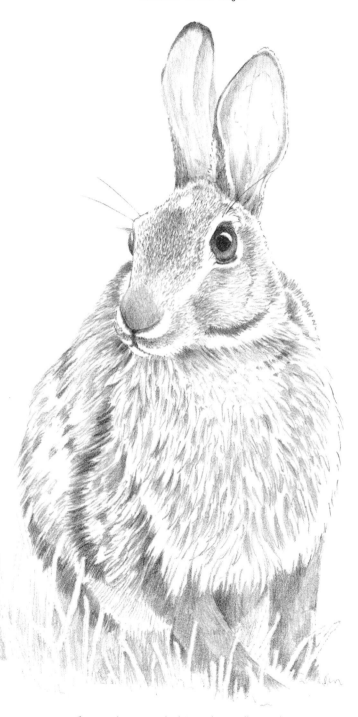

To get the ragged white edge, pull pencil strokes from the surrounding dark area.

Fur on the Side & Legs:
Add a second layer of texture over the first.

Chest Fur:
Add a medium tone between the bases of the little Vs, then add variation by making some areas darker. To clean up the lower and outer edges of the white border on the chest, pull strokes from the surrounding darker areas inward.

Eyebrows & Eyelashes:
With a very sharp pencil point, pull eyebrow hair and a few eyelashes on the left eye.

Shading & Final Details

See completed drawing on page 105.

For the final layer, you want to increase the value contrast in the drawing as well as add shading and details. Constantly refer to the photo as you work for the placement of darks and lights as well as any details you may have missed.

Head:
Darkening the left ear visually pushes it back from the right one. Continue to darken the forehead and nose with a dull pencil lead. Similarly, add an even tone over the cheek and around the white part of the muzzle. Then add dark fur strokes in the area slanting from beneath the eye to the nose. To bring the chin forward, lay an even light tone under the chin.

Chest:
Similarly, pull the chest forward by adding tone to the body to the left of the chest and to the legs and belly beneath it. Darkening the little shadow areas between the clumps of fur deepens the texture on the chest. Lay an even tone over the left and lower portions to make it appear more rounded.

Grass:
Outline the grass in front of the rabbit. Darken the blades to the left that lay over the background. With a very dull pencil lead, put in the background grasses with a few parallel strokes. TIP: Leaving a little white space between the two strokes gives the illusion of a highlight.

Whiskers:
Finally, pull the whiskers with a very sharp pencil lead.

Finish:
Sign and date your work. Spray with a coat of fixative to protect it. ❑

CUTE BUNNY
YOUNG RABBIT PORTRAIT

Jerry Walter titled this photo "Cute Bunny" – who could possibly argue with that? This is a great photo to use for drawing a rabbit's head because the features show clearly and the pose is so typical of these endearing creatures.

Supplies

- Light ivory acid-free drawing paper
- Near-white acid-free vellum drawing paper
- 5mm mechanical pencil with HB lead
- 5mm mechanical pencil with 2B lead

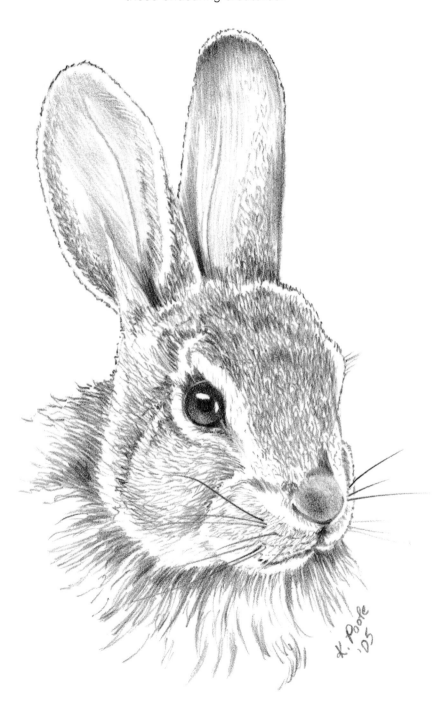

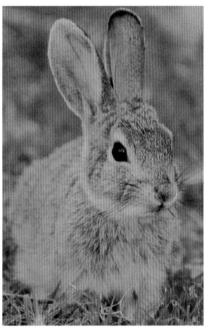

Photo credit: courtesy Jerry Walter, 2005

Observations

Although I am just drawing her head, I want to include some of the chest and back fur and will fade it at the edges vignette-style.

In the following sections, "right" refers to my right, and "left" to my left.

Establishing the Framework
METHODS: BASIC SHAPES, ANCHORS

Head Shape:
Her head is an oval that is slightly tilted. Using an HB pencil and a sheet of acid-free drawing paper, draw an oval at the correct tilt.

Centerline of Head:
Next, draw the centerline of her head. When you look closely at the direction of her fur, you'll see that her profile is somewhat flat along her forehead, then slants downwards to the base of her muzzle, then flattens out again. Be sure your centerline reflects this.

Eyeline & Muzzle Shape:
If you imagine a straight line from the bottom of her nose back through the eye to the base of the ear, you'll see that the eye and the line at the back of the muzzle divide this line roughly in thirds. Using that information, draw the eyeline and the little line at the back of the muzzle. Then rough in an oval for the muzzle shape.

Ears:
The ears are just slightly less long than the length of her face. The right one is vertical, while the left one slants slightly. Draw lines representing the centers of the ears. Place their bases at the top of the head, fairly close together and at equal distances from the head's centerline.

Refining the Sketch

Eye:
The eye is round and shiny, and highlights emphasize the shine. The eye is also very dark, to the point that the pupil, which is round, barely shows – but draw in the pupil nonetheless. (Drawing the eye a little lighter than it is in the photograph will provide more detail and interest.) The eye protrudes slightly, so that from this angle, the eyeball appears to overlap the lower lid in its center.

Face Fur:
The positioning of the light fur around the eye and towards the muzzle is important to the bunny's expression; draw it carefully. Also indicate the dark lines that define the edge of the muzzle and the folds behind and beneath the eye.

Nose:
The nose is very round and somewhat larger than the eye. It is completely covered with very short fur.

Ears:
The ears stand upright for two reasons – because they are cartilaginous, and because they curve around their vertical centerline and then join the head in a near circle, forming a modified tube. A prominent vein runs along the centerline of each ear. Because of the angle of the head, the tip of the right ear appears rounder than the left.

Body Fur:
The bunny's fur is made up of hairs that are tipped with taupe as well as a separate coat of soft under-fur. Because the hair is light-tipped, we see a narrow, light edge along the left edge of the head that visually separates the head from the chest and body.

Transfer Drawing:
When satisfied with your line drawing, transfer it to a sheet of vellum drawing paper for final drawing.

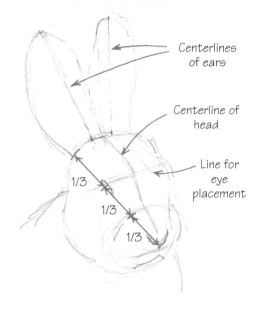

Framework Sketch

Centerlines of ears

Centerline of head

Line for eye placement

1/3

1/3

1/3

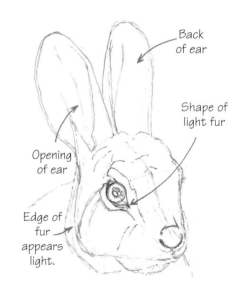

Refined Sketch

Back of ear

Shape of light fur

Opening of ear

Edge of fur appears light.

First Tonal Layer

In this first layer, concentrate on beginning to establish the texture of the fur and differentiating light from darker areas.

Eye:

Carefully outline the eyeball, the pupil, and the primary highlights. Lay a smooth medium tone over the iris and a dark tone over the pupil, but leave the highlights the white of the paper. As you darken the area immediately around the eye, pay careful attention to the shape. The darks are concentrated in the corners of the eye, with none above the eye and only a narrow band below it.

Left Ear:

The left ear opens toward the viewer. The inside of the ear is covered with extremely short thin fur, so the texture is smooth. Accordingly, lay in a light tone, keeping it as smooth as you can. Soften it further by lightly smudging it with your finger. The left and right edges have slightly longer fur – draw it with short, light, slightly criss-crossing strokes. As you work, be careful to leave a white edge around the ear.

Right Ear:

For the right ear, keep the texture very smooth except at the bottom and right edge – work those areas short, criss-crossed lines. Then deepen the shadows, referring to the photo for placement.

Face Fur:

Work the fur on the center of the face with short, slightly criss-crossing lines. Make the texture lines on the muzzle short and slightly smoother. Draw the ones on the cheek longer, following the curves of the face.

Body Fur:

On the body, both the chest fur and the back fur (on the left) are visible. Be careful to draw the texture lines in the correct direction. The chest fur is pretty long.

Nose:

The nose is soft and smooth.

Accents:

Add dark accents around the nose, behind the muzzle, and around the eye. Place a shadow underneath the right side of the face.

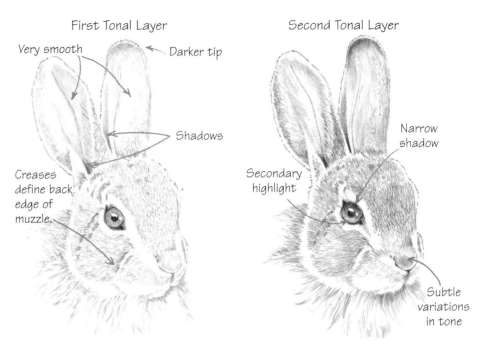

First Tonal Layer

Very smooth ← Darker tip

Shadows

Creases define back edge of muzzle.

Second Tonal Layer

Narrow shadow

Secondary highlight

Subtle variations in tone

Second Tonal Layer

Eye:

Deepen the upper portion of the eye, smoothing the transition to the light area at the bottom, which is the secondary highlight.

Fur Around Eye:

The light fur above the eye curves downwards, so there is a narrow shadow at the lower edge – draw this as a series of light strokes. Further deepen the corners of the eyes, and extend a light area in the middle of the white fur pointing towards the nose.

Other Fur:

Apply a second layer similar to the first. This both deepens the tone and enriches the texture. As you work, refer to the photo for guidance in placing relatively lighter and darker areas. For example, the face fur between the eyes is slightly darker than that on the forehead. Add detail around the muzzle to help define its form.

Shading & Final Details

See completed drawing on page 110

White Fur:

Except for the edges of the left ear and the small area of fur over the right eye, add light texture lines to the areas of white fur to deepen them very slightly.

Eye & Shadows:

Switch to the 2B pencil and deepen the eye (except for the highlights) and the shadows around the eye, on the ears, and around the nose and muzzle. Deepen the shadows on the chest and body to visually bring the head forward.

Mouth & Muzzle:

Deepen the mouth and add little splotches on the muzzle at the base of the whiskers.

Fur:

Deepen the brown fur bordering the white areas around the eyes to bring out the white fur and add detail. Using the photo as a guide, further deepen the darkest areas of the fur with more texture lines.

Whiskers & Eyelashes:

With a very sharp pencil lead, draw a few whiskers and eyelashes on the right eye.

Finish:

After signing and dating your work, protect it with a coat of spray fixative. ❑

TINY EARS
BABY COTTONTAIL

This darling baby cottontail was an orphan in the care of
Volunteers for Animals. Thanks to their dedication and care,
she was released back to the wild.

Instructions begin on page 114

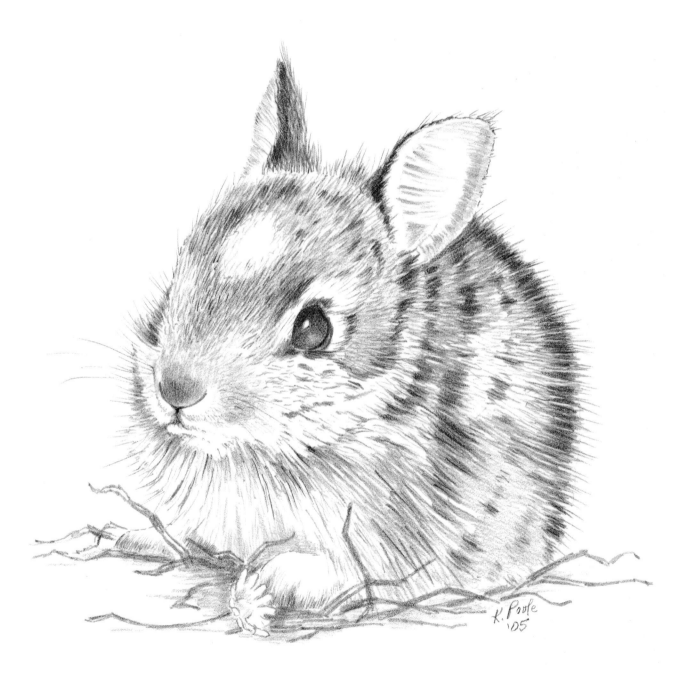

K. Poole
'05

Supplies

- Light ivory acid-free drawing paper
- Near-white acid-free vellum drawing paper
- 5mm mechanical pencil with HB lead
- 5mm mechanical pencil with 2B lead
- Compass

Observations

This baby rabbit will be fun to draw – she's all fluff. Because she's so young, her ears are still tiny and rounded. Some cottontails have little white stars on their foreheads, and I think I'll put one on her just for fun. I'm also going to add a flower.

In the following sections, "right" refers to my right, and "left" to my left.

Establishing the Framework

METHOD: BASIC SHAPES

Seeing the Shape:

This baby is very round! With your compass, discover that her eye is the center of a circle that touches the tips of her ears, her back at a point horizontal with her eye, and a point that is probably the lower edge of her body if it were visible behind the foliage.

Drawing:

To start, use the HB pencil on a sheet of acid-free drawing paper and sketch her eye. Then draw a circle centered on it. From there, block in the major shapes. As you proceed, notice that a straight line through the corners of her eye would intersect the tip of the right ear. Although the photo doesn't show a strong highlight, draw one in. Also sketch lines to place the dark stripes, and add front paws. She is all fur and eye, so the shape of the eye as well as the eyelids and light fur areas around it are very important.

Transfer Drawing:

Carefully transfer your line drawing to a sheet of vellum drawing paper.

First Tonal Layer

Eye:

Using the HB pencil, outline both the eyeball and the highlight. With a dull pencil lead, add an even medium tone.

Nose & Ears:

Add a soft tone to her nose and the inside edges of the ears, feathering away to nothing.

Fur:

Next, pressing fairly hard on the pencil, lay in the dark areas with back-and-forth, slightly criss-crossed strokes. Fill in with lighter strokes, but avoid the light areas around her eye, on her muzzle, her forehead star, and the lower rear side. Keep your

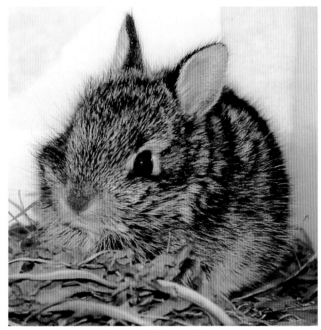

Photo credit: courtesy Dominique Shimuzu, 2004

Framework Sketch
Circle centered on eye.
Circle touches tips of ears.

Circle touches the edge of the back at the level of the eye.

strokes very short just above her nose and on her paws, short on her ears and face, a little longer on her back and side, and long on her chest.

Flower:

Lightly outline the flower and add a little shadow under her.

Second Tonal Layer

Eye:

Still working with the HB pencil, darken her eye, but avoid the highlight and go easy over the secondary highlight.

Fur:

Add a second layer of texture to both darken the drawing and add richness to the fur. As you work the dark areas, be careful to vary the length of your strokes so the edges of what appear to be her "stripes" are less regular. (She doesn't actually have stripes; each hair is tipped with black so the edges of curved shapes appear dark.)

Face:

Add more markings on her face by adding more small dark areas, referring to the photo for their placement.

Shading & Final Details

Fur:

With the HB pencil, lay in a very light tone over the entire rabbit except for the white areas around her eye and muzzle, the tops of the paws, the center area of her chest, and the star on her forehead.

Shadows:

Add shadows at the bottoms of the paws and on the chest behind the forward paw.

Right Ear:

Detail the right ear by deepening the areas between the white hairs coming from the inner edge. Also darken the area just inside the outer edge.

Guard Hairs:

With a very sharp pencil lead, pull tiny guard hairs around the edges of her body, face, and ears. Add several hairs in a pointed shape at the tips of her ears.

Whiskers:

Again using a very sharp pencil, pull a few whiskers from each side of her muzzle.

Grass & Flower:

With a dull pencil lead, draw the strands of grass and shade the flower. With horizontal strokes and dull lead, draw a shadow beneath bunny.

Increasing Contrast:

Switch to the 2B pencil and darken the eye and the dark areas in her fur. (Increasing the value contrast in this way adds sparkle to the drawing.)

Finish:

Sign and date your work, then protect it with a layer of spray fixative. ❏

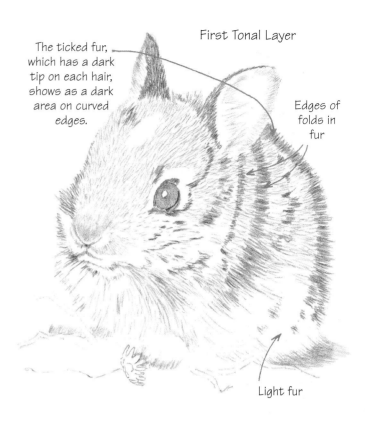

The ticked fur, which has a dark tip on each hair, shows as a dark area on curved edges.

First Tonal Layer

Edges of folds in fur

Light fur

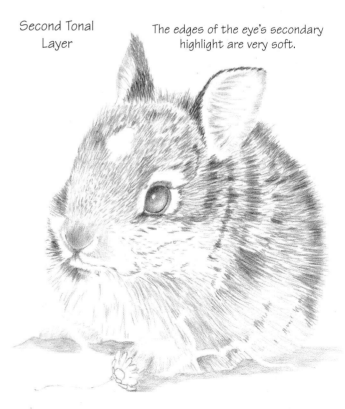

Second Tonal Layer

The edges of the eye's secondary highlight are very soft.

ALBERT RESTING
RABBIT PORTRAIT

Albert is one of the many rabbit members of the Dasher menagerie,
and he is quite photogenic.

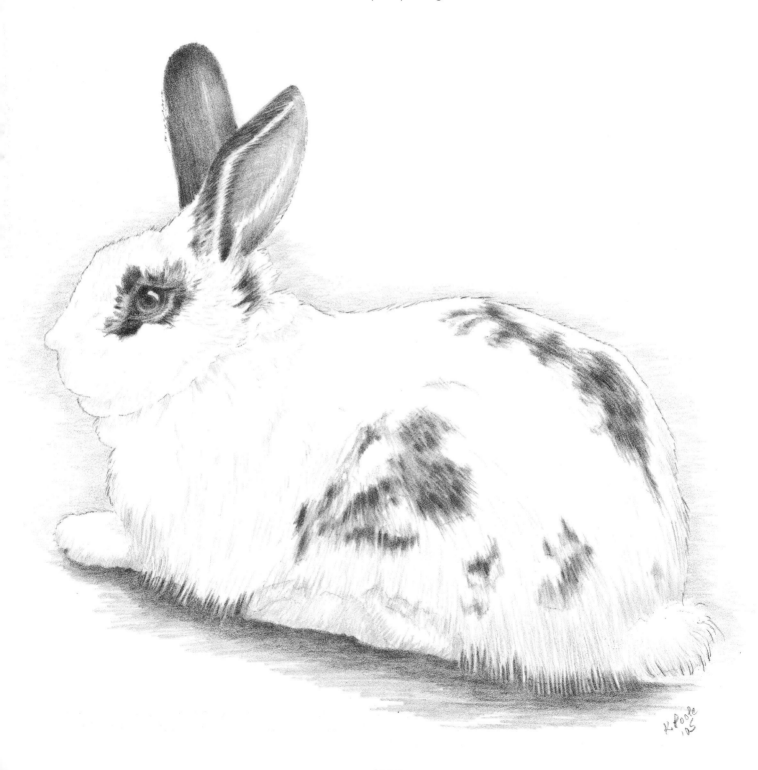

Supplies

- Light ivory acid-free drawing paper
- Near-white acid-free vellum drawing paper
- 5mm mechanical pencil with HB lead
- 5mm mechanical pencil with 2B lead
- Compass

Observations

I like this relaxed pose. It's simple, but has a few features that make it special. His body is turned slightly away from the viewer, giving us a clear view of the markings on the back half of his spine and his cute little tail. But his head is in full profile, with the ears angles jauntily. I also like the white fringe along the inside edge of his ear and the markings around his eye, especially the little bit of white beneath the eye, which really sets it off.

Albert's coat is mostly white, and drawing him on white paper will be an interesting exercise. With all the white, the viewer's attention will naturally focus on the face, so capturing the expression is very important. The expression is largely portrayed in the eye and the cocked ear.

In the following sections, "right" refers to my right, and "left" to my left.

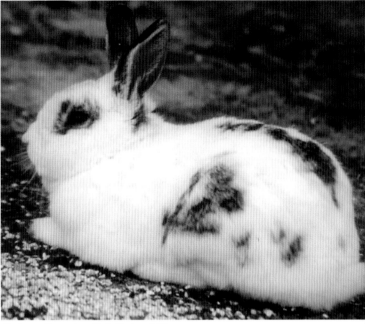

Photo credit: courtesy Karin Dasher, 2001

Establishing the Framework

METHODS: BASIC SHAPES, ANCHORS

Seeing the Shapes:

The most distinctive thing about Albert's shape is how round it is. His head is a flattened oval, and his body is a rounded mound. Using the HB pencil on a sheet of acid-free drawing paper, begin by drawing an oval for the head.

Measuring the Relationships:

Using a compass, discover a few crucial proportions. The length of his head is the same as the distance between the front of his chest and the forward edge of his hip. From the front of his chest to the tip of his tail is a little less than three head-lengths. His ears are as tall as his head is.

Drawing the Shapes:

Draw in the main shapes as well as the line of his spine and the line intersecting the corners of his eyes. His eye sits on an imaginary line midway between the top of the forehead and the jowl. As you place the eye on this line,

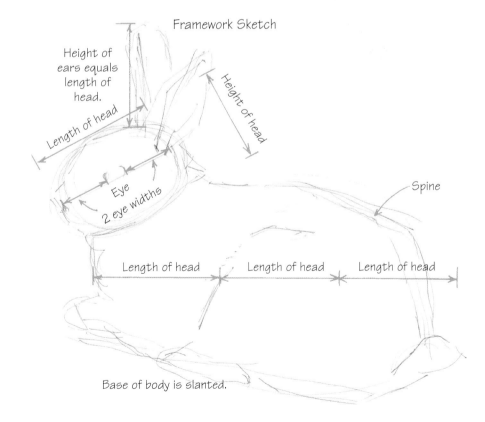

Framework Sketch

Height of ears equals length of head.

Length of head

Height of head

Eye

2 eye widths

Spine

Length of head — Length of head — Length of head

Base of body is slanted.

notice that there are about two eye-widths between the forward edge of the eye and the tip of the nose, and two eye-widths between the back edge of the eye and lower tip of the ear opening.

Refining the Sketch

Eye:

The eye has several parts – the eyeball itself, the lids, and the intricate fur markings around the eye. (In the photo it is difficult to distinguish some of these details, but it's important to be clear about them in the drawing.) When you study the photo closely, notice that the lids frame the eyeball in a squarish shape. The lids show on the bottom and on the forward portion of the top of the eye.

Forward Ear:

The forward ear has an interesting shape, angular on the front and rounded on the back. The ear is not a flat flap, but a roll shape, attached to the head in a near circle.

Overall Shape:

As I study my sketch, I see a few problems in the basic rabbit shape – I have the tail too high and the back isn't rounded enough.

Fur:

The line dividing the head from the body is pronounced because of the rolls of fat and luxurious fur on Albert's neck and chest. Place the markings as carefully as you can.

Transfer Drawing:

Carefully transfer the line drawing to a sheet of vellum - drawing paper.

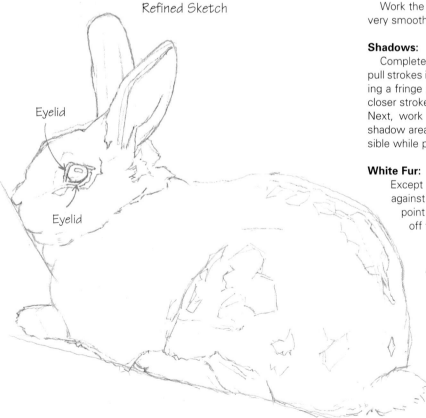

Refined Sketch

Eyelid

Eyelid

First Tonal Layer

The goal for this first layer is simply to establish the markings, the eye, and the shadow under Albert.

Eye:

Carefully outline the eye and pupil. Add tone – the iris is light, the pupil darker, and a small circle in the center of the pupil somewhat darker still. Avoid drawing over the highlight. The dark areas closest to the eyeball are the eyelids – work them in tiny strokes radiating from the eye.

Fur Around Eye:

Work the remainder of the markings around the eye with strokes in the direction of the fur.

Ears:

The fur on the ears is very short and velvety. Work the rear ear with long, smooth strokes along the length of the ear, leaving small slivers of white showing here and there. Along the very edge, work tiny strokes perpendicular to the edge. This gives a soft rather than a hard edge.

On the forward-facing ear, the two outer dark areas are the outside edges of the ear wrapping around to the opening. They are fringed with light fur. The inner dark area is the inside of the ear.

Markings:

Work the markings lightly with a dull pencil lead, striving for a very smooth look.

Shadows:

Complete the shadow underneath Albert in three stages. First, pull strokes into the fur areas at the haunch and lower chest, leaving a fringe of long white hairs between the strokes. Use much closer strokes under the feet because the fur is very short there. Next, work horizontal strokes along the entire bottom of the shadow area. Strive to make the shadow as even a tone as possible while preserving the softness of the white fur.

White Fur:

Except for the shadow areas, the rabbit's white fur lies against a white background. Accordingly, use a very sharp point to draw little hairs around this entire edge to set it off from the background.

Second Tonal Layer

In the second layer, darken the ears, spots, and eye. In the first layer, a lot of detail showed in the eye, whereas in the photo the eye is very dark. By defining the details early on and then gradually darkening the eye, the details will show slightly in the final drawing even though the eye will still be dark.

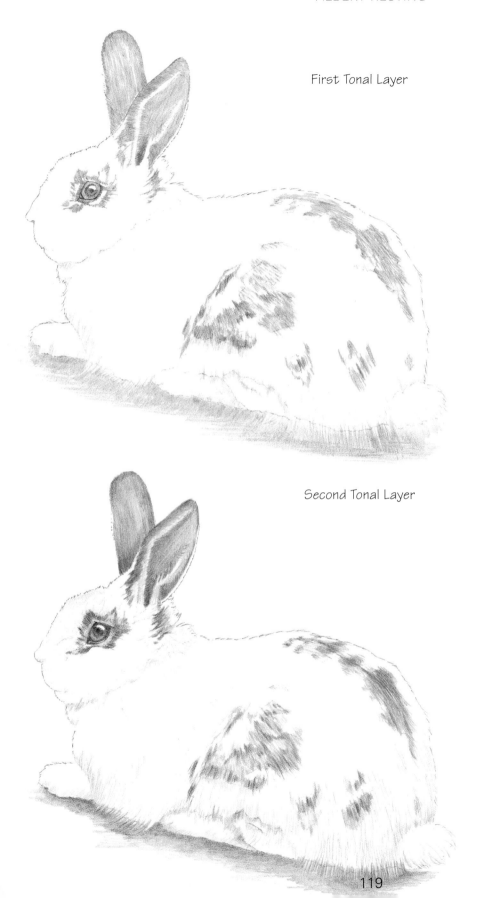

First Tonal Layer

Second Tonal Layer

Eye:
Darken the entire eye, except for the highlight, making the upper portion darker than the lower.

Ear:
As before, when you work on the ear, keep the tone as smooth as possible, especially on the inside of the forward-facing ear.

Markings:
As you study the photo, notice that Albert's spots contain a wide variety of tone and that the darkest tones tend to be towards the center of the spots. Try to render the spots as accurately as you can because the markings are a major visual clue to Albert's identity.

Shadows:
Deepen the shadow under Albert, then begin to add shadows to the white fur to bring out his round shape. Draw the shadows on his fur with very light lines in the direction the fur is growing. Shadows on the neck visually separate the neck from the head. There are also shadows under the folds of fur on the chest, where the body fur overhangs the back foot, on the lower edges of the feet, the lower portion of the body, and the back behind the tail.

Shading & Final Details

See completed drawing on page 116

Adding Depth:
In this layer, continue darkening the ears, eye, and spots, but this time use a 2B pencil for more depth. Darken the entire rear foot (it is completely in shadow). Also deepen the shadows on and underneath Albert.

Background:
Return to the HB pencil and, using a dull lead, add a light gray area in the background all around the white fur. This very light tone separates Albert from the background.

Finish:
Protect your drawing by applying a coat of spray fixative after signing and dating it. ❏

9 Squirrels

Squirrels are one of the few mammals who have success-fully adapted to living in close proximity with humans and, as a result, are among the most familiar of wild animals.

Most squirrel species spend much of their time in the trees, bounding confidently from limb to limb, searching for food and escaping from predators. They are incredibly strong and flexible creatures. Seemingly effortlessly, they flip, turn, and twist in mid-air to grab the next branch. In a matter of seconds they climb many tens of times their body length. And they are amazingly adaptive. Squirrels without tails and those with only one eye have been known to succeed in the wild.

Squirrels' eyes are large and round, and are often surrounded by a ring of lighter fur, making the eyes seem even larger. The irises are so dark that it's difficult to distinguish them from the pupils, giving the eye an overall black appearance. Their ears are upright and alert. Some species sport long tufts of fur on their ear tips. The whiskers are thick and abundant. The fur on the belly, insides of the legs, and chin is usually lighter than the rest of the coat and, in some species, is a glistening white.

The feet and paws are long, jointed like our hands and feet, and outfitted with thick pads that help grab and grip. There are four fingers on the front paws with a large fleshy nub in the location of a thumb. The back paws have five toes. The innermost toe is quite short, the middle three are long, and the outer one is somewhat shorter. The claws are long and curved.

The tail is thick, lush, and bushy. Squirrels use their tails for warmth and shelter, and also to warn enemies and communicate with each other. The more excited a squirrel becomes, the more wildly he flicks his tail. A squirrel's spine continues to nearly the tip of the tail, giving the animal a great deal of control over even the smallest tail movements.

Tip

Avoid subjects you know personally.
You will be more likely to be satisfied with a drawing of "a" golden retriever than a drawing of "my golden retriever, Goldie." Your standard for a good drawing of Goldie will be much higher because you know her every little detail.

Squirrels Worksheet

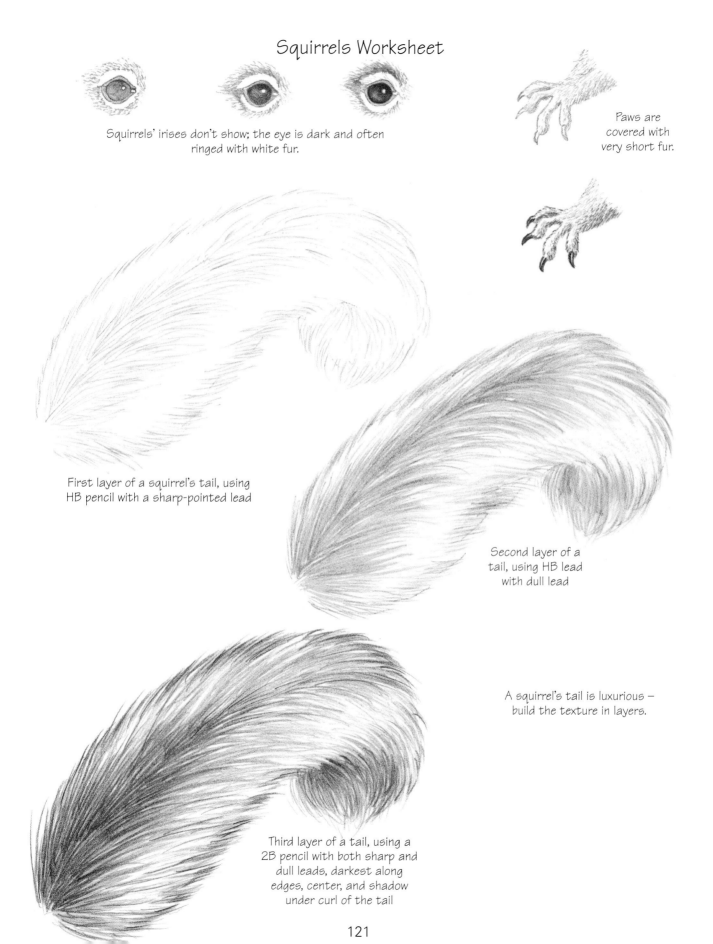

Squirrels' irises don't show; the eye is dark and often ringed with white fur.

Paws are covered with very short fur.

First layer of a squirrel's tail, using HB pencil with a sharp-pointed lead

Second layer of a tail, using HB lead with dull lead

A squirrel's tail is luxurious – build the texture in layers.

Third layer of a tail, using a 2B pencil with both sharp and dull leads, darkest along edges, center, and shadow under curl of the tail

SWEETHEART

FOX SQUIRREL

Fox squirrels are frequent visitors to Jerry Walter's backyard and he has taken several endearing photographic portraits. This one provides an excellent, detailed view of the squirrel's facial features.

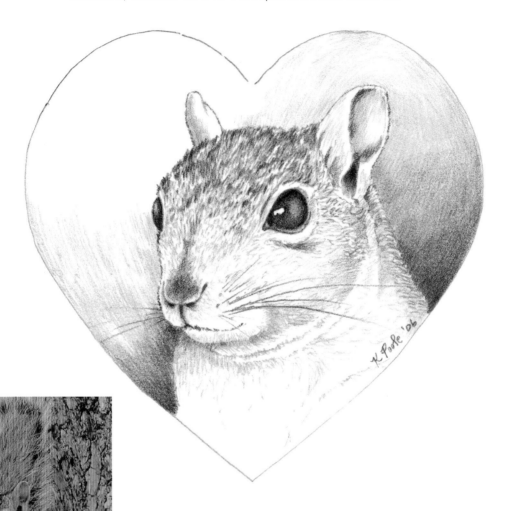

Photo credit courtesy Jerry Walter, 2005

Supplies

- Light ivory acid-free drawing paper
- Near-white acid-free vellum drawing paper
- 5mm mechanical pencil with HB lead
- 5mm mechanical pencil with 2B lead
- Card stock, 6" square
- Scissors or craft knife

Observations

A drawing of the squirrel's head in a heart-shaped frame will be a nice valentine for a squirrel lover! The photographer titled his photo "Munching," but since I'm eliminating the nut, I'll call my drawing "Sweetheart." I decide to frame the drawing with a heart shape, and to add a toned background to set off Sweetheart.

In the following sections, "right" refers to my right, and "left" to my left.

Establishing the Framework

METHOD: BASIC SHAPES

Oval Shape:

The squirrel's head is an egg shape pointed forward and to the left. Using an HB pencil and a sheet of acid-free drawing paper, begin your drawing with an oval.

Adding Lines:

The centerline follows the direction the egg is pointing – from the center of the forehead to the nose – and is important for correctly placing the features. The faint dark stripe running upwards from the nose is the lower end of this line. As it moves upwards, it curves to the right, then begins to flatten out at the top of the head. The top of the head is tilted slightly; draw a line to indicate that.

The line connecting the eyes is at a similar tilt but slightly rounded as it curves around the shape of the head. A line running from the back corner of the eye to the front corner points roughly to the center of the nose.

Ear Shapes:

Sketch rough shapes for the ears, noting their placement relative to the eyes, nose, and each other.

Refining the Sketch

Observations:

I see that the nose is a deeper and narrower U-shape than the one I initially drew, so I correct it. I also need to redraw the left side of the face beneath the eye so that it is nearly vertical.

Eyes & Mouth:

Sketch the left eye and the mouth. Although the left eye is nearly vertically aligned with the left edge of the nose, the right eye is far to the right because of the angle of the head – about one eye-width. Verify the angle between the corners of the right eye and sketch it in. The front corner is quite pointed while the back corner is nearly out of view, leaving the appearance of a smooth curve.

Ears:

The left ear is facing away, but the right ear is facing the viewer so the more complex structure of the inner ear shows. It is clear from this vantage point that the ear attaches to the head in a tall, narrow oval.

Muzzle:

The muzzle where the whiskers come from is slightly puffed out from the rest of the face. Lightly sketch its outline to help you place shadows and highlights later.

Neck:

This girl is well fed. Sketch a few fold lines around her neck.

Transfer Drawing:

When you're satisfied with your drawing, transfer it to a sheet of vellum drawing paper.

First Tonal Layer

Eyes:

Begin the eyes by carefully outlining them. Fill in the right eye with a smooth, even, medium-light tone, avoiding the highlights. On the left eye, grade the tone from medium-light at the bottom to nothing at the top.

Framework Sketch

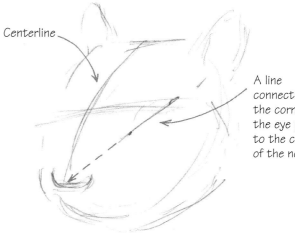

Centerline

A line connecting the corners of the eye points to the center of the nose.

Refined Sketch

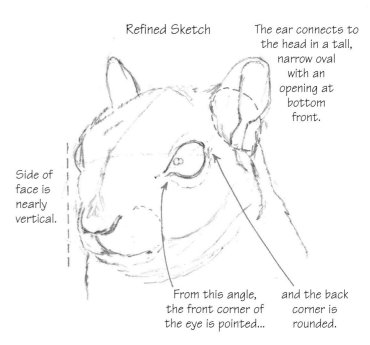

The ear connects to the head in a tall, narrow oval with an opening at bottom front.

Side of face is nearly vertical.

From this angle, the front corner of the eye is pointed... and the back corner is rounded.

First Tonal Layer

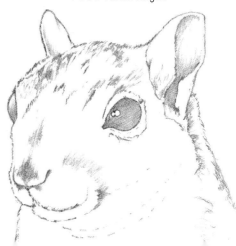
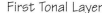

123

Nose & Mouth:

Outline the lower edge of the nose with a smooth line and the mouth with small, broken lines. The tone on the nose is soft and feathers away to nothing at the edges.

Fur:

To emphasize the edge of the squirrel, draw tiny strokes in the direction the fur is growing. Begin to create the illusion of depth in the ear by darkening the inner portion, especially at the bottom.

While working the fur, use short back-and-forth strokes in the direction the fur grows. At this stage, only lay in the darkest areas – the markings on the top of the head and the shadow area that separates the face from the back of the neck.

Second Tonal Layer

Eyes:

Increase contrast by deepening the tone. As you work the right eye, be careful to avoid the highlight, but also leave a lighter area towards the middle of the eye for a secondary highlight.

Nose & Ears:

Deepen your work on the nose and ears.

Fur:

In the first layer, the focus was on the darker areas. In this layer, cover all but the lightest areas on the chest and around the muzzle with texture lines. As always, be careful to run your strokes in the direction of the fur. Use the photograph as a guide.

The lines on the chest where the fur breaks are important because they suggest the forward position of the arms that are just out of sight. They also add visual interest – breaking the predictable pattern of the fur on the head and neck. As you work, create a variety of values consistent with the markings in the photograph by varying the pressure on the pencil.

Heart Shape:

To draw the heart, fold a square of card stock in half. Lay it over the drawing, aligning the fold with the vertical centerline of the drawing. Mark the card stock where you think the top, bottom point, and side of the heart should be, then sketch half a heart and cut it out. When you unfold the card stock, you'll have a heart-shaped frame. Position it over the drawing and draw a line around the inside of the heart. The frame provides the edges of the drawing. Extend the squirrel accordingly and erase any drawing lines that were outside the frame. Spray your drawing with fixative and let dry.

Shading & Final Details

See completed drawing on page 122

Deepening Dark Areas:

To further deepen the darks, use a 2B pencil. Darken the eyes, the inner ear, the nostrils, the shadows under the nose, the mouth, and the darkest areas of fur.

Light Shadows:

With the HB pencil, add light shadows around the muzzle, under the chin, and under the folds around the neck.

Whiskers:

Pull the whiskers with a very sharp 2B pencil.

Background:

Begin at the lower edges and lay in a soft, gently graded tone with the HB pencil. Deepen the lower areas with the 2B pencil.

Finish:

After signing and dating your work, protect it with a coat of spray fixative.

Second Tonal Layer

These breaks or folds signal that the squirrel's arm is bent forward.

ROXY
A WESTERN GRAY SQUIRREL

Meet Roxy, a young western gray squirrel. Nan Powers, a squirrel rehabilitator at Sierra Wildlife Rescue, took the charming photo of Roxy enjoying a snack. She is about fourteen weeks old, just about ready for release back into the wild.

Instructions begin on page 126

Supplies

- Light ivory acid-free drawing paper
- Near-white acid-free vellum drawing paper
- 5mm mechanical pencil with HB lead
- 5mm mechanical pencil with 2B lead
- Compass

Observations

The squirrels' large ears and eyes are a sign of youth. I have chosen to draw Roxy, the squirrel on the left. I will add the tip of her tail, which is out of range of the photo. I decide on a finished size of 5-1/2" x 7".

Before I begin to draw, I take a few minutes to look closely at the photo. Roxy is hunched over in a typical squirrel munching pose. As a result, her body looks wide from this angle. Her tail swirls gracefully over her head. Her head and upper half of her body are tilted slightly. This adds interest to the pose. Her upper lip overlaps the top edge of the nut. The white area to the viewer's right of her nose is actually her chest fur. I take a minute to clearly understand where the right edge of her face is. I notice that the inner edge of her left arm is obscured because the white fur on the inside of her arm blends into the white of her belly fur.

In the following sections, "right" refers to my right, and "left" to my left.

Establishing the Framework
METHOD: ANCHORS

Establishing the Size:

Use a color copier to enlarge the photo to the finished size. Lightly outline a rectangle 5-1/2" wide and 7" tall on a sheet of acid-free drawing paper.

Looking for Anchors:

Look for anchors to help you with proportions while you develop the initial sketch. Notice that the top edge of the left eye is about one-third of the height down the rectangle. The center of the same eye is about one-third the width of the rectangle going from right to left. Sketch the left eye in this position.

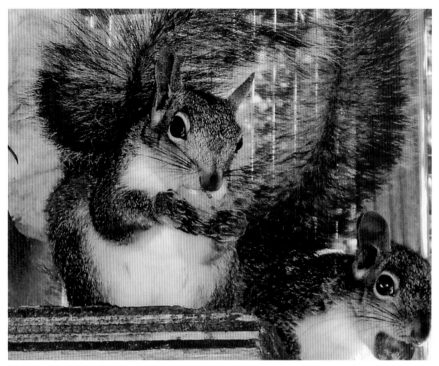

Photo credit: courtesy Nan Powers, 2005

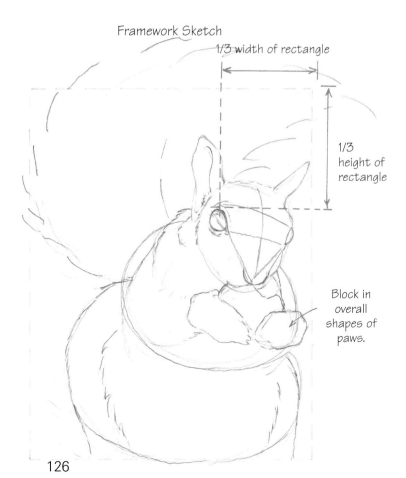

Framework Sketch

1/3 width of rectangle

1/3 height of rectangle

Block in overall shapes of paws.

Drawing the Shapes:

Roxy's head and body are three simple shapes: an egg shape for the head, a flat oval encompassing the arms and shoulders, and another flat oval encompassing the legs and lower body.

Tail:

Sketch the centerline of the tail and faint lines indicating its fluffy edge.

Facial Features:

Roxy's head is turned slightly to the side, so the centerline of her head will curve slightly to the right. Her head is tilted with the left eye higher than the right, so the lines between the top and bottom edges of the eyes will curve downwards as well. With these lines established, draw her right eye.

Using a compass, mark off the distance between the bottom corners of her eyes. Notice that the lower corners of her eyes and the bottom left point of her nose form a triangle. This helps you properly position her nose.

Ears:

The top edge of her head is a tilted line, mirroring the tilt of the line between her eyes. The top edge of her head is about one eye-height above the top of her left eye. Place the ears by noticing their vertical alignments with the eyes and nose.

Paws & Nut:

Rough in the paws and nut, noticing their positioning relative to eyes, nose, and ears.

Outlines:

Define the outer edges of the shoulders, arms, and body.

Refining the Sketch

Observations:

As I compare my sketch to the photo, I notice a few problems with the facial features. I have drawn the left eye too round and not slanted enough. I have the nose too short and fat and the tip of the left ear should be straighter. My first task is to correct these problems. TIP: If you know something's wrong – take a break, then work to fix it. This is how you learn.

Paws:

In the photo, the knuckles of the paws are quite prominent. Begin drawing the paws by placing small ovals in the positions of the knuckles. From there, draw the lines separating the fingers, and add the long claws.

Refined Sketch

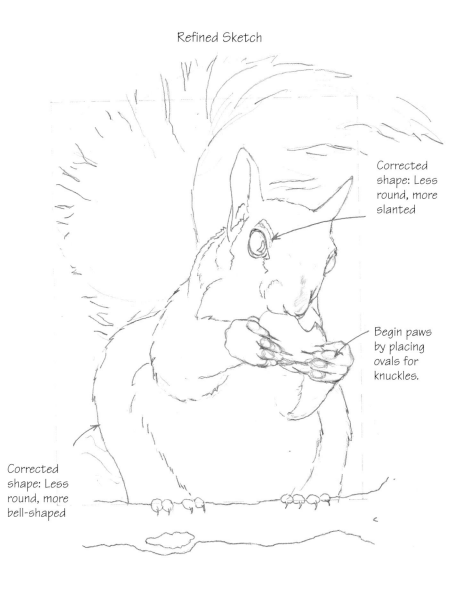

Corrected shape: Less round, more slanted

Begin paws by placing ovals for knuckles.

Corrected shape: Less round, more bell-shaped

Observations

I see that the line along the left side of the body is too rounded. The actual shape is more bell-like, so I correct it.

The photo shows Roxy sitting on a shelf in her cage. The camera is looking slightly up at her, so her feet don't show. I'd rather have her sitting on a branch.

Branch & Feet:

Using the drawing as a guide, sketch in the branch and the ends of her toes.

Transfer Drawing:

Carefully transfer your line drawing to a sheet of vellum drawing paper.

First Tonal Layer

In this first layer, establish the dark and light areas, begin the facial features, and begin texturing the fur.

Light Fur:

The white fur on her chest will be largely the white of the paper, but her gray fur is flecked with tiny, very white specks and the tail has some white hairs that are especially prominent on the left side. To create the white hairs and specks, incise them with the fine tip of a stylus, pressing into the paper to leave indentations. Because these indentations represent fur, make them in the direction the fur is growing. (When you draw over them later they will show as white.)

Similarly, incise long squiggly lines over the tail, pulling them from the center outward.

Eyes:

The first step is to carefully outline them and then fill the areas of the eyelids with a dark tone. Cover the eyeball with a

First Tonal Layer

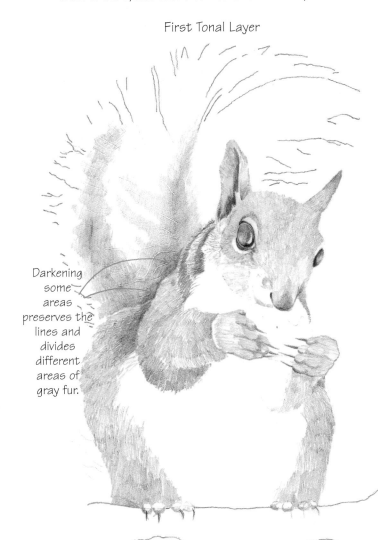

Darkening some areas preserves the lines and divides different areas of gray fur.

medium, even tone, but leave the highlight untouched. Also leave the area across from the primary highlight – the secondary highlight – a little lighter than the rest.

Nose:

The nose is velvety smooth. Cover it with a smooth, even tone, darkening it in the center and bottom.

Paws:

The fur on the front paws is very short. At this stage, work the paws with even .tones to begin establishing the shape by placing shadows. Use the shapes of the shadows to help define the roundness of the knuckles. Draw the claws with two heavy black lines, leaving a white highlight between the two lines. The claws are very long and sharp.

Gray Fur:

Establish the gray fur with gray tones, using a back-and-forth motion with lines very close together, working in the direction the fur grows. Use short strokes where the fur is short (ears and face) and longer strokes where the fur is longer (longer on the arms, and even longer on the legs and haunches). Where you are in danger of losing the lines from the drawing, add a little shading to lightly establish these lines. (Example: The line separating the edge of the back from the tail behind it.) At this stage, keep it light. You are simply establishing the location of the darker areas. Shadow and texture will be added later.

Left Ear:

Because the inner portion of the left ear is in shadow, darken this area.

Tail:

The part of the tail behind Roxy is the darkest. Add a gray tone to this area, feathering at the edges.

Second Tonal Layer

Eyes:

Although the eyes in the photograph are a uniform very dark shade, it's possible to create more value range in the drawing. In the left eye, break the large highlight in two. (If left as one highlight, it looks more like the white of her eye.) Leave a relatively light area opposite the highlight as a secondary highlight, giving the eye a transparent, shiny look.

Nose & Ears:

Darken the nose and ears by adding a second layer in the same manner as the first layer.

Fur:

Slowly build up color and texture with small strokes, crisscrossing them slightly to create a somewhat rough texture.

Tail:

Use a variety of techniques to build up the tail. First, as you draw, the incised lines become apparent as white lines. Second, add dark squiggly lines like the white ones. Build soft

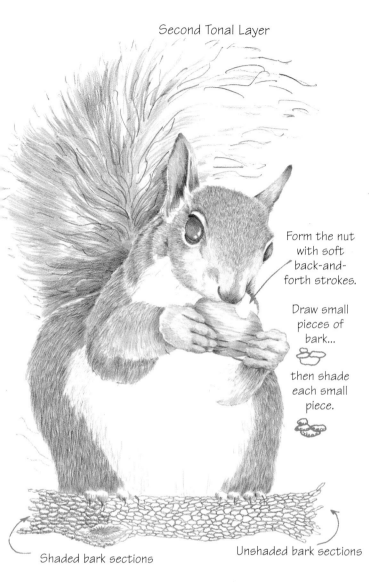

Second Tonal Layer

Form the nut with soft back-and-forth strokes.

Draw small pieces of bark...

then shade each small piece.

Shaded bark sections

Unshaded bark sections

Shading & Final Details

For the final layer, switch to the 2B pencil. The goal is to further deepen the dark areas to increase the value contrast in the drawing.

Eyes:
Darken the eyes dramatically, leaving the bright highlight. Blend smoothly into the mid-tone secondary highlight.

Dark Fur:
Deepen the darker areas in the fur. (This brings out the white incisings.)

Paws:
Increase the shadows in the paws to further define their form.

White Fur:
The white fur needs a little texture to make it more realistic. Add light texture lines. Also, draw light shadows on the neck and behind the left paw. A light gray tone on the belly helps blend the areas where the dark fur meets the light fur.

Tail:
Continue to add tone and dark lines until you are satisfied. Leave the right side wispy.

Branch:
To finish the branch, shade the overall structure, graying the bottom half of the branch. Further darken an area in the center of the grayed area to place the darkest area a little above the bottom edge rather than right along it. (The resulting slightly lighter area at the bottom edge is the reflected light.) Add shadows on the branch cast by the toes.

Whiskers:
Add the whiskers.

Claws:
Darken the claws.

Finish:
Sign and date your work, then give it a final spray of fixative.
❏

tonal areas of varying shades of gray against which the black and white lines appear in contrast.

Nut:
Form the nut with soft back-and-forth strokes, leaving highlights for ridges.

Branch:
Begin the branch by drawing the outline of the little sections of bark. Then go back and shade each little section with small back-and-forth strokes from the bottom edge up towards the middle. For the knot, add an even, medium tone in the middle. On the edges of the knot, draw small lines radiating outward, then shade along the bottom edges.

BACK TO THE WILD

FOX SQUIRREL

As a squirrel rehabilitator with Sierra Wildlife Rescue, I was privileged to raise four abandoned fox squirrel babies in the summer and fall of 2004. When I received them, they were so small that their eyes were still closed. But they were healthy babies, and with proper care grew to young adults. After spending four weeks in a large, outdoor cage, they were released into the wild. This is one of the girls exploring her new world on release day. In this picture, she is about four months old.

Supplies

- Acid-free drawing paper
- Tinted textured drawing paper – Oyster
- 5mm mechanical pencil with HB lead
- 5mm mechanical pencil with 2B lead
- Colored Pencils – Yellow Ochre, Orange, Cream, Marine Green, White, Black
- Compass
- Ruler

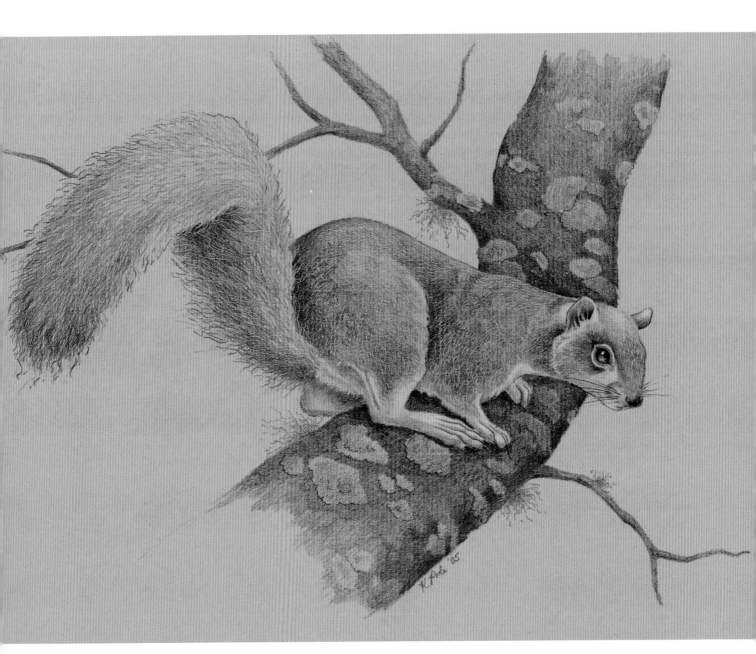

Observations

Fox squirrels have a lovely reddish tint to their coats, and their bellies are a soft caramel color. They are lovely, lively little animals. Because this squirrel has such warm colors, I will do the final drawing on colored paper and use a few colored pencils to add color.

I like this pose because it is a little unusual. She is still, but the pose is full of action – she seems ready to spring off the tree trunk at any moment. If we could see her from above, we would observe that her spine is curved in a gentle arc – both her hips and her head are turned slightly towards us. The tree trunk is relatively large, and her paws follow its gentle curves.

Although I will do my final drawing on colored paper, I develop my line drawing on acid-free drawing paper to allow for plenty of erasing and re-working. In the following sections, "right" refers to my right, and "left" to my left.

Establishing the Framework

METHOD: BASIC SHAPES

Establishing the Size:

The squirrel fits inside a rectangle that is about twice as long as it is high. Using an HB pencil on a sheet of acid-free drawing paper, draw a 4" x 8" rectangle. This size fits nicely on the paper and it's the correct proportions – twice as long as high.

Defining the Shapes:

The squirrel's head and body are three ovals. The oval comprising the hips is the largest and is nearly round. Its axis tilts slightly backwards. The oval comprising the shoulders and upper arms is smaller and narrower, and tilts forward a little more than the hip oval tilts backwards. The head is a slightly pointed oval – an egg shape – and its axis is quite slanted.

Draw these ovals, using a compass to check relative sizes. Use a see-through ruler to check the tilts on the oval by placing the photo on the table just to the left of the rectangle on the drawing paper and lined up with it. Line up the ruler with the axis on the hip oval, for example, then slide the ruler straight to

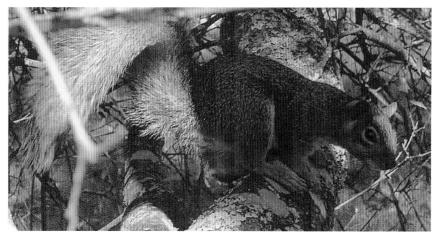

Photo credit: courtesy Kaaren Poole, 2005

Framework Sketch

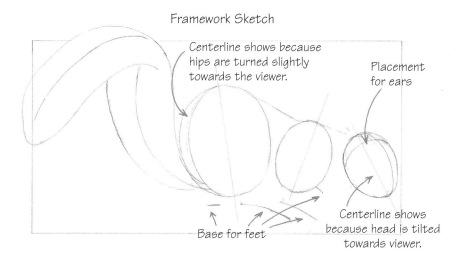

Centerline shows because hips are turned slightly towards the viewer.

Placement for ears

Base for feet

Centerline shows because head is tilted towards viewer.

the left without changing its tilt until it is over the hip area on the photo. Does the tilt seem the same? If not, adjust accordingly and try again.

Centerlines:

Draw the centerlines on the front and back ovals. The centerline on the back oval indicates that the hips are turned slightly towards the viewer. Likewise, the centerline on the front oval indicates that the head is turned slightly towards the viewer. Note that the centerlines begin and end where the axis line intersects the oval.

Head:

Draw a line curving around the top part of the egg-shape that represents the head. (This is to help you position the ears.)

Tail:

Rough in the shape of the tail, beginning with the centerline. Add lines to indicate the outside edges.

Paws:

Sketch lines roughly indicating the bottoms of the feet and front paws. Notice that they follow the gentle curve of the log she is sitting on.

Refining the Sketch

Head:
Draw the head. The front edge is somewhat flattened and the nose is pointed and a little up-turned. The muzzle is squarish. When you are satisfied with the general shape of the head, place the eye and ears.

Eye:
The eye appears to be centered on the face. Using a compass, verify that the distance from the center of the eye to the tip of the nose is the same as the distance from the center of the eye to the back of the head. Likewise, verify that the center of the eye is halfway between the forehead and the chin. Place the eye accordingly. The eye is almond shaped, wider towards the back and narrower towards the front. Because we are viewing her from slightly above, the upper eyelid appears narrower than the bottom one.

Ears:
We see the right ear from behind and the left ear from the front. The ears attach to the head in a curve. The edges of the left ear appear to curl towards us.

Nose:
The details of the nose are difficult to see in the photograph, but you can see the left nostril. Because her face is turned slightly towards the viewer, a tiny bit of the right upper lip as well as the full left lip would be visible. Draw them.

Hips & Black Legs:
The front edge of the rear leg is nearly vertical, but tilts slightly towards the rear. A fringe of ruddy belly fur shows at the bottom edge of her haunches.

Tail:
In framework sketch, the forward edge of the tail is too far back. Also, in that sketch, the upper curve of the tail is too high. I made these corrections, then sketched the edge of the tail as a series of small broken lines.

Neck & Forearms:
Draw the neck and forearms.

Feet:
The four paws are planted firmly on the curve of the log. Use your compass to discover that her back paw is as long as her head, and that her front right paw is the same length as the distance between the back corner of her eye and the tip of her nose. Observe how close together these two paws lie on the log. Also pay attention to the negative space between her body, rear right foot, and front right paw. These clues help you produce a better likeness.

Log:
Draw in the outline of the log, then the splotches of lichen. Curve the lichen splotches around the log as a visual prompt to its shape. A few clumps of feathery moss (even though they don't appear in the photo) are a nice touch.

Transfer Drawing:
Carefully transfer the line drawing to a sheet of tinted paper. The approach is to complete the detail and value using a graphite pencil, then add highlights and very light hints of color with the colored pencils.

First Tonal Layer

Eye:
Outline it, then fill it with an even medium tone, drawing around the highlight. Outline the eyelids. Add a medium-light value to the ears, being careful to leave the light areas untouched.

Fur:
Use a stylus to incise lines into the paper that will become the light tips of the fur on the face, body, and legs. (When you add tone later, these incisings will show as lines the color of the paper.) Using short back and forth strokes, cover the face, body, and legs, going darker in the shadow areas and lighter in the highlight areas. Leave the lightest fur on the face, belly, and feet untouched. Because of the texture in the paper, the individual strokes barely show, but work in the direction the fur grows.

Tail:
Incise the light hairs with the stylus. These hairs are somewhat kinky. Add an even medium tone to the shadow areas. On the remainder of the tail, draw individual hairs, placing them more closely in the

Refined Sketch

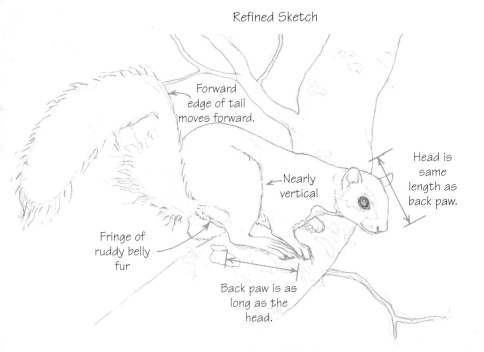

Forward edge of tail moves forward.

Nearly vertical

Head is same length as back paw.

Fringe of ruddy belly fur

Back paw is as long as the head.

darker areas and further apart in the lighter ones.

Log & Branches:

Darken the log and branches by working back and forth with the pencil in small areas, varying the value somewhat from area to area for texture. Place the darkest tones closest to the squirrel. For now, leave the lichen shapes alone.

Second Tonal Layer

For the second layer, switch to the 2B pencil to deepen the darker fur, add shadows, and define form.

Head:

Darken the eye to as close to black as possible, but avoid the primary highlight and blend smoothly into a lighter area at the lower right for the secondary highlight. Also darken the inner ear. For the darker fur on the forehead and around the eye, work closely spaced tiny strokes in the direction the fur grows.

Body:

To add form to the body, add dark tones in the shadow areas on the neck behind the head, on the side in front of the back leg, on the rump behind the tail, and along the tip and lower section of the tail.

Tail:

Continue to add long, kinky strokes until you have a deep enough tone.

Branch:

Deepen the shadow areas under the squirrel. Outline the lower edges of the lichen splotches with small scalloped lines. Add a light tone to the lichen. To round the branch, add darker shadow areas along the edges of the main branch and on the lower sides of the smaller branches.

Whiskers & Moss:

With the HB pencil, draw the whiskers and the small clumps of feathery moss.

Shading & Color

Light Values:

The first step with the colored pencils is to add the lightest values using White and Cream. The primary highlight in the eye is White. The light areas on the fur are Cream with White highlights.

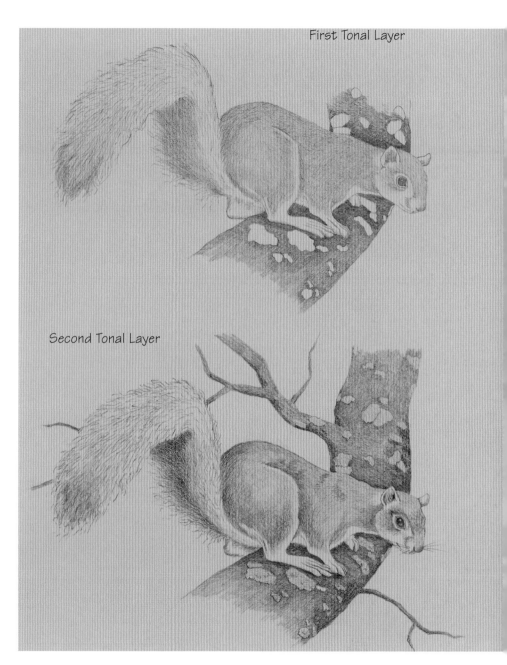

First Tonal Layer

Second Tonal Layer

Dark Values:

To further deepen the darks, use the Black colored pencil to darken the eye, the inner ear, and the deepest shadows on the body, tail, and log.

Color:

Slowly add tints of Yellow Ochre and Orange in the light areas of the fur, but be careful not to add so much color that the value darkens too much. A little Marine Green adds the slightest bit of color to the lichens and the bases of the clumps of moss.

Finish:

After signing and dating your work, protect your drawing with a coat of spray fixative. ❏

10 Raccoons

We know raccoons by their striking black masks and ringed tails. A few months ago I was fortunate enough to visit our local raccoon wildlife rehabilitator and his four young charges. The youngsters were juveniles, about four months old, and still too young to release to the wild. Seeing them, I was struck not just by their beauty but also by their behavior. They were constantly working their hands, touching and investigating everything in sight.

It is this behavior that gave them their name. In 1612 Captain John Smith of Jamestown wrote of an animal that the local native Americans called *aroughcun,* meaning "he scratches with his hands." Our word, raccoon, derives from this. The Biloxi Sioux name for raccoon is *atuki,* meaning "he touches things."

Raccoons' hands and feet look so like ours. Their fingers are long and mobile, and they have a fine sense of touch. They are also agile climbers. The claws look like fingernails.

Their eyes are round and very dark. If it weren't for highlights in their bright eyes and along the dark skin of the lower lids, the eyes would be lost in their mask. The nose is very round, black, and shiny. The muzzle is pointed and equipped with a multitude of stiff white whiskers. The body and tail fur is long and somewhat coarse.

These are magnificent animals, and their distinctive markings and interesting behaviors make them fun to draw.

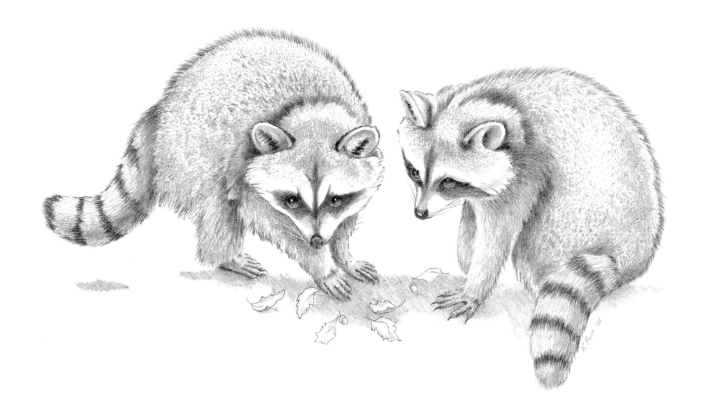

Raccoons Worksheet

Eyes

 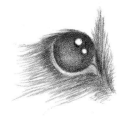

Even though the fur of the mask is very dark, it's important to have texture for a realistic look.

The dark eye would disappear into the mask if it weren't for the highlights on the eye and on the black skin of the lower lid.

Nose

The nose is round and dark.

Highlights provide shine.

The whiskers are actually white.

Paws

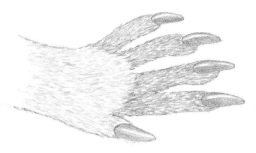

The front paws look so much like human hands, and the claws look like fingernails.

FROM A HOLLOW TREE
RACCOON PORTRAIT

I find this photo of a raccoon peeking out from a hollow tree trunk irresistible. The tilt of the head, the bright shiny eyes and nose, the magnificent white whiskers, his bandit mask and fluffy fur, all combine to make an unforgettable portrait.

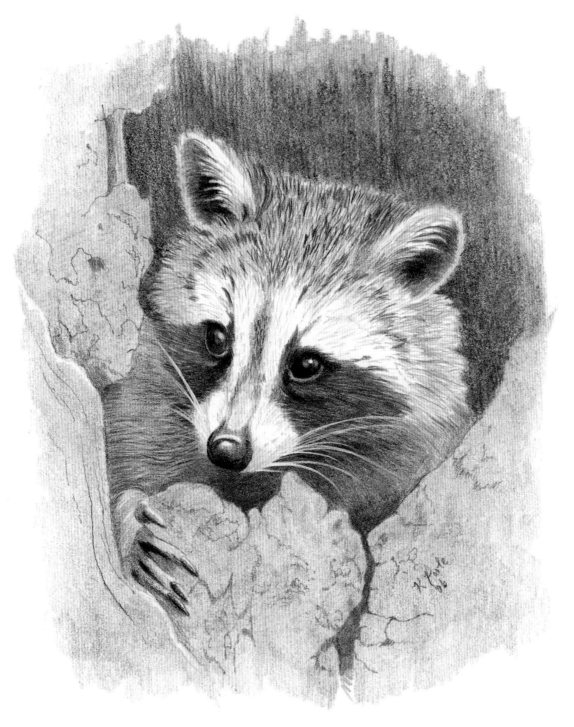

Supplies

- Light ivory acid-free drawing paper
- Near-white acid-free vellum drawing paper
- 5mm mechanical pencil with HB lead
- 5mm mechanical pencil with 2B lead
- Watercolor Pencils – Dark Brown, Dark Umber, Cool Grey
- White gouache • #00 scroller brush
- Strong paper towels • Compass

Observations

Luc Giroux's composition, with the raccoon right of center, is beautiful. But in my drawing, I am going to center the head and surround it with just a little of the tree trunk.

There is a lot of dark area in this photo, so I decide to use watercolor pencils to quickly darken the background. I'll also use watercolor pencils to add touches of color to the drawing. The background colors in the photo (dark brown on the inside of the hollow trunk and gray on the outside) work well with the colors of the raccoon, who is primarily black, white, and shades of gray, but who also has brownish tinges on his fur here are there. I will be able to later pick up the background colors as tints in the fur to unify the drawing.

Watercolor pencils can be tricky – they look so much darker after they're dampened. I decide to do the background before I work on the raccoon. That way, if I don't like the background, I can start again without having wasted much effort.

In the following sections, "right" refers to my right, and "left" to my left.

Establishing the Framework

METHODS: BASIC SHAPES, ANCHORS

Seeing the Shape:

The raccoon's head is a circle with the nose, eyes, and ears forming a V-shape. The centerline of the V is slightly tilted, as is the animal's head. To begin the sketch, use the HB pencil and a sheet of acid-free drawing paper to draw the circle and V.

Discovering the Relationships:

Place the nose and ears on the circle. Use your compass to discover that the eyes lie halfway between them, and sketch them in. The tufted, furry cheeks extend beyond the circle, as does the thick fur at the top of the head. Make lines to suggest them. Sketch the edges of the main shapes of the log. Place the hand.

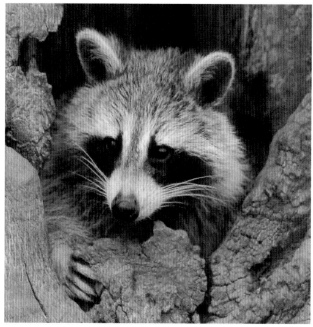

Photo credit: courtesy Luc Giroux, 2005

Framework Sketch

Centerline of V-shape indicates the tilt of the head.

The distance from the base of the ear to the center of the eye is the same as the distance from the center of the eye to the nose.

Refining the Sketch

Eye:

Although the eyes are very round, the upper and lower lids meet at a point at the inner corner. The lids meet at the outer corner in a more rounded pointy shape. The inner corners are at the bottom of the eye while the outer ones are at the top. From this angle, we see the thickness of the bottom lids. Carefully draw the shapes of the eyes and lids, and add the highlights. The highlight on the right eye is larger than the one on the left.

Nose:

The nose is quite round, and the nostrils are visible from this angle. All the edges of the nose are sharp except for the top edge, which fades smoothly into the white fur.

Muzzle:

The muzzle appears to have a ridge along the top edge, indicated by the shapes of the dividing lines between the white fur on the nose and the black fur of the mask.

Mask:

The eyes are at the top edge of the mask, but little dark points extend upwards at the inner corners of the eyes. The white stripe between the eyes is divided by a brownish gray stripe down the center.

Ears:

From this angle, since the head is tilted slightly downwards and to the side, we see a little of the back of the left ear. The insides of the ears are lined with thick fringes of light fur.

Fingers:

The fingers are long and curve around the piece of log. The claws are dark, long, and pointed.

Transfer Drawing:

When you are satisfied with your drawing, carefully transfer it to a sheet of vellum drawing paper.

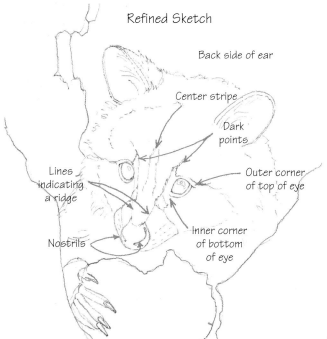

Refined Sketch

Back side of ear

Center stripe

Dark points

Outer corner of top of eye

Lines indicating a ridge

Inner corner of bottom of eye

Nostrils

First Tonal Layer

In this first layer, start by using watercolor pencils to darken the background. Then use both the HB and 2B pencils.

Inside of the Trunk:

Lay in an even, fairly dark tone of Dark Brown watercolor pencil. Go back over it with Dark Umber. Work darker close to the animal and grade to a lighter tone further away from him.

Outside of Trunk:

Lay a tone of Cool Grey over the outside of the trunk.

Dampening:

To bring out the watercolor effect, soak a strong paper towel in water, wring much of the water out so the towel is wet but not dripping, and smooth the towel out flat. Lay it over the drawing and press the wet towel on the surface without moving it around. (This dampens the watercolor pencil and causes the color to dissolve and deepen in tone.) Immediately and carefully remove the paper towel. Allow the drawing to dry completely before proceeding.

Dark Areas:

Beginning with the darker 2B pencil, work the eyes, mask, nose, the central area of the chest, and the inner ears. Draw an even medium-dark tone over the eyes and nose, carefully avoiding the highlights. Work the mask with close-set lines in the direction the fur grows. For the inner ears, work from the dark center areas outward, but don't touch the white hairs growing from the inner edges of the ears. Finally, draw an even, dark tone on the center area of the chest underneath the muzzle.

Gray Fur:

Switch to the HB pencil and work the texture of the gray fur with close set lines in the direction the fur grows. (Criss-crossing the lines slightly portrays the rough texture of the fur.) On the muzzle these lines are very short, but they are medium length on the head and longer on the left and right sides of the chest.

White Fur:

Place a few lines on the white fur to add texture without deepening the tone much.

Fingers & Nails:

Working with the HB pencil, shade each finger and nail. The back of the hand is covered with long hairs flowing around its curved shape.

Second Tonal Layer

The main task for the second layer is to deepen the values. Work with the 2B pencil for this layer.

Fur:

To deepen the value on the gray fur of the head and shoulders, add more texture lines. Press harder for the darker areas and to create the bands of dark markings on the head.

Features:

Deepen the eyes, nose, and inner ears with even tones. While adding a light tone to the outside portions of the lower lids, carefully leave a highlight in the centers.

First Tonal Layer

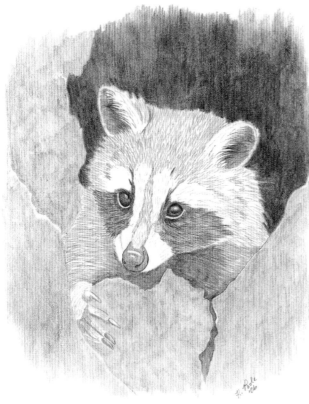

Second Tonal Layer

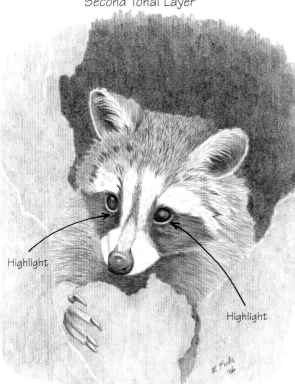

Highlight

Highlight

Chest Fur:

The chest fur is in deep shadow so texture isn't visible. Darken this area with an even tone, but be careful to preserve a smooth gradation to the textured areas of the shoulders.

Paw:

Deepen the shadows areas on the paw, creating more contrast and more form.

Shading & Final Details

Gray Fur:

With the 2B pencil, add more dark texture to the gray fur on the head to create contrast.

Light Areas:

At this stage, it's necessary to tone down some of the light areas. Use the HB pencil to lightly shade the outer light-colored edges of the ears, the base of the inner light-colored edges of the ears, the lower eyelids, and the lower portions of the white muzzle that lie in shadow.

Eyes & Nose:

Further darken the eyes and nose. Be careful not to lose the details of the nostrils.

Shadows:

To bring out the face, you must darken the body. Add dark tone with the 2B pencil. At this stage there is little differentiation between the dark mask and the shadow areas on the chest and neck.

To push him into the hollow log, shade the fur near the edge of the hollow log, especially on the left. Also add shadows on the log beneath the paw and fingers.

Log:

To add texture to the inner portion of the hollow log (the brown area), draw a series of close-set parallel vertical lines with the 2B pencil. Then deepen the left and lower edges of the brown areas.

The texture on the outer portion of the hollow log is simply squiggly pencil strokes. Draw them, using the photo as your guide. Of course, you can't add every single texture mark; suggesting them is sufficient.

Adding Color:

Note: Before proceeding to add tints of color with the watercolor pencils, it's necessary to protect the drawing with a layer of spray fixative. Let dry. (If you don't fix the graphite, it will run when you dampen the watercolor pencil.)

Carefully add just a little Dark Brown watercolor pencil to the base of the ears, the center stripe running up the muzzle, randomly in the gray fur, and randomly on the gray areas of the log. This needs to be very light, or it will be too dark when you add water. To dampen it, dab carefully with a moist paper towel. Let dry.

Eye Highlight:

Add a highlight dot in the right eye with white gouache.

Whiskers:

Paint the whiskers with white gouache, using a script liner.

Finish:

To protect your drawing, spray it with a coat of fixative after signing and dating it. ❏

SCOTTY'S FIRST DAY OUT
BABY RACCOON

Scotty is one of seven baby raccoons rescued by Diane Lee Long, a dedicated wildlife rehabber. They were severely at risk and the odds of their survival were small. But with love, devotion, and proper care, Diane successfully raised four of them and was able to release them to the wild. This charming photo documents Scotty's first supervised outing.

Supplies

- Light ivory acid-free drawing paper
- Near-white acid-free vellum drawing paper
- 5mm mechanical pencil with HB lead
- 5mm mechanical pencil with 2B lead

Observations

The look in his eyes says it all – "Mom!" I am going to omit the branch in front of his face. His hands are so similar to human ones! His weight is on the two rear feet and the right hand.

In the following sections, "right" refers to my right, and "left" to my left.

Establishing the Framework

METHOD: BASIC SHAPES

Seeing the Shapes:

This baby raccoon is a series of simple shapes, but before you begin to draw, you need some proportions. With a compass, notice that his entire body is three times the height of his head. Using an HB pencil and a sheet of acid-free drawing paper, place marks along the left side of the paper to guide you as you block in the head and body.

Drawing the Shapes:

For the head, draw a flattened circle between the top two marks. The imaginary line connecting the eyes curves slightly and is about halfway down the head. The muzzle is another flattened circle. The ears are triangles with rounded tips, and the left one is turned slightly downwards.

His arms and left hind leg are tubes, and his body is two egg shapes, one sitting below and behind the other. Block in each hand as two shapes, one representing the upper hand and the other the fingers.

As you look closely at the photo, see the right rear foot on the thick branch next to the right hand. (It is mostly hidden behind the branch growing upwards.) You can also see the right hind leg and hip behind and to the right of the branch.

Branches:

Draw a branch coming in from the right that covers the right side of the face just slightly.

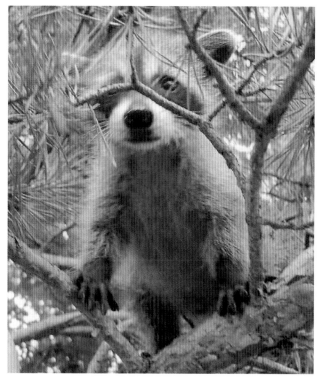

Photo credit: courtesy Diane Lee Long, 2005

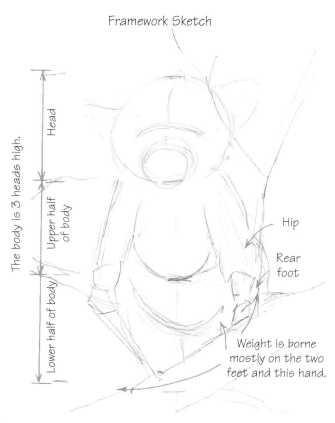

Framework Sketch

The body is 3 heads high.

Head

Upper half of body

Lower half of body

Hip

Rear foot

Weight is borne mostly on the two feet and this hand.

Refining the Sketch

Observations:

The eyes and mouth convey a worried look that will be important to capture. The outer corners of the eyes are slightly lower than the inner ones. This may be partly because we are looking up at him, but it is a visual signal for worried. The mouth is wide, but unsmiling.

I find this little guy quite challenging to draw because his body has few visual clues to distinguishing the body and arms from each other. But I realize that the breaks between the light and darker areas on the arms, leg, and chest provide important clues to understanding his pose. The two arms are coming forward and his chest angles back.

Because it is such a distinctive feature of raccoons, I decide to draw in the tip of the tail even though I don't see it in the photo.

Face:

Observing the photo, draw the facial features.

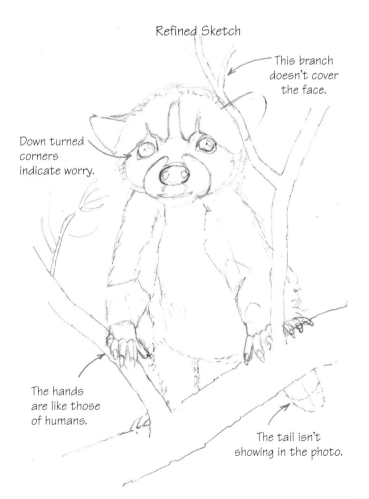

Refined Sketch

This branch doesn't cover the face.

Down turned corners indicate worry.

The hands are like those of humans.

The tail isn't showing in the photo.

Body:

Using horizontal and vertical alignments to guide you, draw in the arms, legs, feet, hands, and body. For example, the top edges of the two hands are horizontally aligned.

Tail:

Draw in the tip of tail.

Transfer Drawing:

Carefully transfer your line drawing to a sheet of vellum drawing paper.

First Tonal Layer

The goal in this first layer is to simply establish the basic forms and begin the texturing.

Eyes:

Fill them with a medium tone, avoiding the highlights.

Face:

The whiskers are a significant feature. Incise several with the thick end of a stylus, then incise hairs in the ears with the narrow end. Lay a medium tone over the mask and front face of the nose, making strokes parallel to the incised whiskers to bring them out. As you work the mask, be careful not to come all the way to the nose. Leave the highlight on top of the nose.

The nostrils are lighter than the rest of the nose. Ordinarily they would appear very dark, but in this pose the sunlight is shining through the nose, slightly brightening the inside of the nostrils. Darken the mouth with tiny up-and-down strokes to leave a fuzzy edge on both the top and bottom, then darken the area between the nose and mouth.

Ears:

Darken the ears, working in the same direction in which you incised the hairs. On the right ear, the lower edge is darker than the upper one. On the left ear, a small bit of the top of the ear shows, and it is dark.

Paws:

The fur on the paws is very short. The nails are dark. Work the paws and nails with a dull lead and short strokes – the goal is to begin to create the form with medium and light tones. Leave the highlights on the nails the white of the paper.

Body Fur:

Work the body fur with medium length back-and-forth strokes in the direction the fur grows, criss-crossing them slightly to give a fuzzy look. Pay attention to the lines you drew that indicate where the darker and lighter tones meet, using darker or lighter values on each side of the lines as in the photo. At this stage, leave the center of the belly untouched. The fur is fairly light at this stage of the drawing.

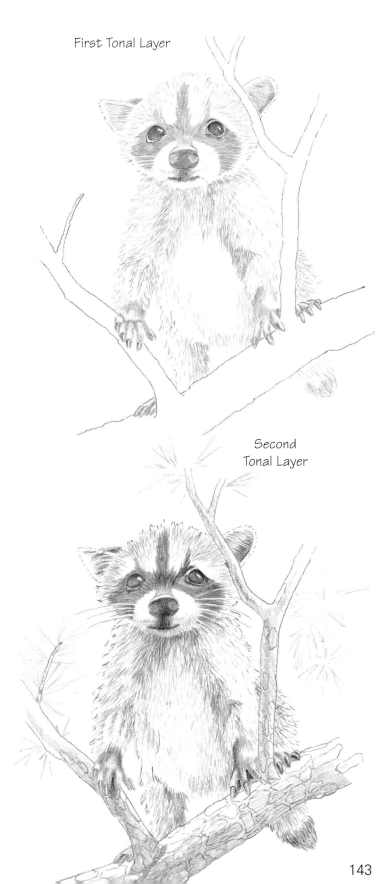

First Tonal Layer

Second
Tonal Layer

Second Tonal Layer

For the second layer, repeat the first layer, deepening the tone and the texture.

Fur:
In this layer, stroke fur over the part of the belly that you left untouched in the first layer. As you work, deepen shadows. Widen the neck area on the right. Shade the lower part of the muzzle with a very light tone.

Branch:
First draw irregular shapes of bark over the surface, then cover the branches – except for the highlight areas – with a light tone. Finally, deepen the tone near the shadow side. Stroke in a few clusters of pine needles.

Final Details & Shading

In this layer, the main tasks are to increase the value contrast by darkening the darks and to improve the illusion of roundness by adding even tones for shading. Switch to a 2B pencil for the final layer – you'll be able to get darker tones.

Face:
Darken the eyes and nose. Deepen the entire eye area (even the tiny areas of light around the eyes). (This integrates the eyes with the mask.) Deepen the tone on the forehead stripe. Add a light shadow to the lower half of the muzzle to give it roundness, and darken the front face of the nose.

Shadows:
Deepen the shadow areas on the body, paws, and tail. (Shading the portions of the leg and tail that lay behind the branch separates these elements.)

Paws:
The nails are very shiny, so deepen the darks but leave the highlights bright.

Branch:
Add a dark tone on the main branch around the bark sections on the shadow side. (This contributes to the texture.) Switch back to the HB pencil and draw in some shadowy branches and more needles.

Finish:
After signing and dating your work, protect it with a layer of spray fixative. ❏

143

ROCKY & RASCAL
RACCOONS IN CONSULTATION

My friend, Don, took this photo of three young raccoons from his deck in the mountains of North Carolina. The one on the right, Rascal, seems to be advising Rocky on what to do next to coax a treat from a recalcitrant human.

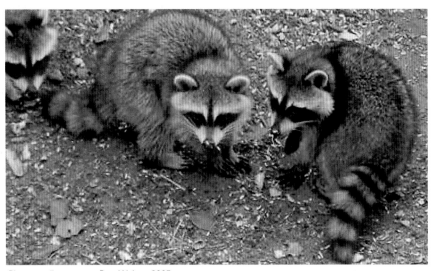

Photo credit: courtesy Don Weiser, 2005

Supplies
- Light ivory acid-free drawing paper
- Near-white acid-free vellum drawing paper
- 5mm mechanical pencil with HB lead
- 5mm mechanical pencil with 2B lead

Observations

I'm going to draw the pair on the right because I like their orientation towards each other. In the following sections, "right" refers to my right, and "left" to my left.

Establishing the Framework

METHOD: BASIC SHAPES

Seeing the Shapes:

The basic shapes of these animals are quite obvious. Rocky's body is nearly a perfect circle from this vantage point, and his head is a second circle. Rascal's body appears to be an elongated oval with a circular head. Notice that their tails are quite thick, but slightly tapered to a rounded end.

Framework Sketch

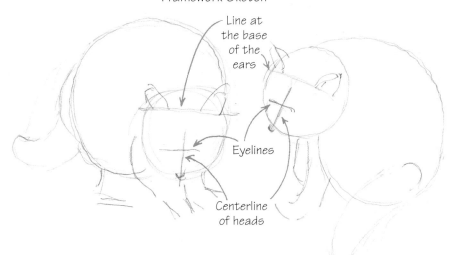

Line at the base of the ears

Eyelines

Centerline of heads

Drawing the Shapes:

Using an HB pencil and a sheet of acid-free drawing paper, draw these basic shapes. Next, draw lines to indicate the centerlines of the faces, the bases of the ears, and the level of the eyes. Roughly block in the shapes of the legs and feet.

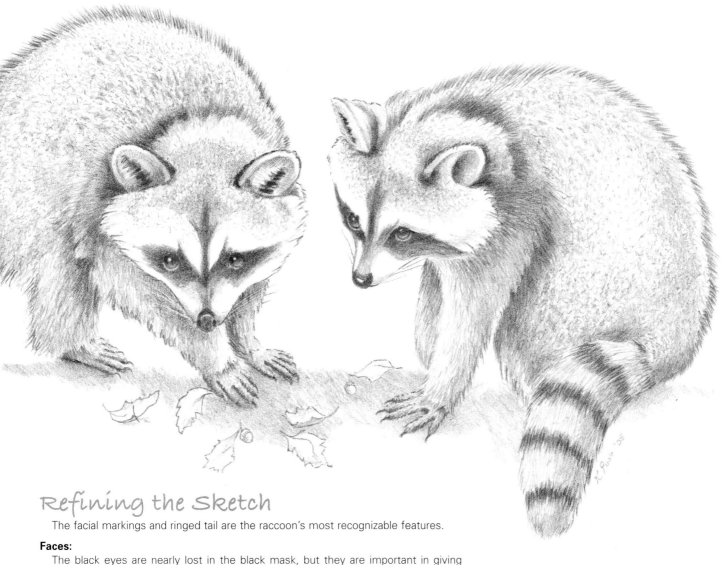

Refining the Sketch

The facial markings and ringed tail are the raccoon's most recognizable features.

Faces:

The black eyes are nearly lost in the black mask, but they are important in giving character to the face. (In the finished drawing, highlights in the eyeballs and on the lower lids distinguish the eyes.) The line separating the black mask from the surrounding light fur gives expression to the face and provides a visual clue to the direction the head is pointing.

Refined Sketch

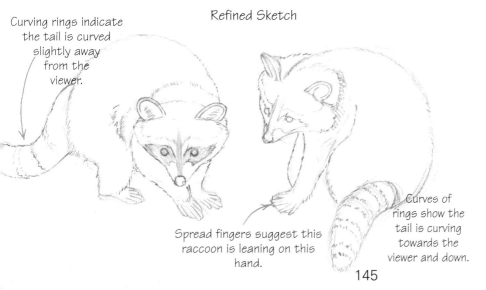

Curving rings indicate the tail is curved slightly away from the viewer.

Spread fingers suggest this raccoon is leaning on this hand.

Curves of rings show the tail is curving towards the viewer and down.

The nose itself is very round and shiny. The muzzle, when seen in profile, is quite pointy. The whiskers sweep back rather than sticking straight out from the face. The ears are fleshy and furry with white rims.

Tails:

The curves of the rings on the tails indicate the directions the tails are curving. The left raccoon's tail is curving away from the viewer, while the right raccoon's tail is curving towards us.

Hands & Feet:

The hands and feet each have five digits and look remarkably like human hands and feet. It is easier to draw the hands

and feet by first drawing the overall shape, then detailing the fingers and toes. The right raccoon's fingers are spread, giving a visual clue to the fact that he is leaning on this paw.

Transfer Drawing:

For the final drawing, make the raccoons to be a little larger and a little closer to each other. To accomplish this, enlarge the drawing on a copier, add a few leaves and acorns on the ground, then carefully transfer the drawing to a sheet of vellum drawing paper, moving the raccoons closer to each other in the process.

First Tonal Layer

The purpose of this first layer is to establish the basic light and dark shapes and the first layer of texture on the fur.

Eyes:

Rim them with a dark thin line. After lightly outlining the highlights, fill in the eyes with a medium tone, graduating to a lighter tone at the bottom. Avoid the highlights as you work.

Noses:

Similarly, outline the highlights on the noses, then fill the noses with a medium dark tone. Deepen the nostrils so that they are darker than the rest of the nose.

Head Fur:

To begin the fur, first cover the mask with an even medium tone. The masks are so dark that their furry texture only shows at the edges. Leave the lightest areas on the muzzles and cheeks untouched. Cover the foreheads and tops of the heads with tiny, short, light squiggly lines to suggest fur that is growing straight towards the viewer.

The fur in the ears grows from the edge of the ears inward. Draw the fur in these areas with short, straight, slightly criss-crossing lines. As you work your way around the ears, keep the lines pointing from the edges in. The very center of the ear is the opening, and it is dark. Add dark lines around the outside edges of the ears.

Body Fur:

The fur texture is different on different parts of the body. For the tails, arms, and legs, cover the areas with straight but slightly criss-crossing lines. (The criss-crossing gives the fur a somewhat rough look.) On the tail, make the dark stripes by pressing harder on the pencil.

The shadows behind the head and arms are simply even, medium dark tones. Because each hair on the body fur is tipped in black, there appears to be a black edge around the body because at those points we are seeing the hairs from the side and their black tips become apparent.

Draw the fur on the rest of the body with longer squiggly lines. Towards the center of the body, where the fur is foreshortened, these lines are shorter – nearly blotches rather than lines – while towards the edge they are longer.

Foot Fur:

The feet are covered with very short fur, so use correspondingly short pencil strokes. Use dark strokes in the shadow areas and lighter strokes in the highlight areas, beginning to suggest their three-dimensional forms.

First Tonal Layer

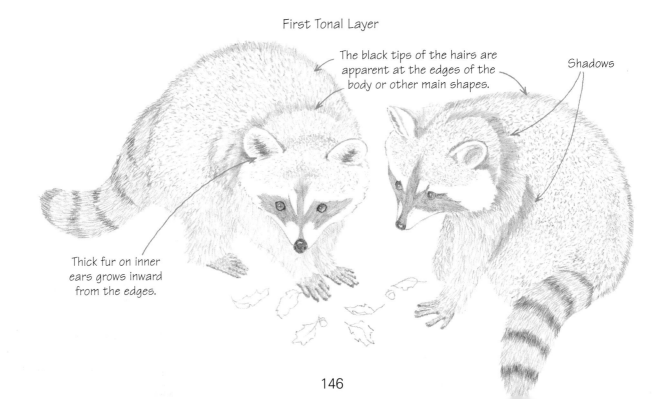

The black tips of the hairs are apparent at the edges of the body or other main shapes.

Shadows

Thick fur on inner ears grows inward from the edges.

Second Tonal Layer

As you place the second layer, pay careful attention to the photograph and establish more value range by working more in the dark areas than in the light ones.

Face:

Begin with the eyes, nose, and mask, using the same method you used on the first layer, except don't darken the lower lid. (This creates a highlight.) As you darken the mask, place the darkest areas around the eyes and in the middle of the vertical stripe.

Fur:

Deepen the dark areas and increase the amount of texturing. Begin to develop form by adding more additional texture to the shadow areas than to the highlight areas – this will darken the shadow areas.

Claws:

Add claws with a very sharp pencil point.

Shadow on Ground:

Place a shadow under the raccoons with an even, medium light tone.

Final Shading & Details

See completed drawing on page 144

For this finishing layer, switch to the 2B pencil. Stroke the pencil back and forth on a piece of scrap paper to get the flattened lead you can use to add soft shading to the drawing. "Soft" means the individual pencil strokes don't show. You are creating areas of even tone.

Darkening:

Remember that value contrast is a powerful drawing tool. Darken the darkest areas, making them as close to black as you can get. Use mid-tones to deepen shadows. **Note:** In the photo, the left raccoon's forward front leg is lighter than it is in the drawing. This is to increase its visual separation from the head.

Bodies:

In middle-tone areas of the raccoons' bodies, draw small splotches of soft-tone rather than larger solid areas. (This helps further define the texture.)

White Areas of Faces:

Add a little soft shading in the white areas of the faces, then use the sharp tip of the pencil lead to define their edges.

Ground Shadows:

Deepen the shadows on the ground. Make them slightly darker close to the animals.

Finish:

After signing and dating your drawing, protect it with a coat of spray fixative. ❏

Second Tonal Layer

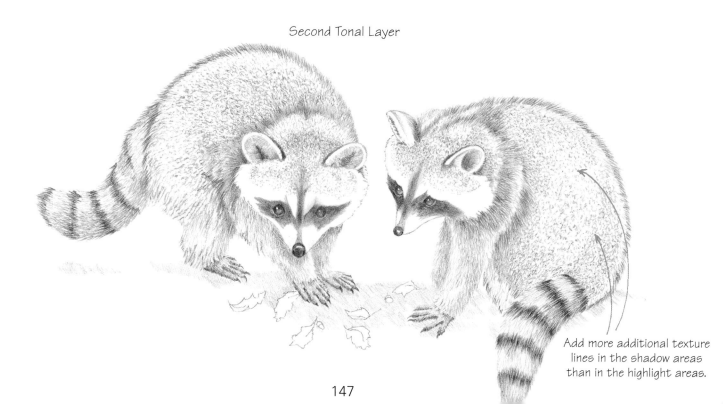

Add more additional texture
lines in the shadow areas
than in the highlight areas.

11 Deer

In rural Northern California, where I live, I often see deer in the morning and evening enjoying my roses, grapes, and tender foliage from the young fruit trees. I imagine they think I planted my garden just for them, and, in fact, I don't mind at all. Seeing the deer, especially the mothers with fawns, is worth it.

To many Native Americans, deer symbolize gentleness. The doe's face is a study in gentleness, as is her tender care for her young. But deer have a strong side as well. They are built for speed and camouflage, a combination that has made them highly successful animals, even in areas inhabited by humans.

Deer have highly developed senses of sight, smell, and hearing that help them evade predators. Their eyes are large, soulful, and particularly sensitive to movement. Their noses are large, black, shiny, and often surrounded by lighter markings. Their ears are large and flared; they work together rather independently of each other.

Antlers are the distinctive feature of the male. (But both male and female reindeer have antlers.) Antlers are bony, and they re-grow each year from bony stalks on the skull. A blood-rich velvety skin covers them as they grow, but when growth is complete, the blood supply is cut off and the skin dries and is rubbed off. At the end of the season, the antlers are shed. Each year, they grow back larger and more complex in structure.

During the first few weeks of life, a fawn lies quietly for most of the day, carefully hidden by the doe as she forages for food. After a few weeks, the fawn accompanies the doe. Although deer have several methods for successfully hiding their young, too often they are discovered by humans who wrongly assume the baby has been orphaned.

If you should find a young fawn, the best course of action is to remove any dogs from the area and watch for a few hours to be sure the baby is, in fact, abandoned. Do not try to raise a fawn yourself – they are very fragile. Instead, contact a licensed wildlife rescue organization.

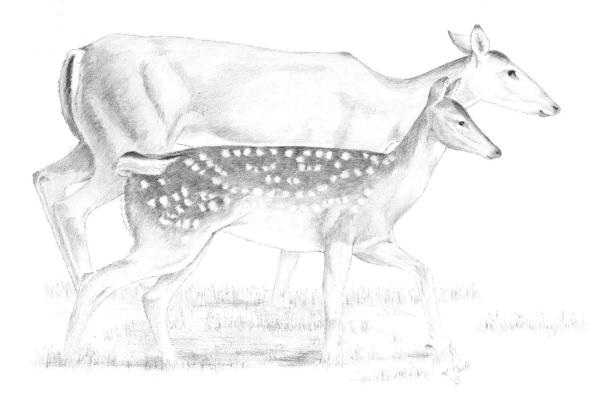

Deer Worksheet

Eyes

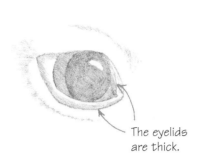 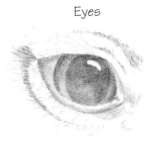 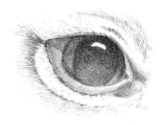

The eyelids are thick.

Nose

The top of the nose is flat.

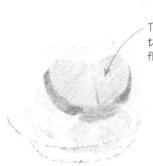

Ears

 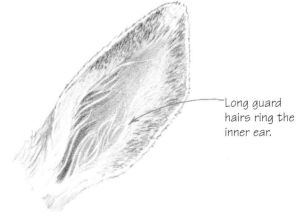

Long guard hairs ring the inner ear.

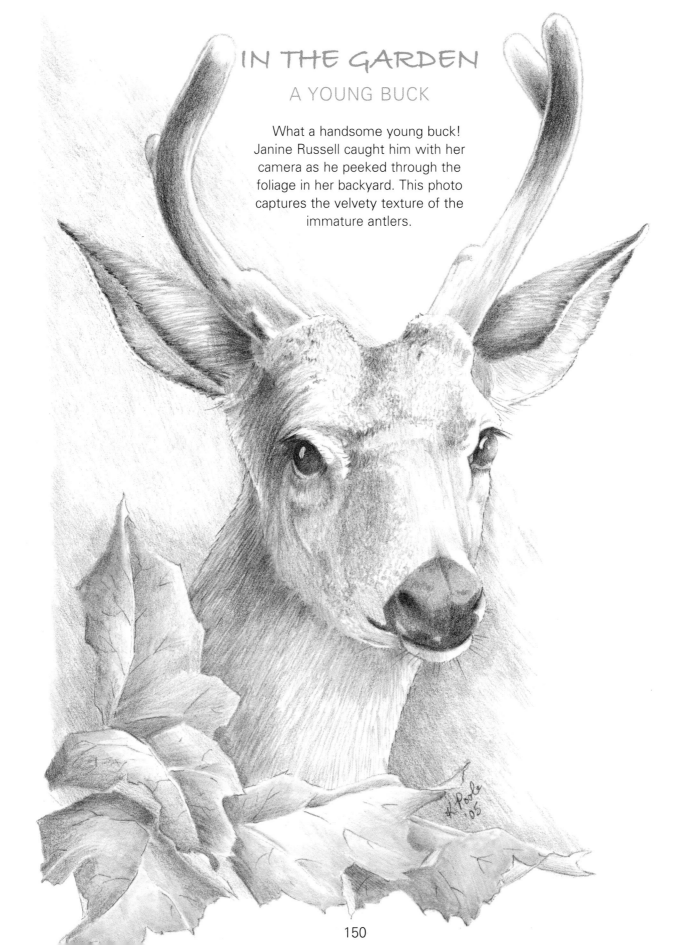

IN THE GARDEN

A YOUNG BUCK

What a handsome young buck! Janine Russell caught him with her camera as he peeked through the foliage in her backyard. This photo captures the velvety texture of the immature antlers.

- Light ivory acid-free drawing paper
- Near-white acid-free vellum drawing paper
- 5mm mechanical pencil with HB lead
- 5mm mechanical pencil with 2B lead
- Compass

Observations

The bony structure of the skull and antlers is quite apparent. We clearly see the structure of the ears and nose. The right eye is shining brightly in the sunlight. He will be a joy to draw. I am going to include some leaves in my drawing. I have seen too many deer heads hanging on walls, and I definitely want to avoid that look.

In the following sections, "right" refers to my right, and "left" to my left.

Establishing the Framework

METHOD: ANCHORS

Discovering the Proportions:

Work with a compass to measure proportional relationships. First, the distance between the outside edges of the eyes is the same as the length of the ears, the distance downwards from an imaginary line connecting the eyes and the bottom of the chin, and the distance between the antlers at the point of the little nubs just above the head.

Second, the length of the head is the same as the vertical distance from the top of the forehead to the tips of the antlers.

Drawing:

Using an HB pencil and a sheet of acid-free drawing paper, draw a slanted vertical line for the centerline of the face for the initial anchor. Then draw a cross-wise line at the eye level. Sketch an eye at each end of this line, placing the left one a little farther from the centerline than the right one.

Use the proportions you found with the compass to block in the remainder of the features. As you work, pay attention to vertical and horizontal alignments. For example, the base of the right antler is vertically aligned with the nose, and the base of the left antler is aligned with the left eye. Horizontally, the tip of the left ear is just a tiny bit higher than that of the right ear, while the tip of the right antler is a tiny bit higher than that of the left antler.

Observing the negative space between the two antlers, and between the antlers and the adjacent ears, helps you position the ears and antlers.

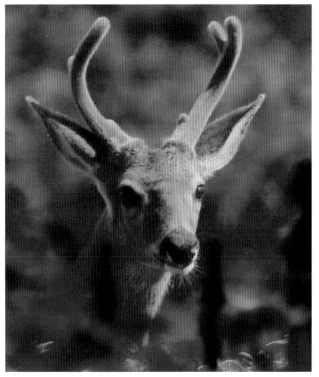

Photo credit: courtesy Janine Russell, 2005

Framework Sketch

Negative space

Negative space

A

Negative space

A

A

Same distances

All distances labeled "A" are the same as the distance between the outside edges of the eyes.

Eyeline

A

Centerline of head

Refining the Sketch

Observations:

I realize I've drawn the antlers a little too short. As I begin to correct this, I see I need to adjust the angles of the left ear and antler, which are angled too low. I refine the shapes of the ears. As I study the photo, I realize that I have misunderstood the shape of the left ear, mistakenly interpreting the bright blaze as white fur on the edge of the ear. As I look closer, I realize it is the sun shining on the brown fur on the back side of the ear. The white fur actually on the edge of the ear is dark because it is in deep shadow, and the left ear is, in fact, folded forward in the same way as the right ear.

Eyes & Nose:

Detail the eyes and nose, referring to the photo. Because the deer's head is facing slightly to the right, the shapes of the two eyes are different. The light fur above the left eye is quite prominent where the upper lid overhangs the eye.

Head:

Add some lines to guide you as you draw the head where the antlers attach. These shapes make it clear how the antlers are an integral part of the structure of the skull (necessary for strength).

Foreground:

Add some leaves in the foreground.

Transfer Drawing:

Carefully transfer the drawing to a sheet of vellum drawing paper.

Refined Sketch

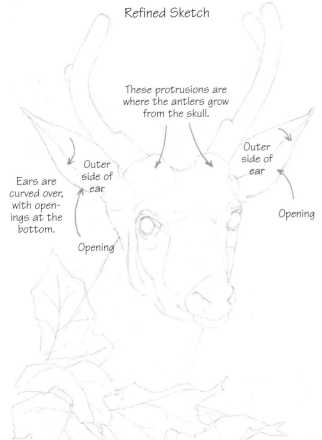

These protrusions are where the antlers grow from the skull.

Ears are curved over, with openings at the bottom.

Outer side of ear

Outer side of ear

Opening

Opening

First Tonal Layer

In this first layer, establish basic tone and texture.

Eyes:

Lay a light even tone over each entire eye, except for the highlights, then darken the edges of the upper lids. Outline the lower lids.

Nose:

As you work the nose, try to keep the tone smooth. The darkest areas are the insides of the nostrils. The front and sides of the nose are darker than the top where the light falls. There are a few light areas around the edges of the nostrils – be careful to preserve these.

Mouth & Chin:

The mouth is quite dark. The chin is white, but the left side falls in shadow so it appears to be a very light gray.

Fur:

The fur on the ears, neck, chest, and side of the head is medium length and lies quite smoothly. Work these areas in long strokes in the direction the fur grows. Notice that on the ears the direction of the fur curves slightly, following the curved form of the ears.

The fur on the forehead and side of the nose is shorter and fuzzier, so work these areas with small squiggly lines. Refer frequently to the photo as you work, carefully picking out the dark and light areas. On the left side of the face, the shadow makes all the areas fairly close in value, but at this point leave the lighter areas white, increasing the contrast. These areas will be toned down later, but you want to establish the darks and lights because they add form and detail to the drawing.

Antlers:

Work the antlers with very long even strokes, striving to eliminate the look of individual pencil marks. As you work, refer to the photo for placement of darks and lights. These shadows and highlights are very important because they help define the curves of the antlers. The antlers are covered with short soft velvet. Smooth them by lightly running your finger along the length of the antlers, moving from dark areas to light ones.

Second Tonal Layer

For the second layer, add another layer over the entire deer. This second layer enriches the texture in the fur.

Dark Areas:

Working in the same manner you did in the first layer, add a layer of tone, working the darker areas more than the lighter ones to increase the contrast.

Light Areas:

Add a light tone over the light areas on the left (shadow) side of the deer. This begins to round the form of the head and neck.

Chin:

Deepen the shadow under the chin to visually push the head forward.

Leaves:

Work a light first layer on the leaves, then soften them with your finger the same way you did the antlers.

First Tonal Layer

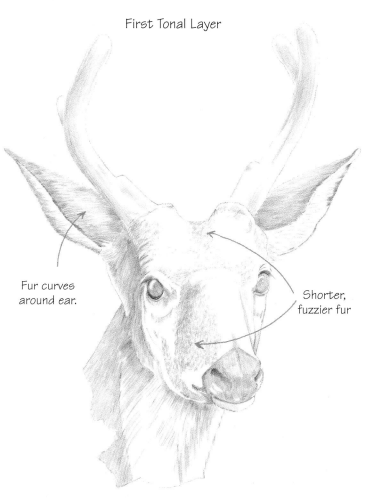

Fur curves
around ear.

Shorter,
fuzzier fur

Leaves:

To finish the leaves, darken the dark areas, add a light tone to most of the highlights, and draw some veins with a sharp pencil lead.

Background:

A tone in the background gives the drawing a finished look. Typically, these types of backgrounds are relatively darker along the highlight side of the animal and lighter along the shadow side.

Finish:

Sign and date your work, then protect it with a layer of spray fixative. ❏

Second Tonal Layer

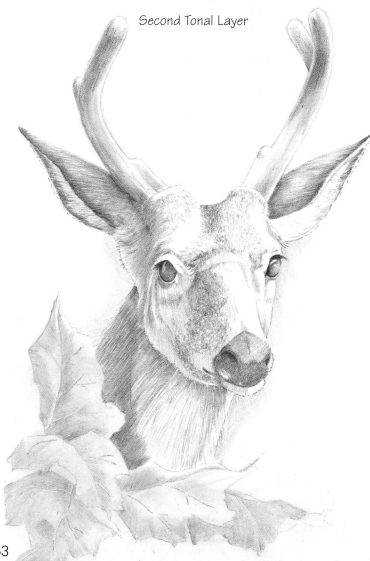

Shading & Final Details

See the completed drawing on page 150.

For even more value contrast and texture, repeat the second layer.

Dark Areas:

In the darkest areas of the eyes, the nose, the antlers, and edges of the ears, use the 2B pencil.

Light Tones:

Tuck a light tone in the inner right ear for a shadow. Add a light tone to the remaining white areas of fur except for the brightest highlights above the left eye and along the right side of the face.

Eyelashes & Whiskers:

With a very sharp HB lead, deepen the eyelashes, pull a few whiskers around the muzzles, and draw tiny individual hairs along some of the edges where light fur is against the background (for example, the right side of the face).

MOTHER & DAUGHTER
DOE & FAWN

Karen Whitenton took this lovely photo of a doe and older fawn in her backyard in Texas.

Photo credit: courtesy Karen Whitenton, 2001

Supplies

- Light ivory acid-free drawing paper
- Near-white acid-free vellum drawing paper
- 5mm mechanical pencil with HB lead
- 5mm mechanical pencil with 2B lead

Observations

These two are clearly in synch with each other, and they will make a beautiful drawing. I like the composition. The two deer fit snugly in a rectangle, a very stable shape, but there is a clear sense of motion. The overall effect is calm. I also like the subtle differences between the poses of the two. The head held high, the ears forward at attention, and the flicking tail of the fawn all say "youth." The doe's ears – one forward and the other back – communicate caution.

These deer will be a challenge for me. Their bodies are long and their heads are pointed. My tendency will be to shorten the bodies and round the faces. Using the grid method will help keep these tendencies in check. I plan to draw the grid on the left side of my paper, leaving plenty of blank space on the right for the deer to walk into. This will balance the composition.

In the following sections, "right" refers to my right, and "left" to my left.

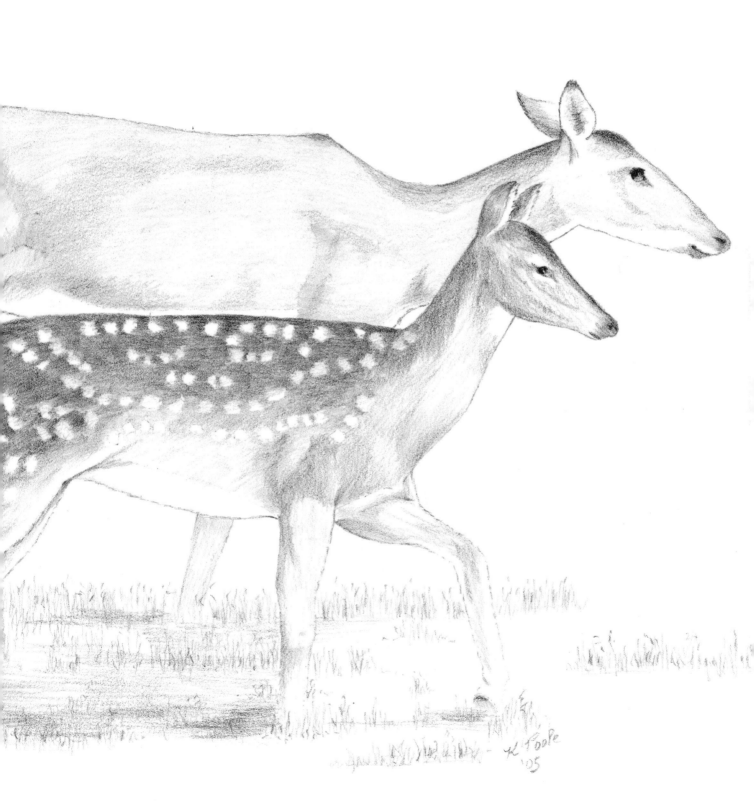

Establishing the Framework

METHOD: GRID

Drawing the Grid:

Using an HB pencil and a sheet of acid-free drawing paper, draw a large grid, just two sections tall and three sections wide. Further divide the section with the heads to help with details.

Drawing the Outlines:

Using the grid as your guide, block in the general outlines of the doe and the fawn.

Refining the Sketch

Now that you have the general outlines, you can pay attention to detail. There is not much texture in the coats, and, except for the fawn's spots, minimal markings. The subtleties of the shapes – legs, neck, etc. – will make or break the drawing. Each line is critical in defining the shape and suggesting the muscles underneath. Study the photograph carefully as you go back over each line, getting them as true as you can.

Eyes:

The eyes are too small for much detail, but their positioning and shape are important details.

Doe:

Sketch in the outlines of the dark shadings in the fur.

Fawn:

Sketch the spots. Don't try for each and every one, but draw enough of them to be convincing. The individual spots are placed randomly along a generally linear pattern.

Transfer Drawing:

Carefully transfer your line drawing to a sheet of vellum drawing paper.

Framework Sketch

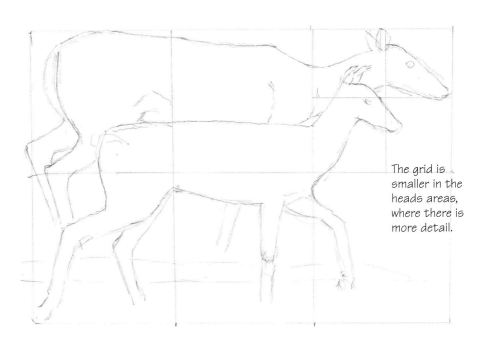

The grid is smaller in the heads areas, where there is more detail.

Refined Sketch

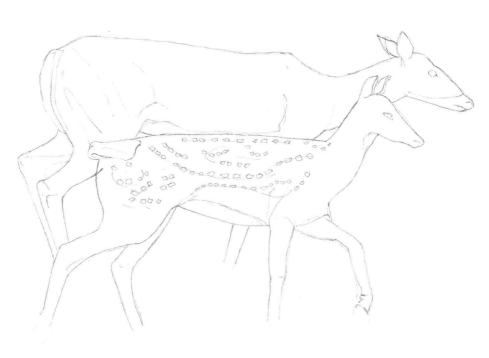

First Tonal Layer

The texture in this drawing is simple to describe ("smooth") but not so simple to attain. The values could probably be made deep enough in one layer, but, inevitably, some pencil marks show when you try to draw smoothly, no matter how careful you are. One way to alleviate this problem is to build the color in a couple of layers. In this first layer, try to keep things smooth and begin to suggest the darks and lights. (Those will be developed in the next layer.)

Doe:

Add tone to the doe. When you're finished with her body and legs, dab lightly with a chamois to smooth the strokes. Then erase any smudges outside the body area and proceed with the face. Her eye is small, but still large enough for a highlight.

Fawn:

As you work the fawn, work around the spots. She is quite a bit darker than the doe, darker on the top fading to a lighter tone down the sides. The belly is white.

Grass:

With horizontal strokes, sketch in lines for the bases of the grass clumps, then work the grass with random up and down strokes.

Second Tonal (Final) Layer

See completed drawing on pages 154 & 155

Doe:

In the second layer, concentrate on increasing the value contrast on her body, thereby suggesting the roundness of her form and the structure of the large muscles.

Fawn:

Concentrate on darkening the coat on her back and haunch.

Details:

For both, deepen the eyes and add more detail on the faces in the form of shaded areas to define the musculature.

Grass:

Add darker random strokes to the grass, then work the shadows with horizontal strokes until they are dark enough to look like they can visually support the deer. (If the shadows are too light, they appear insubstantial and give the animals a floating look.)

Finish:

Sign and date your work, then spray it with a coat of fixative to protect it. ❏

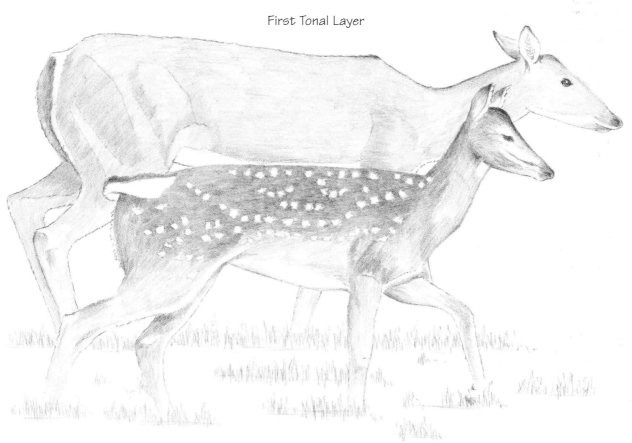

First Tonal Layer

HAVING A SNACK
WHITETAIL FAWN

Sandy and Lee Gardner are fawn and squirrel
rehabilitators with Sierra Wildlife Rescue.
I was privileged to visit them and their young
charges. Fawns are delicate and imprint very
easily so my visit was brief, but I was able
to snap several photos.

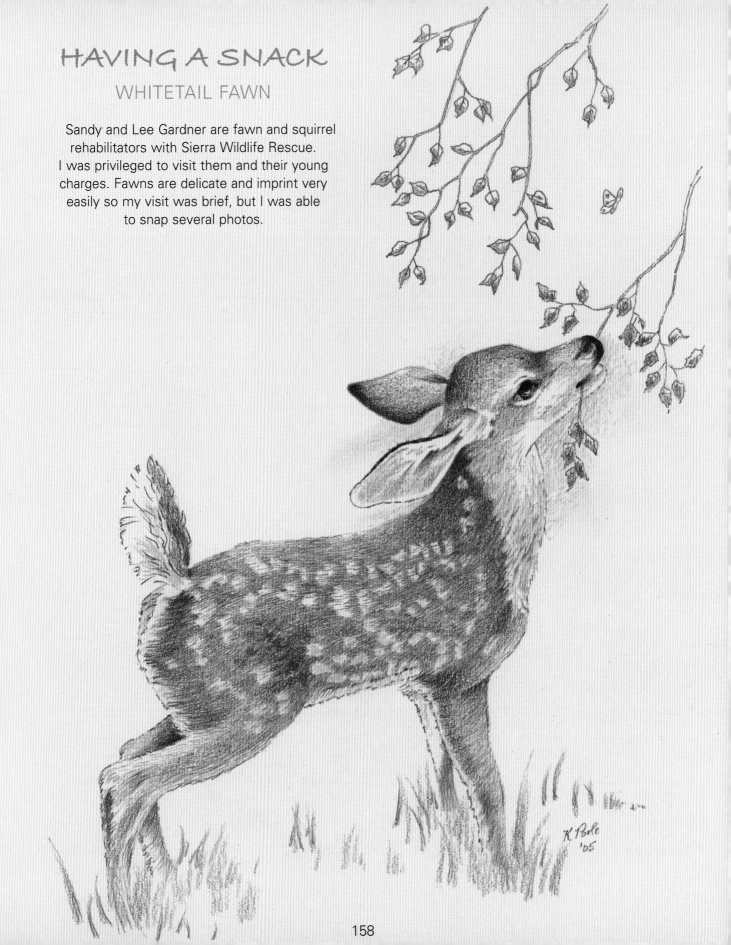

Supplies

- Light ivory acid-free drawing paper
- Lightly textured drawing paper – Champagne
- 5mm mechanical pencil with HB lead
- White charcoal pencil
- Colored Pencils – Black, Tuscan Red, Marine Green, Burnt Ochre, Cool Gray, Dark Brown
- Compass

Observations

I decide to draw the little one closer to the camera, and I will use my artistic license to replace Sandy's finger with a leafy branch! I'm going to use a vertical orientation to emphasize how small the fawn is. I am not familiar with deer anatomy, so I must rely on careful rendering of what I see in the photograph to make my drawing convincingly realistic.

Because some details, such as the fawn's other ear and the shape of the nose and muzzle, aren't visible in the photo with the two fawns, I will use a second photo from my visit that includes those details.

I decide to use a colored paper for my finished drawing, and select a sheet of drawing paper in a color called Champagne. The warm tone seems to fit this young animal. I was tempted to select a green paper, which would be good for the background, but was concerned that the fawn would have a green cast, even after colored pencil washes.

In the following sections, "right" refers to my right, and "left" to my left.

Establishing the Framework

METHOD: BASIC SHAPES

Seeing the Shape:

Sometimes an animal is clearly a series of basic shapes, but in the case of this fawn, the only basic shape is the elongated rectangle of her torso. From there, her neck curves gracefully. Her back is slanted upwards from rear to front, and that same slant is reflected in the top of her forehead and nose, and the centerline of her ear.

Drawing the Shape:

Using an HB pencil and a sheet of acid-free drawing paper, begin by drawing a rectangle a little more than twice as long as it is tall and slanted slightly upwards at the right.

Checking Proportions:

Proceed via trial and error, using your compass to constantly check proportions. For example, the length of her head is the same as the distance from her knee to her ankle, and also the same as the distance from her elbow to a little below the wrist. Sketch a centerline for the far ear, which doesn't show in this pose.

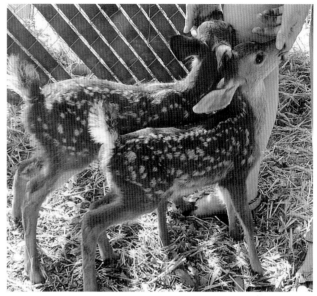

Photo credit: courtesy Kaaren Poole, 2005

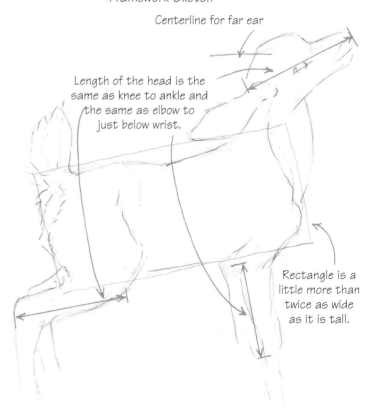

Framework Sketch

Centerline for far ear

Length of the head is the same as knee to ankle and the same as elbow to just below wrist.

Rectangle is a little more than twice as wide as it is tall.

Refining the Sketch

Observations:

I am fairly happy with individual portions of this drawing, but I see that the body is a little too long and a little too thick towards the front. The underside should slant up more. I could erase and re-draw, but I would lose much of the drawing that I'm satisfied with, such as the legs and head. So I use tracing paper, transfer paper, and a stylus to transfer the sketch to a fresh piece of paper, making these changes as I trace.

Shapes:

In refining the sketch, pay close attention to the subtleties in the shapes of the legs and neck. Every curve defines an underlying muscle or ligament stretched or tensed to allow the fawn to maintain this particular stance. These lines are very important in a short-haired animal, where the shape is much more defined than in a long-haired one.

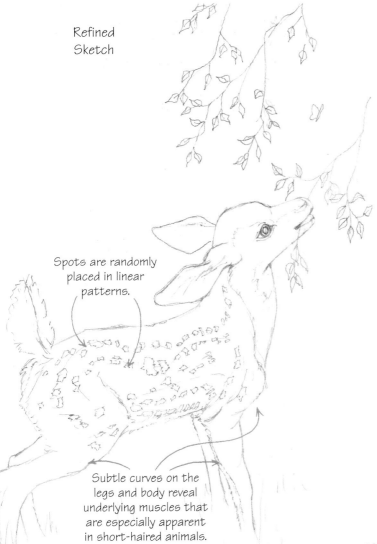

Refined Sketch

Spots are randomly placed in linear patterns.

Subtle curves on the legs and body reveal underlying muscles that are especially apparent in short-haired animals.

Eye:

The fawn's eye is quite large, and although it is dark brown, the pupil shows slightly.

Muzzle & Nostril:

Use the second photo as a guide to draw details of the muzzle and nostril.

White Spots:

Notice that the white spots are not randomly placed, but occur in vaguely linear patterns. Accordingly, lightly sketch these lines and place the spots randomly along them.

Background:

Branches and grass are necessary to complete the drawing, but keep them minimal so as not to detract from the fawn. Add a butterfly for a touch of whimsy.

Transfer Drawing:

Transfer your drawing to the colored paper.

First Tonal Layer

The objective for this first tonal layer is to begin establishing the texture and tone in the darker fur and to begin detailing the face.

Eye:

Begin with the eye, darkening the pupil and iris but leaving the highlight untouched. Check the size. If the eye and the light ring surrounding it seem a little small, correct that.

Dark Fur:

Cover it with short, parallel lines running in the direction the fur grows. It is very important to get the fur strokes going in the proper direction, so refer constantly to the photo. Notice that the fur curves around the front legs and does not run up and down. As you work, leave the white spots untouched.

Light Fur:

On the chest and front of the neck, instead of drawing lines, draw small areas of light tone by working the pencil back and forth in very short lines. (You're actually drawing the shadows between clumps of fur rather than the fur itself.) Use this same technique for the light areas of the head.

Ears:

For the forward ear, use the photo as a guide to draw in the shadows that define the depth of the inner ear. For the dark fur on the head as well as the far ear, work an even tone with back-and-forth strokes of dulled pencil lead. Because the fur is very short – almost velvety – in these areas, you do not want individual strokes to be visible.

Shadows:

At this stage you are not striving for much variation in value, but do establish the main shadows so as not to lose track of the form.

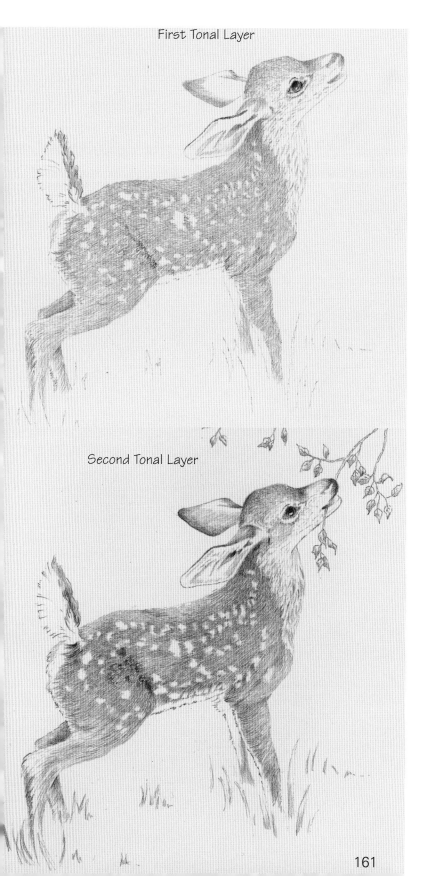

First Tonal Layer

Second Tonal Layer

Second Tonal Layer

Colored Fur:
Work a second layer in the same manner as the first one to darken the overall tone of the colored fur. As before, leave the spots and white part of the tail untouched. As you apply the second layer, go darker in some places than others, creating the beginnings of highlights and shadows. For example, leave the back as well as the top and side of the back leg lighter for highlights; darken the shadow areas on the neck beneath the ear, in front of the hip, and separating the two back legs.

Background:
Draw in the leaves, branches, butterfly, and grasses.

White Areas:
Spray the drawing with a coat of fixative. (Otherwise, the white charcoal pencil will smear the graphite, and you will end up with a gray mess.) Use the white charcoal pencil to lighten the white spots and the white fur on the tail, haunches, back of the front legs, and inside the forward ear. Spray with another coat of fixative.

Shading, Color & Final Details

See completed drawing on page 158

Dark Fur:
Use colored pencils to lightly tint the drawing, but don't do too much – this is not a colored pencil drawing. Using Burnt Ochre with a very light stroke, tint the brown fur. Then go back with Dark Brown in the shadow areas. For the darkest tones on the ear, nose, and eye, use Black. (A Black colored pencil gives a deeper black than the graphite lead in the mechanical pencil.)

Light Fur:
Add some shadow strokes in the white fur with Cool Gray. Warm the mouth and inner ear with Tuscan Red.

Foliage:
Tint some of the foliage with Marine Green.

Finish:
After signing and dating your work, protect your drawing with a coat of fixative. ❏

12 Foxes

Foxes are members of the dog family, a fact that is apparent from their facial features. The red fox is the most common fox in North America, but the gray fox is also widespread. European settlers brought red foxes with them to America for "sport," but there already was a red fox on the continent, and now biologists classify American and European red foxes as a single species.

The fox's most prominent features are the round black nose at the end of a long, pointed snout, and the luxurious bushy tail. Their eyes are round and gold to light brown. They are surrounded with dark eyeliner in an almond shape. Sometimes a little of the white shows, but it is a light gray or tan rather than pure white. Foxes' ears are triangular with rounded tips and black edges. The inner ears are thickly furred, especially along the inner edges.

The typical coloring of the red fox is beautiful. The animal is a rich reddish brown with a black nose and ear tips. The eyes appear very dark because of the eyeliner. There are white markings on the face, throat, and belly. The lower legs are black, and the tail is tipped in white. Red foxes also may have black, white, or silver fur.

Tip

A Dot of Gouache
Sometimes a very small thing makes a big change. White paper is seldom pure white, so a dot of white gouache over the highlight in the eye on the light side of the face brightens it even more.

A completed drawing for "Foxy, Red Fox Portrait".
Instructions begin on page 164.

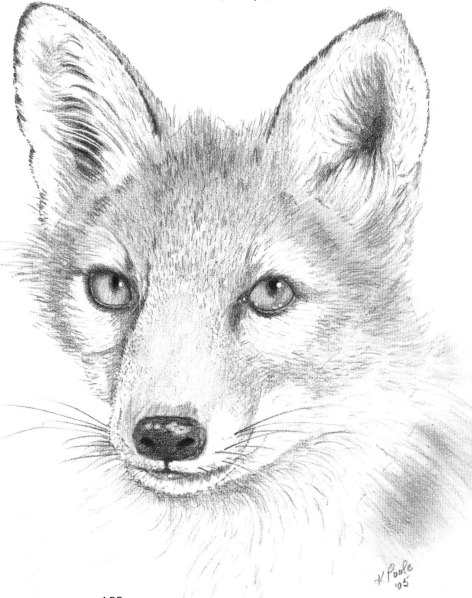

Foxes Worksheet

Eyes

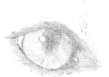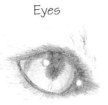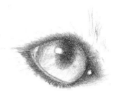

Foxes' eyes are light in color and surrounded by a dark eyeliner, which consists of black skin on the eyelids surrounded by a narrow area of black fur. Overall, the eyes appear dark.

Ears

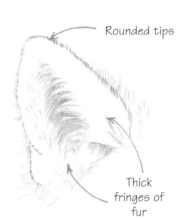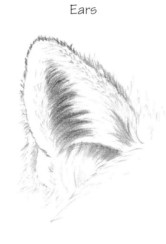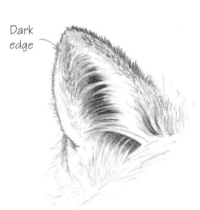

Rounded tips

Thick fringes of fur

Dark edge

Noses

The nose is very round, and the snout is pointed.

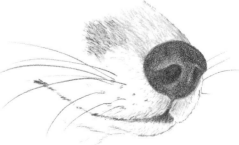

FOXY
RED FOX PORTRAIT

Rhonda Clements took this gorgeous portrait shot of a red fox on her vacation to the San Juan Islands. The beauty of the animal and clarity of the photograph take my breath away. It's a privilege to have such a wonderful photograph to work from.

Supplies

- Light ivory acid-free drawing paper
- Near-white acid-free vellum drawing paper
- 5mm mechanical pencil with HB lead
- 5mm mechanical pencil with 2B lead
- Colored Pencils – Orange, Yellow Orange
- Compass

Observations

Foxes are related to dogs and it sure shows in the eyes and nose. The tiny bit of tongue adds a note of humor, and the tufts of fur at the sides of the face are pronounced. I have a tendency to draw the ears too large, perhaps because they are such a prominent feature. Foxy's beautiful dark "eyeliner" is a combination of dark skin on the eyelids and short dark hairs radiating from the eyes. I'm going to add a bit of color to the fur in the completed drawing.

In the following sections, "right" refers to my right, and "left" to my left.

Establishing the Framework
METHOD – BASIC SHAPES

Seeing the Shapes:
The basic shape in this photo is a diamond – from the tip of the forehead, outward to the cheek tufts, then down to the tip of the nose. Using the compass to check proportions, you'll see that this diamond is very slightly longer than it is wide. The tops of the eyes are on the line between the side points. This line is just slightly higher than midway up the diamond.

The distance between the outer edges of the eyes is repeated elsewhere in the photograph. It is the same as the distance between the tip of the tongue and the eyeline. Also, the ears are just slightly longer than this distance.

Drawing the Shapes:
Using an HB pencil and a sheet of acid-free drawing paper, draw a diamond. Add the eyeline and place the eyes just beneath this line.

Blocking in the Features:
The face is turned just slightly to the left, so the nose is just slightly left of center. Look for other alignments, and notice that the inner edge of the right ear and the inner edge of the right eye are vertically aligned. The right edge of the muzzle is just a little further to the right. The right edges of the left ear and eye and left edge of the nose are also vertically aligned.

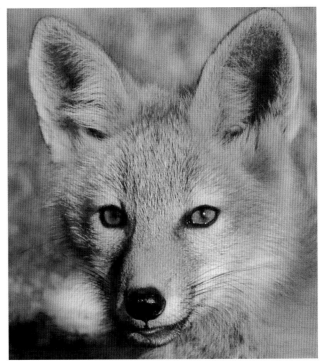

Photo credit: courtesy Rhonda Clements, 2005

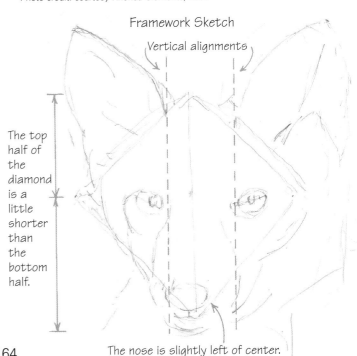

Framework Sketch

Vertical alignments

The top half of the diamond is a little shorter than the bottom half.

The nose is slightly left of center.

Refined Sketch

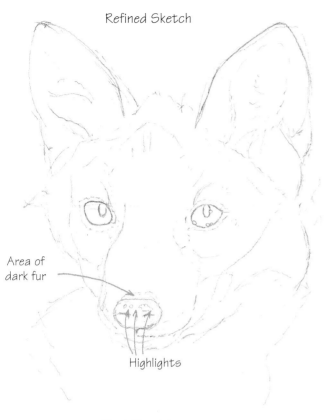

Area of dark fur

Highlights

First Tonal Layer

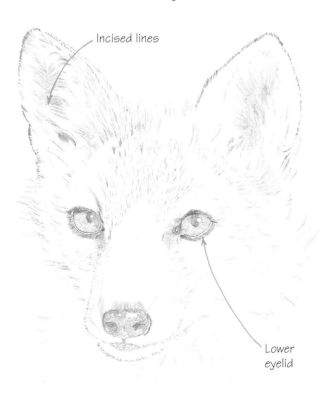

Incised lines

Lower eyelid

Refining the Sketch

Eyes:

Because the face is turned slightly to the left, the left eye appears a little narrower than the right, and the shapes are slightly different.

Nose:

Notice it is flat on the top and bottom and that there is a dark area on the fur of the muzzle right behind the nose. Draw in the highlights – they are crucial to making the nose appear shiny.

Ears:

Work on the shapes of the ears, adjusting the angles and widths until you are happy with them.

Fur:

Indicate main shapes in the fur to help you later.

Transfer Drawing:

Carefully transfer you drawing to a sheet of vellum drawing paper.

First Tonal Layer

Eyes:

Darken the pupils, then add a lighter tone to the irises. (The fox's eyes are a light gold so don't go too dark.) After carefully outlining the eyes, draw a thin line just outside this line along the bottom of the eye. This is the lower eyelid. For now, leave the eyelid light, with the paper showing between the two lines, but draw in the tiny dark lines radiating from the eyes. Be careful to orient them properly, and notice how their angles change at various points around the eye. (For example, along the top, the angle is shallow and the lines are near horizontal, while along the lower lids the lines are nearly perpendicular to the edge of the eye.)

Nose & Mouth:

Darken the nostrils, then add a medium tone over the entire nose, avoiding the highlights. Indicate the edges of the muzzle and chin with tiny lines and a sharp pencil lead – the hairs are very short here. Darken the tongue and the little vertical line between the nose and mouth.

Ears:

Rim the ears with tiny dark lines. For the insides of the ears, use a stylus to incise some of the longer white hairs. Darken the inner ears around these lines to bring them out.

Fur:

The fur on the forehead is short and highly textured. Begin by drawing medium dark lines representing the dark areas between the light hairs. For the rest of the fur, add soft lines in the areas where the fur is darkest, but leave the rest alone for now.

Second Tonal Layer

Eyes:

In addition to the eyes being very light, the outline of the pupil is somewhat blurred. As you darken the pupils, be careful to create a soft edge. Add very little additional color to the eyes – very soft color in the areas where the irises are darker – the upper, inner, and outer edges on the left eye and the upper edge to the left of the pupil and directly below the pupil on the right eye.

Nose:

Darken the nose, avoiding the highlights. As you increase the value contrast in this way, the nose begins to get a shiny look.

Fur:

At this stage, add texture to the fur in all areas except the white fur and the smooth center of the nose. Add lines of fur on the chest to set off the chin. Then add a little soft tone to the left of the white chest fur, and use a chamois to soften it.

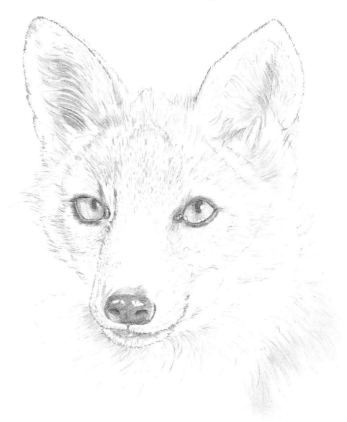

Second Tonal Layer

Final Shading & Details

See completed drawing on page 162.

Eyes, Nose & Ears:

Switch to the 2B pencil to darken the centers of the pupils, the nose, and the dark fur rimming the ears.

Fur:

At this stage, the fur is sufficiently textured – but add even tones to darken the red fur and create shadows. Switch back to the HB pencil and, using a dull lead and soft strokes, evenly darken the areas of light fur. Continue to deepen the inner ears. Add shadows to the left of the nose and under the chin to help bring the face forward.

Color:

Spray your drawing with a coat of fixative and let dry. Add **very light** washes of color with colored pencils – Orange on the red fur, and Yellow Orange on the eyes.

Finish:

Sign and date your drawing, then protect it with another coat of spray fixative. ❏

IN A FIELD OF FLOWERS
RED FOX

What a beautiful fox in this field of spring flowers. She will be fun to draw with her bright eyes, alert ears, and glamorous tail.

Supplies

- Light ivory acid-free drawing paper
- Near-white acid-free vellum drawing paper
- 5mm mechanical pencil with HB lead
- 5mm mechanical pencil with 2B lead
- Compass

Instructions begin on page 168

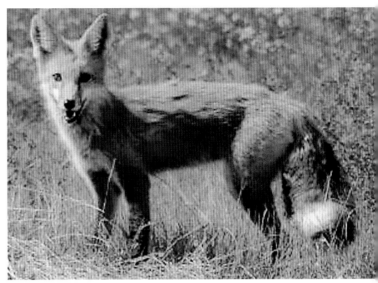

Photo credit: courtesy Jerry Walter, 2005

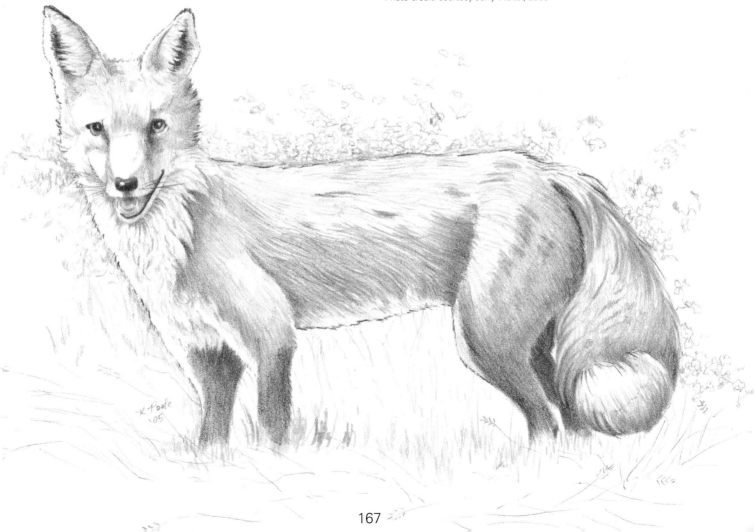

Observations

Drawing her will be a challenge. Her head is turned ever so slightly, allowing the viewer to glimpse the side of her open mouth. Her tail is flipped towards us, and foreshortening is often tricky. On the other hand, the overall form is fairly simple. The fox's body is long and lean, and I decide to anchor my drawing on a horizontal line at the level of her elbow.

I can't see her far back leg in the photo. The photo looks fine without it, but I find its absence disturbing in the drawing. It's possible that the dark vertical edge to the left of the tail is the edge of her back leg mostly hidden by the tail. Or it's possible that the forward leg completely hides the rear one. Typically, in a quadruped (four-legged animal), the legs on one side of the body are either angled towards each other under the body (as her two legs nearest the viewer are), or are angled away from each other. Following this principle, her back far leg would be angled back, so I sketch it in that position.

In the following sections, "right" refers to my right, and "left" to my left.

Establishing the Framework

METHOD: ANCHORS

Seeing the Anchors:

With the compass, notice that the horizontal line at the level of her elbow, running from the front edge of her chest to the rear portion of the tail, can be divided into quarters at identifiable points: the back edge of her elbow, the extension of the angle on her lower leg, and the rear of her leg. A vertical line at the front end of the horizontal anchor line, and half its length, marks the top of the head just inside the right ear. The midway point of this line is at the bottom of the chin.

Drawing the Shapes:

Using these anchor points, block in the main shapes, using the HB pencil and a sheet of acid-free drawing paper. Her back is fairly flat, but rises slightly just forward of the hips. The belly rises at a steady slant between the front and back legs. Her ears are wide and pointed, about as tall as they are wide. The outside edge of the left one echoes the slope along the left side of her head, neck, and chest.

Refining the Sketch

Face:

In working the face, it's helpful to draw a V-shape upwards from the nose. The eyes lie along these lines, and the ends of the lines intersect the tops of the ears just a little to the outside of the tips. Her ears are quite upright.

The proportions of the face are deceptive. Surprisingly, the horizontal distance between the outside corners of the eyes is the same as the vertical distance between the eyes and the bottom of the gums in her open mouth. Noticing vertical alignments between the eyes, ears, nose, and mouth helps you position the features correctly.

Body & Legs:

There is not a lot of detail in the body and legs, but the subtle curves of the outlines are important to creating a convincing drawing. Also, the lighting in this photo is quite dramatic – indicate the shadow line along the back. Along the left edge of her face, neck, chest, and forward leg is a narrow very bright area. Sketch a light broken line along the right edge of this highlight. Draw the far back leg.

Tail:

To indicate the flip of the tail, sketch the light tip.

Carefully transfer your drawing to a sheet of vellum drawing paper.

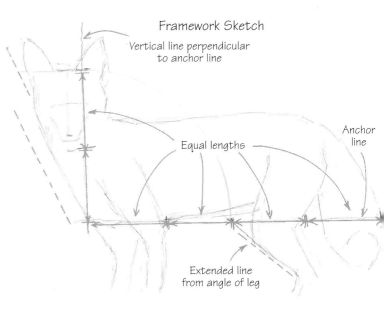

Framework Sketch

Vertical line perpendicular to anchor line

Equal lengths

Anchor line

Extended line from angle of leg

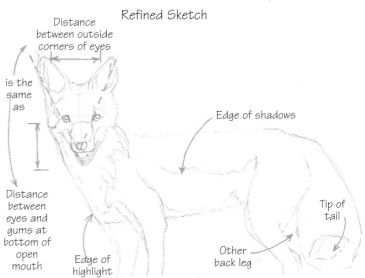

Refined Sketch

Distance between outside corners of eyes

is the same as

Edge of shadows

Distance between eyes and gums at bottom of open mouth

Edge of highlight

Other back leg

Tip of tail

First Tonal Layer

Eyes:

Even though the eyes are very small, work around a tiny highlight in the pupil. The pupils are very dark, and the irises less so. Outline the eyes with dark lines, striving to preserve their correct shapes. Both eyes are very round on the lower edges, but the sides and tops are shaped by the shadows from the bridge of the nose and upper lids. Each eye has its own unique shape, with the right one appearing somewhat larger overall.

Nose & Mouth:

Leave a small highlight on the dark nose, and carefully draw around the two tiny canine teeth. The tongue is a medium tone, the front curve of the gums is very light, and the lower lip (continuing around the side) is very dark. There is a white edge to the chin where the short white fur is.

First Tonal Layer

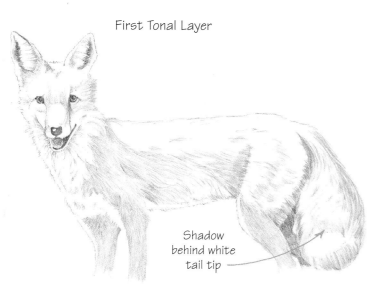

Shadow behind white tail tip

Second Tonal Layer

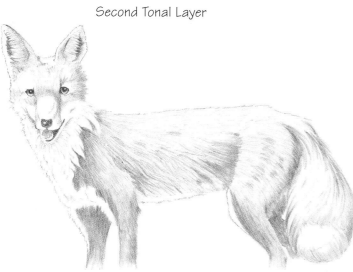

draw long lines, waving them slightly along her side. At this stage, leave the large highlight on her back untouched.

Rear Haunch:
The rear haunch is more complex. A shadow down the center of the haunch and a highlight to its immediate right reveal the underlying large muscles. Carefully mimic these value shifts, indicating only the darker areas at this stage.

Tail:
To begin to form the flip at the tip of her tail, shade behind (above) it with a smooth tone, then work the dark fur at the bottom with upward-curving strokes. Work the remainder of the tail with long strokes and a dull lead, once again leaving the highlight untouched.

Second Tonal Layer

Apply a second layer in the same manner as the first. At this point, cover the highlights on the back and haunch with very light fur strokes preserving the value contrast. Add a very light tone to all but the brightest highlight areas on face. Deepen the fur on the legs. Develop the shadows on the red fur of her side behind the white ruff, and also the shadow on the side to the front of her haunch. Working with a dull lead, add more strokes to her tail and deepen the shadow behind the tail tip.

Shading, Background & Final Details

Highlights:
Work more texture into the white chest fur. To bring the brightest highlights forward, add a very light gray tone to the white fur on the right side of the chest, right side of the face, knee, belly, and rear portion of thin area of white fur at the front of the right front leg. Cover the highlight on the tail with a light gray tone, and shade the lower portion of the white tip.

Dark Tones & Shadows:
Switch to the 2B pencil and darken the eyes, nose, inner ears, black lip, dark fur on the legs, and the small shadow between the rump and the tail.

Outlines:
With a very sharp lead, outline the light edges of the fox with small broken lines.

Background:
Working with the HB pencil, put in the background. Sketch the grasses in the foreground with long thin lines, then dot in grain heads on some. Work the shorter grass in the fox's shadow with a dull lead. Suggest the wildflowers behind and around her with short squiggle lines.

Finish:
Sign and date your work. Protect it with a coat of spray fixative. ❏

Ears:
There are very long thick tufts of fur along the inner edges of the ears. Draw the dark area behind them, leaving a jagged edge.

Face Shadows:
Carefully draw the main shadows on the face, but leave the highlights untouched at this point.

Chest Fur:
Indicate the white fur on the chest by lightly outlining curved tendrils.

Fur:
The legs are smooth tonal areas because their fur is very short and shows little texture. For the long fur on the body and tail,

RELAXING ON A ROCK

GRAY FOX

This little gray fox looks so comfy curled up for a rest, with his leg
stretched out in front of him. Wouldn't this make a nice Christmas card
with the fox curled under the low branches of a pine tree with snow drifting
in front of him?

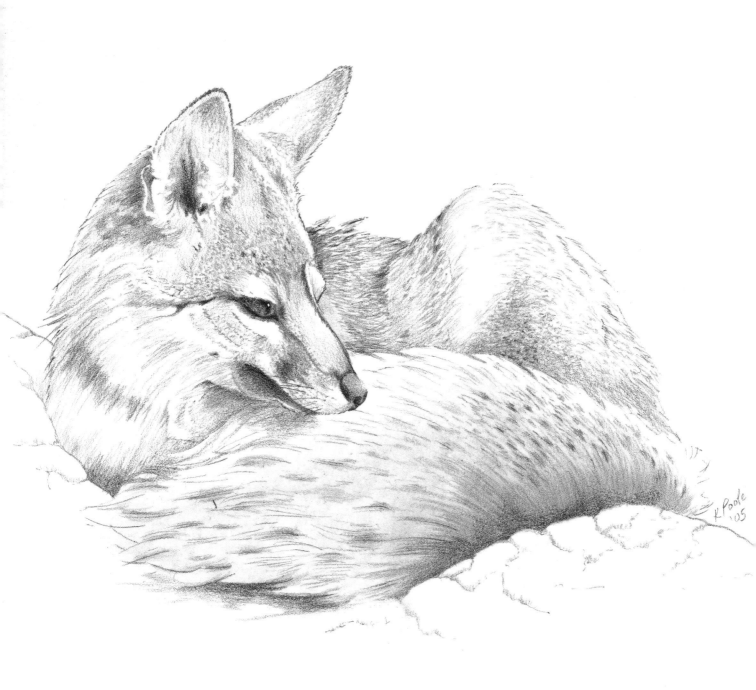

Supplies

- Light ivory acid-free drawing paper
- Near-white acid-free vellum drawing paper
- 5mm mechanical pencil with HB lead
- 5mm mechanical pencil with 2B lead
- Small piece of chamois
- White gouache
- Compass

Observations

There is one thing in the photo that I want to change for my drawing. I can't see his foreleg well enough to draw it accurately, so I'm going to tuck it under the tail.

There are several different textures and colorations on this fox, so I will need to use a variety of techniques. Although there is no eye highlight in the photo, I feel that the drawing needs one so I'll add one with white gouache.

In the following sections, "right" refers to my right, and "left" to my left.

Establishing the Framework

METHOD: ANCHORS

Discovering the Anchor:

Notice the fox fits neatly within a circle. Explore the photo with a compass to discover that a circle centered on the tip of his nose touches the tip of the right ear, the tip of the light fur on the back of the neck, and the far right end of his body. Also, the curve on the back of his neck follows the curve of the circle and falls just slightly outside of it. The bottom edge of the tail is about halfway to the edge of the circle from the center. (The circle is an obvious anchor.)

Drawing the Main Shapes:

Using an HB pencil, draw a circle on a sheet of acid-free drawing paper to begin. Notice that the tip of the nose, the tip of the right eyebrow, and the little tuft of fur just beneath the right ear lie in a straight line. These three points, drawn on a radius of the anchor circle, divide the radius in thirds. Using these observations as guidelines, block in the main shapes.

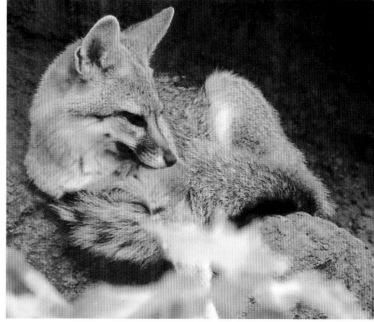

Photo credit: courtesy Pat Tamarin, 2003

Framework Sketch

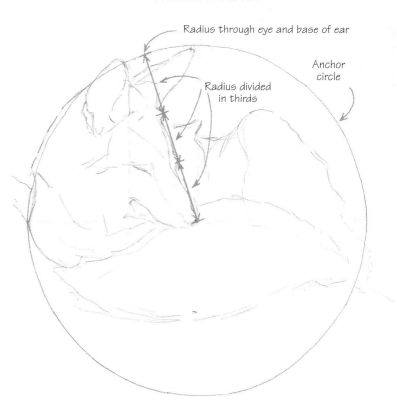

Radius through eye and base of ear

Anchor circle

Radius divided in thirds

Refining the Sketch

Nose:

The fox's nose is very sharp, but its shape is subtle. Without capturing these subtleties, it will look harsh. Draw the centerline from the nose up to the crown of his head.

Forehead & Muzzle:

Notice that just behind the nose itself, the line curves slightly upwards for a short distance then gently curves the other way. The highlight along the length of the forehead follows the continuation of the centerline. Also draw the edge of the dark fur on the near side of the muzzle.

Right Ear:

The right ear is turned away from the viewer so we see the outside of that ear. It is curved downwards around the center line of the ear. Draw this centerline to help you place highlights later.

Left Ear:

The left ear is turned towards us, and we see only the inside of the ear. There are long tufts of fur along the front edge. The little flap behind the ear is a characteristic feature. Sketch the tufts of fur around the opening of the ear.

Refined Sketch

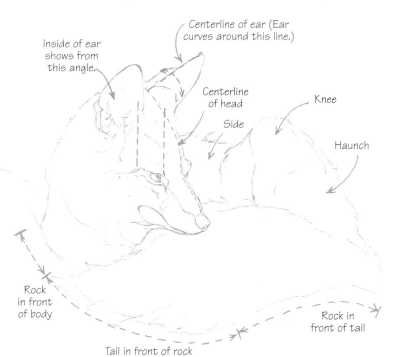

Inside of ear shows from this angle.

Centerline of ear (Ear curves around this line.)

Centerline of head

Side

Knee

Haunch

Rock in front of body

Tail in front of rock

Rock in front of tail

Eye:

The forward eye is a little tricky because it is so dark. The first thing to do is sketch the outline of the dark area, vertically aligning the back of it with the forward edge of the left ear and the front with the forward edge of the right ear. Then draw a light line from corner to corner and place the actual eye along that line.

Mouth:

Like the eye, the mouth is simply a dark shape with little detail.

Fur:

Sketch the line at the break between the head and neck fur. The vertical light area of fur about halfway back on the body is actually the knee. The inside of the fox's leg is light, like the belly, and that's what we see here. The darker fur towards the front is on his side, and the darker fur towards the rear is his haunch.

Tail:

The fox is lying in a hollow in the rock. The forward half of the tail is in front of the rock, but the shoulder and back half of the tail lie behind the rock.

Transfer Drawing:

Carefully transfer your drawing to a sheet of vellum drawing paper.

First Tonal Layer

Eye:

Draw a medium tone over the pupil, a lighter tone on the iris, and a darker tone in the area around the eye, keeping your strokes as smooth as possible.

Nose & Mouth:

Draw a smooth dark tone in the mouth, transitioning to a slightly lighter tone at the bottom. There are three tones on the nose – a dark at the bottom of the side and in the nostril, a medium tone on the front edge and the bottom beneath the nostril, and a light tone on the top.

Left Ear:

Outline the left ear with tiny dark hairs. The center portion is dark, grading lighter as you move upwards. For the textured area at the top, use a light squiggle stroke, but leave a light rim around the ear. Draw in a few light hairs at the lower right. The hairs in this area are curved from the outside of the ear in.

Right Ear:

Outline the right ear in the same manner. Use light squiggle lines to darken the area inside the rim and the back edge. (There is no rim showing at the back edge because the ear is curved around.)

First Tonal Layer

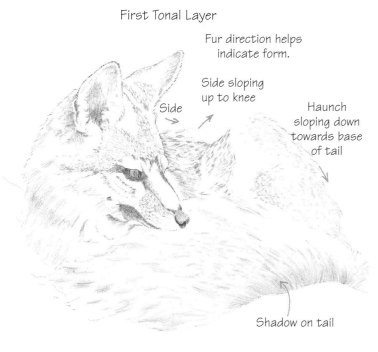

Fur direction helps
indicate form.

Side sloping
up to knee

Side

Haunch
sloping down
towards base
of tail

Shadow on tail

Second Tonal Layer

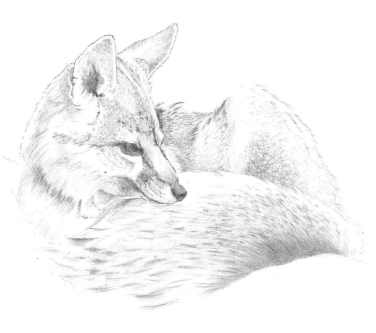

Dark Markings:
Work on the dark markings along each side of the snout and behind the eye, and the dark shadow under the mouth.

Neck & Head Fur:
The fur on the neck and the back of the head is smooth. Just behind the ear there are is a lot of value variation – depict it as accurately as you can, using short, smooth strokes with a dull pencil lead. Render the rest of the fur on the neck and back of the head with light, smooth, parallel strokes. Render the textured patches of short fur on the forehead, side of the head above the eye, and side of the muzzle with short squiggly strokes.

Body Fur:
The direction of the hairs on the fox's side are very important because they help portray the form. Begin at the lower left of this area with fairly smooth even strokes, then draw individual patches with close, squiggly strokes as you move up and to the right. Leave a small highlight area untouched in the lower center.

Leave the knee and ridge of the leg white at this stage. For the fur on the haunch, use short, fairly dark squiggly strokes at the lower left, then gradually lighten and lengthen them as you move up and to the right.

Tail:
The lower right area of the tail is pushed up against the rock in front of it and is in shadow. Draw it with closely placed, dark curved strokes. Draw small patches in the central area, then larger ones as you work towards the tip of the tail at the left. To smooth the tail, dab the entire area with a chamois.

Housekeeping:
After erasing any smudges or lines on the rock area, spray the drawing with fixative.

Second Tonal Layer

Face & Fur:
Add a second layer just like the first in the eye, nose, mouth, and inner ear. Draw an even tone over the face, head, neck, and body fur. Referring to the photo, properly place the lights and darks, varying the pressure on your pencil as you work the values in the different areas. Leave only the brightest highlights white.

Tail:
Work the tail as before, but add lots of small patches. Once again, smooth it by dabbing with a chamois.

Housekeeping:
Erase any stray smudges or lines, and spray with fixative.

Continued on page 174

Shading, Details, & Rock

See completed drawing on page 170

Face & Fur:

With the 2B pencil, once again darken the inside of the ear, the eye, mouth, and nose. Switching back to HB lead, add more texture to the darker areas of the fur. (Having a sufficiently dark tone on the body behind the tail visually moves the tail forwards.)

Tail & Shadows:

Draw a shadow on the tail beneath the chin. Continuing with the 2B pencil, darken the shadow on the tail behind the rock, and add a shadow under the left portion of the tail, which is lying on top of the rock.

With the HB pencil, draw several long, thin hairs on the tail.

Rock:

Barely indicate the texture in the rock by outlining a few of the bumpy areas. Shade them with very short, squiggly lines. As you do this, draw breaks in the smooth edge of the rock to follow the bumps.

Eye Highlight:

Place a dot of white gouache with the tip of your stylus as an eye highlight.

Finish:

After signing and dating your drawing, protect it with a coat of spray fixative. ❏

Metric Conversion Chart

Inches to Millimeters and Centimeters

Inches	MM	CM	Inches	MM	CM
1/8	3	.3	2	51	5.1
1/4	6	.6	3	76	7.6
3/8	10	1.0	4	102	10.2
1/2	13	1.3	5	127	12.7
5/8	16	1.6	6	152	15.2
3/4	19	1.9	7	178	17.8
7/8	22	2.2	8	203	20.3
1	25	2.5	9	229	22.9
1-1/4	32	3.2	10	254	25.4
1-1/2	38	3.8	11	279	27.9
1-3/4	44	4.4	12	305	30.5

Yards to Meters

Yards	Meters	Yards	Meters
1/8	.11	3	2.74
1/4	.23	4	3.66
3/8	.34	5	4.57
1/2	.46	6	5.49
5/8	.57	7	6.40
3/4	.69	8	7.32
7/8	.80	9	8.23
1	.91	10	9.14
2	1.83		

Index

Hey! Where's my chapter?
Mice are animals, too!

Mouse Portrait, after a photo by Melanie Jaffie

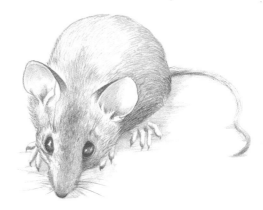

Photo Credits

Rhonda Clements (Red Fox Portrait)

Rhonda is a semi-professional photographer specializing in wildlife and scenic images. Her works have been published in four books, and she sells greeting cards and prints from her photos. She lives in the Seattle area with her husband, Craig, who is also a photographer.

Karin Dasher (Albert Resting (rabbit), School Crossing (hen and chicks))

Karin lives in Ludowici, Georgia and is a multi-media artist. Her favorite medium is clay. She has been interested in photography since childhood, and several of her photographs have been published. She recently opened a fine arts and crafts store where she teaches pottery classes.

Luc Giroux (Raccoon Head)

Luc lives in Montreal, Canada, and is passionate about his hobby of photographing animals and landscape. His photographs have been featured frequently on Webshots.

Melanie Jaffie (Quiet Moment (ducks), Squeak (mouse))

Melanie lives in Peoria, Illinois. She began her photography hobby in 2004 and has been told she has a good eye, which is evident from her beautiful photographs.

Diane Lee Long (Scotty's First Day Out (juvenile raccoon))

Diane is a wildlife rehabilitator who enjoys photographing the creatures with whom she is blessed to share her life.

Kaaren Poole (all dog, cat and horse photos, Donna (duckling), Fox Squirrel, Whitetail Fawn)

Nan Powers (Roxy (squirrel))

Nan lives in the Sierra Nevada foothills of Northern California. She is Public Relations Director of Sierra Wildlife Rescue and a member of the squirrel team. She is a freelance writer and an amateur wildlife photographer.

Janine Russell (chipmunk, Young Buck)

Janine lives in Edmonds, Washington and took both these photographs in her yard. She became interested in photography when her granddaughter was born 13 years ago. She enjoys photographing all of God's creation – people, animals, and landscape.

Dominique Shimuzu (Baby Cottontail)

Dominic took this photo at the Volunteers for Wildlife shelter in Huntington, New York, where she volunteered. The organization runs a shelter, which houses 30 permanent residents who are too injured to return to the wild, and an education center. The organization rehabilitates 800 to 1,000 sick, injured, or orphaned animals each year.

Pat Tamarin (Grey Fox)

Pat took this photo in Tucson, Arizona, where she was working for the Pima Association of Governments. Her photographs have been published in PAG publications and displayed in PAG offices. She currently lives in Everett, Washington.

Jerry Walter (Red Fox, Squirrel Head, Cute Bunny)

When Jerry retired from the postal service he relocated from Southern California to North Dakota. He has been interested in photography his whole life and is now thoroughly enjoying his photographic pursuits. He sells cards produced from his work and has won several awards at the local county fair. He has generously permitted several artists to work from his photographs.

Don Weiser (Raccoon)

Don lives in the mountains of southwestern North Carolina. He is an avid photographer, specializing in wildlife and scenery. He has published two books, one of which is a collection of photographs of the local white squirrels. He sells his book as well as cards produced from his work at local stores and his work has been published in North Carolina magazine. You may visit him at whitesquirrelart.com.

John White (Eastern Cottontail)

Karen Whitenton (Doe & Fawn)

Karen lives in southeast Texas and took this photo on her property. Nature photography is her hobby, and her photos have been featured on Webshots.